WINDSTORM
AND FLOOD

ALSO BY ROSALIND BRACKENBURY

Yellow Swing
Seas Outside the Reef
The House in Morocco
Between Man and Woman Keys

Windstorm
—and—
Flood

a novel

Rosalind Brackenbury

JOHN DANIEL & COMPANY, MCKINLEYVILLE, CALIFORNIA, 2007

Book design and typography:
Studio E Books, Santa Barbara, CA, www.studio-e-books.com

Published by John Daniel & Company
A division of Daniel and Daniel, Publishers, Inc.
Post Office Box 2790
McKinleyville, CA 95519
www.danielpublishing.com

Distributed by SCB Distributors (800) 729-6423

LIBRARY OF CONGRESS CATALOGING-IN-PUBLICATION DATA
Brackenbury, Rosalind.
 Windstorm and flood : a novel / by Rosalind Brackenbury.
 p. cm.
 ISBN-13: 978-1-880284-93-3 (pbk. : alk. paper)
 1. Clergy—Fiction. 2. Hurricanes—Fiction. 3. Life change events—Fiction. 4.
Key West (Fla.)—Fiction. 5. Psychological fiction. I. Title.
 PR6052.R24W56 2007
 823'.914—dc22
 2006034545

This book is dedicated to all those who lost far more in the hurricanes of 2005 than could be envisaged in the slow dream that is fiction.

"Blow winds and crack your cheeks…"

—*William Shakespeare*

AUTHOR'S NOTE

ABOUT eighty of these disturbances form every year in the Atlantic Basin but only five become hurricanes in a typical year. There is no way to tell in advance which ones will develop.

Among the Sioux of the U.S. this force was known as *wakan*. Sometimes it is represented in the form of a wind, as a breath having its seat in the four cardinal points and moving everything.

I would like to thank the following for their support in the writing of this book: the Studio Center, Johnson, Vermont; the Rodel Foundation of Key West; and the Virginia Center for the Creative Arts; all of whom have provided me with time and space to write. I am grateful to the captain and crew of the schooner *Wolf*, who took me sailing, and to Marie-Claire Blais, Delia Morris, and Ann McLaughlin, constant and patient readers. Also Kathryn Kilgore for the Artists' and Writers' house, and Annie Dillard for her room. And my husband, Allen Meece, for his encouragement and belief in me.

WINDSTORM
AND FLOOD

1

THE DAY AFTER THE HURRICANE the city was full of birds.

He came out of his house into the street, where branches lay across the sidewalk—frangipani and poinciana, the big cracked palm fronds like wrecked canoes, debris no one had yet had time to clear. He stood still, breathed the air's sudden sweetness cleaned by rain. Coconuts and avocados rolled wet in the gutter. He picked up one of each, put them on his porch. A ragged man came down the street towards him, also bent to pick some up, looked at each one as if it were treasure, put them in a black plastic sack that hung heavy over one shoulder. The storm had made scavengers of them all.

"Hey, padre."

"Hey, Hank. So, you survived okay?"

"We're all survivors, thank the Lord."

"Okay, take care, have a good one."

"God bless, padre."

Shouldn't he be doing the blessing? Too late. Hank sloped away, a homeless man used to weather in the streets. His uneven stride, one shoulder up, one leg dragged, with the bag growing heavier all the time.

Jim called after him, "Take care now!" He watched him go, and felt the warmth on his face that was indeed a blessing, the gift of the day after, clear sun.

Across the street, part of a roof had slid down and propped itself on one corner on the ground, so the house had a lopsided look, like a stroke victim. A tree lay right across the street, one of the giant

banyans, the torn ligament of its roots turned up so that anybody coming by had to pick a way through their tangle. It made him think of a dead elephant. You could imagine its last gasp, going down: a groan, a collapse. A Force Three hurricane, and the trees were down, but not the houses, so he'd heard on the radio this morning. Crashed giants, felled and now prone in the streets. A few had taken roofs with them as they came. But the damage was minimal, that was what he heard. Thank you, said Jim, for sparing us. For this new day.

He went up the church steps, clambering over branches that lay in his way, turned the key in the lock, pushed the door open, stepped into hot darkness. The air was full of a fluttering presence; he was touched, surrounded where he stood. His instinct was to turn and run out into the sunlight. Then he heard it, the whisper of hundreds of wings. It was like breathing, it was so slight. The air in the church throbbed with small hearts beating. He stood still, then walked like a blind man up the aisle, feeling his way, pew to pew. His church was unknown to him, it was full of something he couldn't have dreamed or imagined. Murmurs and touches, the air filled and thick. He felt in his shorts pocket for his small flashlight, swung the narrow beam up ahead of him. They were perched on the pews, around the altar, in the high arched darkness above, fluttering and settling on the beams. His light found the pews and floor flecked with white. A thousand bird droppings, like flakes of snow.

He went back, opened the church door wide to let them out. Into the daylight, the new-washed steaming morning of that first day, the stream of them, tiny birds escaping back into the world from which they'd come. They came close to him, as if he too were a tree, then escaped into the blue air, the green smashed debris of the street, to perch on broken branches, hop after insects in the wet mass of leaves. Birds. Hundreds, maybe a thousand of them, locked in his church.

He went back into the house, found his book of American and Caribbean birds, sat down on the step to look them up, match what he'd seen with a name, a place on the globe, a reason for all this. The olive and yellow ones, palm or maybe pine warblers. Black and orange, could be American redstarts. The ones that hopped still on his

porch, tails cocked, heads spotted with orange, oven-birds. Metallic black-throated ones, blue warblers. The smallest of all, apparently quite unafraid of him, they came so close: the Cuban finches, that people called chippies.

They'd found a hole somewhere in the fabric of the church. Must have been blown off course, who knew how many hundreds of miles, by the strength of that wind. He began dragging branches off the church steps, his feet in sandals already soaked, his back aching; alone, bareheaded in today's sun, beginning with just his own two hands to put things back.

That was when the change began to make itself felt, he would say later; when the life in him began to surge and move on in an inexplicable way—was it wind, was it weather, was it being suddenly alone—and the feeling of being out of control took hold. Like being on a toboggan, a slide on too steep a hill. How strange life is, he would say, with its coincidences, its premonitions, its sudden feelings. Just when you thought nothing would ever happen to change you, you were on this ride, this skidding descent. Susan was gone, he was alone, his world looked suddenly different, he was half excited, half afraid, and it made him remember being young and the strange, frightening feeling of having your life before you, to begin. But he was nearly sixty, so it was absurd, wasn't it, to feel this way?

SARAH, far away in her own life, took a cab from Logan airport down through the traffic and dug-up streets and market stalls of Boston, to Long Wharf, where the ferries went out.

It had changed so since she was a child. Now, in 1998: all these brick pavements, pedestrian walkways, waterfront wine bars. The boats were still where they'd been, when she and her mother used to go back and forth, for the fun of it, on day trips from the Cape. The purple-blue water in late afternoon, the clouds like huge dirty sails towards sunset. Seagulls, big gray northern birds. The slap and suck of cold water.

She went into one of the new bars while she waited for the Provincetown boat to board. It was a fake pub, with wood veneer, brass, high

bar stools. She ordered a glass of wine and sat sipping, though tea, on second thought, would have been better. It was still strange to be going out there again, with her mother gone, the house sold, nothing left for her but memories, and her mother's old gay friend Johnny, whom she'd promised to visit, and did visit, once a year. They'd been neighbors in their white clapboard houses with their views of the ocean glimpsed through narrow alleyways, and their gardens with lavender, roses, honeysuckle, so New England, the smell of them made for nostalgia, even if you didn't know for what. People leaned on their gray stone walls in the purplish late summer light, looked into their yards and breathed in those smells. People they didn't know, would never see again. The smell of the grass, with Johnny in his shirtsleeves pushing the old hand-mower and the wet grass falling behind him, green as chopped spinach; her mother with scissors in hand, cutting roses for a bowl in the hallway, and then Johnny coming by for a glass of something, sherry, cold wine; after her stepfather's death, when the two of them could be as Anglo-Irish as they liked, with their rose-cutting and their sherry, their quiet talks on summer nights. He was a true friend, old Johnny; and he'd somehow avoided getting AIDS or cancer from the cigarettes he smoked—Turkish, always—and now, ten years after her death even, he was a healthy old man who hugged her to him each time she visited, smelled of Armani perfume and loved her, he said, as if she were his daughter. In P'town these days, he said, he was happy as a pig in shit, with all the beautiful young men parading by and him with no need to do anything more than look. Sarah had seen someone slipping out the back door, when she arrived, someone else out in the back yard picking green beans as if for his own dinner. Johnny said, "They like to be of help to me, dear. They like the house, you see."

To him she was young, a youngster, her mother's child. But she wasn't young, she was in her mid-fifties, not looking it, whatever that meant, still slim, still with a spring in her step. Sarah Henderson, who had been Sarah Flood and briefly Sarah Kirshbaum and then again Sarah Henderson, back to her original name. If anyone had been watching her, they would have noticed a firmness about the way she

walked in a straight line, a slight bounce in her step (she wore sneakers for comfort), a pallor being whipped into some color by wind and sun, hands in her jacket pockets, a leather backpack on her back, her shoulders held back, posture good, hair flying up, neither blond nor gray today, halfway between. She looked active, sporty, probably went to a gym, but equally probably worked indoors. In fact, she was—is— a journalist. Her wrists ache often from too much keyboarding, her eyes sometimes feel filled with sand. But you can't see this. All you can see, really, is a middle-aged woman, single at a guess—no rings, and an air of independence—striding bouncily along towards the Provincetown boat.

She boarded the boat with a few others, not the lines of tourists she'd expected. The sunburned sandy ones had poured off the boat after their week of vacation; the rest of them were dressed for it, but quieter, paler, less rumpled. A week in P'town, Sarah thought, could leave you looking burned out, more ways than one. The boat's engine started, they began backing out of the slip into the harbor. A big sloop passed by their stern. The sailboats that went out for the sunset were beginning to glide out towards the open sea.

They were a couple of miles out, not more, when someone sighted the whales and a shout went up from the bow. At first she didn't understand. She hadn't been watching. The reason she hadn't been watching was the man leaning on the starboard side, his back turned to her, his face invisible but something about the way he stood, his hair, that was familiar. He looked like Patrick Mellon, that was it— that slouch, that lift of shoulder, that tangle of hair in the wind, gray now on black, and Patrick would be graying, as she was under her fading blond streaks. She'd thought of Patrick only yesterday. Odd, how the thought could generate the appearance of the person. But the tall man turned and looked back across the boat deck towards her, just as the cry went up—"Whales! Whales on the port bow!"—and she saw that it wasn't Patrick, just someone out of the same stable, gene pool, memory bank, whatever it was that had made her stare and catch her breath.

"Whales!" Three humpbacks, in the dark blue water that surely

wasn't far enough out for them. The boat hadn't even passed the headland at Hove. She ran to the rail, saw the sudden curve rise up out of the water, the black side and then the white-tipped fin of the whale before it reeled under again, out of sight. A clear patch was made in the ripples on the surface of the water, as if oil had been poured on it. The stink came of the whale's breath, its long outgoing wheeze. Another whale was up now, blunt chin covered with barnacles, black and squared off against the sky. The sun was low, the sky pink-tinged, the whale's snout reared and sank. Then the wheel up again, the turn in the water, the half-somersault, the uplifted white-stained fin, as if splashed with paint. The sigh of their breath. The bulk of them in the water, so close to the boat, they could tip it surely and have it under. Sarah thought, they never come this close to shore. Many times, she'd been out on the whale-spotting boats that went six miles out and slowed on the feeding banks of the open Atlantic, in deep water. There, you saw whales. But here, so close in to shore?

The mate confirmed it. "Never seen these guys round here before. Guess they must be just visiting."

As the cameras and movie cameras came out and the exclamations—"Wow!"…"Get that!"…"These guys are acrobats!"…"Never seen anything like it!"—the whales turned and headed away, out towards the open ocean. Their backs, ridged and surfacing, then the white flukes of their tails, like a farewell. The man who wasn't Patrick sat down next to Sarah.

"Makes you realize, doesn't it? There's a whole world down there we don't know anything about. Incredible. Was that the first time you've seen them too?"

"No, I grew up around here."

But not in this place, not in this stretch of water. She thought—so they are changing their habits. Are they becoming comedians for us? Have we taught them to come close to boats because we clap and cheer?

The man so obviously was not Patrick, when he came close and spoke. There had been just that slight similarity, that fall of hair, that tall man's hunch. Strange, how people slightly resembled each other,

how a look, a gesture came through them. Then you looked again, and it was gone. Just enough to remind you of a time, a place, a series of events you had not thought of for so long a time that they could well have happened to somebody else.

HE was down on the quay for her, Johnny with his old man's questing sideways look, his hand out for her bag.

"No, I'll take it, it's half empty anyway. How are you? Good to see you."

"Ah, it's good to see you, Sarah my dear." His Irishness, hidden for half a lifetime, came out when he was moved or surprised.

They walked in the summer twilight back to his house; along the street, with the glimpses of water and boats off to the right, and then across it to where the galleries were, one after the other, with their signs out and their paintings in the windows, and then Johnny's house and the one next door that had been her mother's. The low stone walls, the fuchsia, the salt in the air, the sound of grass cutting in the evening, the long slopes of lawn. Hollyhocks, cut privet hedges, cold grass. And sudden smells of woodsmoke and patchouli on the air. Young men with their hands in each others' back pockets, sauntering down to the edge of the ocean.

The painters who came here came to paint light, to paint air.

"Are you painting?" she asked him; he who had come here fifty years ago to do that and had never left.

"A little. I find the need to do less of everything, as I get older. A very little satisfies. Still, I'd be glad to show you what I've done."

His arm around her shoulder as he nudged her through the door. "You know, you're the image of Marion these days. I like the hair."

"Ah, we all have to do it. Actually, it needs doing again. But didn't you know her as Mary Ann? I thought you did."

"No, I always called her Marion. Because that was her real name. Sarah—"

"What?"

"You know, she was in a very real sense my best friend. More than a neighbor. I loved your mother."

"Yes. She had a way of being loved." She had been so open with people, always so delighted to see them. Sarah remembered hanging back, shy at her mother's knees, embarrassed at the way she talked to everyone, offered friendship as if it were so easy; made them feel as Johnny still felt today. She, Sarah, had inherited Johnny because her mother was his friend.

"So I want to ask you, you know, no beating about the bush. Are you all right? I mean, for money? Because I've got far more than I need."

Sarah smiled at him, in the long cluttered room with his sagging green armchair, his table covered with papers, his dropping rose petals upon wood.

"Oh, Johnny. I'm fine. I have enough. I have a good job, you know."

"Ah, still a journalist. I always thought they lived off crusts and water. No? You see I had this idea. You want to hear it?"

"Well, it sounds like I should."

"I'm giving you a house. Because you had to sell hers. There, I wanted that out of the way, I wanted to get that clear."

"Hey, let me get my breath first! You can't. I'm fine for money, I've got a good job, I told you. You don't have to give me things, Johnny, a house, what d'you mean, you can't give me a house, you need it yourself."

"I don't mean this house. My other house."

"What other house? I didn't know you had one."

"The one in Key West."

THEY sat down to dinner that he had prepared: sorrel soup, a seafood omelet, pears and Brie. He poured her greenish Muscadet in a slim glass. Outside the seaside darkness gathered, filling the gaps between houses, coming in like water, filling up the town. The light over the ocean, still there. A scatter of stars.

"Darling," he said, "I have received so much love in my life, and your mother's care for me was quite extraordinary. When she died, I felt nearly extinguished. And then you came back to see me, year after

year, an old queer neighbor, nobody you really had to bother with; but you did. I don't have anybody else. All my boys are dead or gone, and anyway, I wouldn't trust them, not the way I trust you. I had it let to a couple of them, nominal rent, you know, and now they've gone off to Costa Rica or somewhere, and it's empty. I don't want to own so much property, I told you. A brush full of paint, a little taste of wine, some good cheese, that's enough for me. I'm an old man, I'm happy here. Winters are a pain in the butt, but not enough for me to hike all the way down there to warm my old bones. So I thought, who could do with a house, now; and who better than Sarah. I know, you like to run around the world and good luck to you. But everyone needs a base."

"Years ago," she said, "someone told me to go to Key West. A French sailor, in Morocco. And I've never been."

"Well, dear, you do hang out with exotic people. A French sailor, eh? Makes me think of Genet. Did you ever read *Querelle of Brest*? Marvelous piece in there about French sailors' pants, the thrill of un-buttoning them. No? Well. But now you can do the thing you were told to do. Go to Key West."

"But I work in New York." Did that sound ungrateful? She didn't want it to.

"Still, I hear there are wonderful means of transportation these days, dear, called planes. I think that this need not be an obstacle. You don't have to live there all the time, you know."

"Johnny. I'm overwhelmed. I'm so overwhelmed that I think I've been rude. But I don't know what to say, how to say it. Is thank you enough, when somebody gives you a house? I don't know."

"It's enough. I could have left it to you in my will, but then I wouldn't have had the fun of giving it to you, of hearing what you do with it, how you like it down there. So I thought up the plan, of giving it to you now. That way, a weight's off my mind and you can tell me all about it. It's not very big or grand or anything, but it'll be big enough for you, and somebody else too, if you should ever do what they call settling down. I suppose the time for having a family is prob-ably over?"

"Yeah. You suppose right. Sorry. But I don't think I was ever the type. And there's no one else on the horizon, even, so I think I'll be settling down in single peace, when I do."

"Well, there's a lot to be said for it. One needs friends, as one gets older. Though of course, lovers are nice."

Silence. He poured her more wine, and she knew he wondered if he had overstepped the mark.

"Tell me about your lovers, Johnny," she said, after that minute. "Who was the best?"

"You really want to know? Well, now. Somehow it always turns out to be the person one expects least from, don't you find? That way, all you get are good surprises." Then, "Tell me, first. How do you like this wine?"

2

ON THE NIGHT BEFORE THE STORM HIT, Jim had been down on his old bicycle to Mallory Square, the place where tourists usually crowded to watch the performers, see the sun go down. There were a few scattered people, under the lights. A journalist from the *Miami Herald* came with a notepad and pen and asked him why he had stayed. There were people from the Weather Channel, wrapped to the eyes in foul weather gear as if it had started already, or as if they wished it had.

"Yeah, I live here. Most of us don't leave." He felt pride at being one of the people who didn't run, but hunkered down for the storm. Behind them, a black band lined the sky; it thickened, spread towards them, so that as the sun went down behind the islands, the town was already dark. On Duval Street, the shops were silent, shuttered with nailed-up boards and ply. Someone had scrawled "Open! All welcome! Hurricane Party!" in black spray paint. A man he knew by sight stood at the corner by Fast Buck Freddie's, playing his saxophone to nobody. The cool firm scatter of notes. The black sky at the street's end. The humans, suddenly visible, one and one and one, where there had been the faceless thousands of tourists all slouching up and down.

"Hi, Jim!" the sax player took his instrument from his lips. "It's a ghost town!"

What was his name? Pete? Pat? Jim waved, called out to him a "Hi!" that was carried on the wind, biked on. A group of young people sang "Amazing Grace." *Ama-a-a-zing gra-a-ace, how swee-eet...* A plastic

bag full of air came down the street on its own, like a balloon. The hurricane was coming, it was there on the map like fate. Jim found in himself a quiet inexplicable joy, that this was happening. He turned around and came back to bike the wrong way up Southard, uninterrupted by any traffic. He was singing too, as he came back home.

IN the rooms empty of any other life—just himself and the cat, who grew skittish and spat at him—he prowled about. He'd watched Susan pack the car with more clothes and objects than he thought a refugee should take. Books, a boom-box, her computer even, two suitcases of clothes, bags of cosmetics, vitamins and jars of the stuff she ate that he always thought looked like dried seaweed.

"Well, nobody knows how long it'll last, do they? They might not let us back soon. Anyway, I have stuff to do, and the power here's bound to go, so I may as well take them."

"Take the TV and the washing machine too, if that's the reason."

"Jim, everyone with any sense is going. The whole town's going to be empty. There won't be any need for you." She challenged him, her arms full of clothes. She had little patience for him these days; it was as if his decisions were all flawed before he made them and bordered on the ridiculous. When he didn't answer immediately, she strode on past him.

"I have to see to the church. It's my job. Anyway, I don't want to come. If anything's coming for me, it can come and find me at home." He spoke to the emptied place where she had been, but loudly, so that as she came back in to the room, he seemed to be yelling at her.

"You are so stubborn!"

"Well, the Conchs aren't leaving, the old ones, they know better. And the homeless people can't. And all the cats will be here, hey, Ginger?"

"Okay, well, I'd better go. There's going to be a lot of traffic on US 1, and I don't want to get to Sherry's late."

He thought of the road out, the bridges packed with cars, panicky drivers in long lines for gas. "Well, maybe the storm will come visit you in Georgia, you never know."

"Jim, for God's sake. Well, goodbye." She hovered close.

"Goodbye."

"I'll call."

"Yeah, do."

"If the lines aren't down."

"Of course."

She reached to kiss his lips, a dry brush of her flesh to his, valedictory, he thought, a true goodbye. Her coolness, where once, long ago, he remembered, she had been hot and clumsy in his arms as they headed for what she called "romance." It was strange how a person who had lived this close to you for years could seem such a stranger. He had no idea what she thought, what motivated her. Had he simply not been paying attention?

"Give my love to Sherry. And little Jamie. And, I suppose, to Jake." Jake, the son-in-law he hardly ever saw, who had mysteriously married his daughter and kept her in a comfort he found claustrophobic. You had to spread love around, in these vague messages, like a radio broadcast, or a pop song. Love, love—

"Take care, Jim." That was another thing; people were always telling each other to take care.

"It's okay," he said, lifting her hand from his arm. "There's someone who'll take care of me. One way or the other."

His faith annoyed her; it seemed to make him immune. She backed off, then, and her glance as she went was almost amused, almost irritated beyond repair. He heard the car start but didn't go out to wave to her, though he knew he should. Her departure left him with a hollow feeling of guilt, as if he had mismanaged something, left something vital undone, unsaid. But whatever it might be, it was too late. She had joined the mass of people who lined their cars up and set out on their perilous adventure, one behind the other on the causeway that stretched and trembled over high bridges and along stretches of wild gray water, all the way up the Florida Keys.

WHEN you lived in a town where a hurricane hit, people called from all over the world to find out if you'd survived. The TV networks

broadcast their pictures: the same wrecked house, furniture floating in seawater, the same boat up-ended in a tree, the hotel patios and tennis courts all covered with rocks and sand. The same woman weeping, telling how terrified she'd been. The images flickered their blue light around the world. Time differences didn't matter; in California people got the pictures at breakfast, in Australia at midnight, late afternoon in France. The hurricane spanned time, was everywhere at once, whatever else was going on. It drew everyone into its vortex. The storm that had formed off the west coast of Africa, spun across the Atlantic, going faster, growing bigger over days, moved over Cuba, advanced on the Florida Straits and would deliver a direct hit, they heard, on Key West at dawn. You could watch it from anywhere in the world. It was photographed and recorded from space. So it was not surprising that during that same day—yesterday—he had heard from both Patrick and Sarah, neither of whom he had spoken to in years. He was in the place where the thing was happening that was a magnet for everyone's attention, which, for a few hours, the world would watch. Patrick, in Australia. Sarah, from up north. Boston, was it? New York?

How are you? We're thinking about you. How amazing the phone lines are still up. Are you all right? Is it as bad as they say? His friends, from the past, from far-flung places, coming in to find him on a frail thread of connection, speaking into his ear. Out of the whirling outer darkness, to this inner darkness where he crouched trying to strike matches, light lamps, find the can opener, move through the constricting sharp-edged mass of furniture that his house had become.

"No, it's not that bad." Cradling the phone against his cheek, one shoulder hunched, while he stretched to light the oil lamp, turn down the blackly smoking long-unused wick. Burning his fingers. Hearing the rain hit the roof like bullets, the extraordinary voice of the wind. Inside him, fear that throbbed still, an old wound. "High winds. A lot of rain. They say the eye's coming over at about eleven. Power's out, of course, it went first thing. A few trees are down. Thank God, the phone and water are still okay."

Patrick's voice, as if from another planet where it was nighttime

and cold, where people were doing ordinary things, like sleeping. His old friend, who, thank heaven, couldn't see him down on his knees in darkness as he had been minutes ago, swearing and fumbling, calling on God. Patrick sounded like an Australian now, with questioning inflections at the ends of his sentences. This man knows me, Jim thought, he cares enough about me to call across the world to find out if I am all right. After these decades, in which we have not met. How strange is that?

"Is your wife with you? You're not alone?" Sarah, only a couple of hours later, as if all these old threads of connection had been tugged into action by the weird meteorology of today. The past, pulled up sudden and dripping as a bucket from a well.

"She's gone to Sherry's. Our daughter, in Georgia. There was mandatory evacuation so she got out before they closed the bridges."

"Then why are you there?"

"I'm the pastor, remember. I'm like the captain. I go down with the ship. No, really, I'm just too lazy, I couldn't see the point." He heard her silence.

Then her "Should I be worried about you?"

"It's up to you. I'm not. It's all exaggerated, really. You know how the media are."

It was noon when he spoke to her. Her voice sounded utterly unchanged. He tried to remember her, how she looked, the details of her; but of course, all these would have changed. Outside, the city was suddenly still. He opened the door, looked out where only minutes ago the tug of wind had made it impossible to open anything. The air smelled raw and wet, fizzed in his nose like cordite; the smell of jungles, of forests far from here. The sky, as he stood looking up with the phone still against his ear, was yellow, a color he'd never seen it before.

"It must be the eye. It's over us. There's even a little light. I think we have an hour or so, then it's scheduled to begin again. This is half time, like in football. Second stage to start later."

"It sounds more like being in labor," she said. Suddenly it was as if they'd talked only yesterday. They knew each other, he realized. Did

that never go away, even after years, silences, distance, the encroachments of age?

"Well, I wouldn't know." Had she had children? He couldn't remember.

"But how are you, anyway?"

"Fine is the short answer."

"I wouldn't mind the long one. If you've time."

"Can you call me back later? I have to go out while I can, check the wood hasn't all been torn off the upstairs windows, see if the roof's still on, things like that. Call me back, oh, in an hour or two. I'll have nothing much to do this afternoon except sit here and listen to it. There's nothing on TV worth watching down here. You guys are getting all the good stuff."

"I'll call you back," she said.

It was oddly exciting. It was like being visited when you'd not expected it; being at the center of other people's thoughts; perhaps like being visited in jail.

During the eye he was out on the street with his neighbors, the Cantwells, Frank and Robbie, and old Alfonso Sanchez who'd been through three of these already in his lifetime. Jim felt the earth move underfoot. It heaved up and down, the street. It's the roots, someone said, the tree roots. They rocked the ground up and down, a small earthquake. Nothing was certain. Anything could come down.

SUSAN called, that evening. She wanted, she said, to hear how he was. Yet somehow this was incommunicable. He spoke only to God, and passersby, the street people who came and needed the wisecracking words of cheer that he'd found for them over years. It was as if the old life had retreated. He would open the church and hold a service, he thought, of thanksgiving for safety. A handful of people might come, sweating in the pews in the gloom and heat of no electricity, and the prayers he led would be heartfelt, for gratitude and renewal, from the place in him of high winds, destruction and miracles and the sea coming in out of darkness.

Then there was Sarah, her "Should I be worried about you?" She'd

called back, mid-afternoon, as the second stage of the storm set in and the wind increased to ninety-five miles an hour and the rain slapped the house about.

"What are you doing?"

"Reading Paul Tillich. I'm under the table, with the cat. I just made some coffee."

"How can you cook?"

"Camping stove. Propane. Otherwise, I eat out of cans, but this afternoon, it seemed like an occasion, so I brewed some real coffee, and boy, is it good."

"D'you smoke still?"

"I would if I had some. But, no."

"So what's it like?"

"The hurricane? Noisy, intermittently scary, seems to be going on a long time. Like being in a war. Only, I guess, no one's actually trying to kill me."

"Is your house okay?"

He looked at the wall behind him, which used to have a painting of flamingoes on it that Susan had bought at a local gallery. The painting was gone, and water was sliding down the wall.

"Yeah, so far. These old houses were built for this kind of thing."

"You know—Jim, I can't believe I'm talking to you."

"It took a Force Three hurricane."

"Don't be snippy. I'm not good at keeping in touch, but I wanted to have a word with you before you get swept off this earth."

"Gee, thanks." He wondered, if he were dying, would he suddenly get all the love and attention he needed? Was that how it worked? "Seriously, it's good to hear from you. How are you?"

"Fine." Silence. Then, "I've been given a house in Key West. So I guess we'll be meeting again."

"A house?"

"It's a long story; but, yes."

"Well. I hope you won't find it blown away, after today." So, he thought, we will meet again. Some turmoil began in his chest that had not been there before. "You know, Patrick called me. He's in Australia."

"He did? How strange. Why?"

"It seems that when you're in a hurricane, people think about you. I'm at that place on the map. Where today's news is happening. That's all."

When they said goodbye, sweat was pouring down his face and arms. He mopped himself with his shirt tails. The hurricane, his situation here, her announcement about being given a house—a house?—was too much to handle. The house he was in was shaking and rattling as if it were being beaten. The wind swung round and came at them from the northeast as the hurricane turned, rain battered at the shutters, water was pouring down the north wall, and he was more alone than he had been, once her voice was gone. There were still hours of this to go.

Then the next day his church was full of birds, and he let them out into the sunlight, to fly free.

3

IT WAS THE WAY EVERYTHING SHOOK; that and the sound of the wind. Martha, who had worked on sailboats in all kinds of weather, had never heard such wind; that loud, that close, as if it had come for her. It roared, it banged. She held the baby, her dense damp weight, the smell of her hair, thinking that they should have left. People with small children should not stay waiting for a hurricane to split their lives open. But where could they have gone?

Everything changed when you had a child. You became the protector, the shield. She was not afraid for herself, but because she might not be able to protect Molly. It was the first time in years that she had felt anything other than tough and self-sufficient, enough.

It had started at eight in the morning, when she was making coffee in the kitchen. Tom was still asleep. The baby lay on her back on the bed beside her sleeping father, her fat legs in the air. Martha took her time in the kitchen, getting out mugs, finding milk. The sky was black outside the window, and the branches thrashed. The tall shag palm at the back of their lot shook like a mop. The wind was finding its way in everywhere, through the cracks of the old house, it skittered across the apartment floor, it knocked at the door. It was trying to break things open. Yes, but where could you go? Would it be better to be stuck on US 1 in a traffic jam, to be up on one of the bridges, to be on blocked roads in south Florida, to sit in a shelter somewhere in Miami eating handouts and waiting to be allowed to go home? No, they'd stick it out, Tom said, it was what the Conchs did. You didn't run from storms, he said, you prepared for them. On water or on

land. He ran out to Winn Dixie in the old Conch cruiser car they had, and filled it with water in plastic containers, cans of food, big six-packs of toilet paper, paper towels. Oh, and batteries, you couldn't forget batteries. He filled the old claw-foot bathtub with water, and got lamp oil in, and found the propane camping stove and two blue cans of gas. He nailed crossbars across the windows, and as he worked she heard the banging and tapping all over town, like a horde of woodpeckers, near and far, as people nailed up ply over glass, fixed crossbars, wrenched their old houses into some sort of shipshape condition, because of what was coming. The bars across shutters like hands crossed across a body: don't touch me. The houses looking suddenly blinded, their eyes closed.

"My dad went through three of these suckers," Tom told her, lugging stuff in from the car. "You should have heard his stories. The old guys, you know, they took them in their stride. Wasn't nowhere to run, in the old days. You just had to stay where you were."

She didn't say to him, everything has changed now, because of Molly. We can't be who we once were. We can't just tough it out, talk about the old days, repeat how people survived.

But Tom liked his stories of the old days, the proofs of survival. These days, people were so afraid, because they didn't have experiences like this, he said, they ran from them, went somewhere else, to be saved. Even slight danger, discomfort, was out of the question. On the phone she told people, "No, we're staying. Yeah, we're fine." But inside, she had lost that certainty. At any moment, a tree could come down and the phone line, their link with the outside world, be cut off. She shuddered but decided, no, I'll be strong, I'll be strong. A mantra, against defeat.

It was when that first crack came that she ran back to the bedroom, heart hammering, and knew that she should not be here. Molly began to cry, and Martha picked her up and held her hard, as if her own body might be enough to save anybody. Tom opened his eyes. "Here we go, then."

But you couldn't keep it out, Martha thought, whatever you decided, however brave you wanted to be. It came inside you and fizzed in

your brain, it made you crazy. You couldn't hold out against it. There wasn't any outside and inside anymore, you couldn't keep the weather out, it invaded you whether you liked it or not. She felt the buzz in her head, the heaviness in her limbs. It was like a drug. She fought against it, against him.

"This is crazy Tom. Aren't you scared? This is real, it's serious. What about Molly? Let's just go, for God's sake, get out before it's too late."

"Honey, we're doing the only thing makes any sense. You want to be up on that highway when it hits? Or spend weeks in some hole in the ground in Miami? Listen, I've been on ships in a big wind, we're on coral rock here, this island's not going anywhere." Anyway, he could have said, it's too late now.

"But how do you know? You don't know. It could wipe us all out!" It doesn't matter about us anymore, she wants to say, it's about Molly. She needs to have a life; she deserves that chance. It's the difference between having split open yourself and brought a baby into the world and having remained your old finite fastened-up self. Between being a woman, a mother, and a man.

His arms around the two of them, not enough. "Hey, baby. Calm down, will you? That coffee smells good. Let's have some."

She groaned and pulled away from him, but poured it, hot and dark, and added hot foaming milk, so that they had a *café con leche*, the way he liked it. The wind gusted, rattling the shutters.

He said, "It's probably not even going to make a category three."

"God, Tom, how can you be so sure? How long d'you think it'll take?"

"Hard to tell. Let's get a look at it on screen." The computer was still working. The swirling mass, like a snowball rolling on blue, was a fraction off the island. Long swathes came from it, embracing the ocean and Cuba and reaching up to the Bahamas. To Martha it looked like the scan she had had before Molly was born, the baby coiled and turning in the womb. Did everything, inside and outside, look the same in the end?

"Damn, it sure is coming." Tom stared at it, the dot which showed

the eye, the trails of white which to him looked like a poached egg breaking up in boiling water.

Half an hour later the computer and all the lights snapped off. It was sudden, everything off at once. "Okay, so that's it for the power."

The ceiling fan slowed towards stopping. It was dark in here, with the darkness of no ordinary morning, dark with the lack of sun. The air inside the house grew warm. When they looked out, the sky was a thick yellowish gray. The wind still came in sharp gusts, thrashing all the areca palms about, toiling in the branches of the mango. The electric touch of the air, a roughness on the surface of the skin as if all the tiny hairs on a human body were rubbed the wrong way. The first slap of rain was almost a relief.

"What was that crack?"

"Tree down, next door. Look, the first casualty."

The big avocado lay felled at the side of the house next door. Its leaves shivered, as if it were giving up its life. Green shining pears rolled in the wet.

"Something could fall on us."

"No more big trees. Look, the palms are going to be okay, they love it. See that? Look at those shag palms just dancing in the wind." The tall palms, Washingtonias, that edged the cemetery whipped about and shook their hair in the air, he said, and welcomed the storm in. There was an excitement in him too that welcomed it. He ran about the apartment, putting things away, touching the walls, the windows, wedging a door shut, tapping in a nail. His hair seemed to crackle, he too was all electric energy.

Molly stopped crying, looked around her, interested. Her hand went to Martha's breast, as she reached to suckle, but she was excited by the storm. Her eyes rolled around to make sure she saw what was happening. Her hands went out to grasp the air. She wanted the world in them, Martha saw, whatever it brought. This is what we're like before we've learned to be afraid.

"No, honey, you're too big for that. I'll get you a drink. Or a banana."

Molly looked appalled, her face crumpled for a moment, then she

pulled it back together as if she'd decided not to cry. She watched her father moving around the room then looked back to Martha. "Nana," she said. It was her first word. Martha hugged her. "I'll get you a banana, honey. Tom, she said banana!"

"Yeah, I heard. Good start for a kid reared in the tropics. Maybe she'll say mango, or papaya next. Molly, want a papaya? Or how about hurricane?" The three of them circled like dancers, close. The child at the center, lifted high, laughing. The man with his big arms around both of them. The woman, herself, Martha, shaking still in his embrace. "Nana!" Molly said loudly again, and received the peeled banana to squash in her tight little fist.

ALL morning it roared out there, the thing that had them in its grip. The wind howled and rain came in sideways attacks upon the house. When the loud crack came again and something fell, Martha cried out because she couldn't help it. At one, the eye was over the island. The wind slowed, stopped, and there was a peculiar silence. Tom eased open the door. The wet deck was stacked with broken twigs, rolling wet avocados, sapodilla nuts, leaves. It was more than ever like living in a tree. All down the outside staircase, branches and twigs, leaves. That'd take some clearing. He kicked some aside, threw them down to make a way through. The street was shining wet, water running through the gutters, debris everywhere. Jesus. And this was only halfway through. The sky was still that strange shade of yellow. He put up his face to feel the last spurts of rain, the coolness. Martha came down the stairs behind him, carrying the baby, who laughed and chirped and waved her arms at the wildness, the electric air.

People began to come down the street in twos and trees, laughing, talking. They bent to pick avocados from the gutter and stuff their pockets at the great fallen tree that lay halfway across the road, from the yard of the house next door. It was booty, it was freebies; there was that sudden reckless excitement at surviving, and everything being changed. Shining wet green alligator pears, as the people here called them, heavy as hand grenades.

"Hey! How're you doing? That was some wind!"

"More coming. We're getting the second half, and it's going to be stronger, that's what I heard." The gusts had been coming at seventy, at eighty; later, they might reach a hundred miles an hour. It was a category three storm, might make even more, and it was on them. Everyone called out to each other and there was a wild party sense of fun, of the fun of danger, of brief reprieve; of being together, not apart.

"Okay, this looks like it, back inside! Time's up. See you later, if we're spared."

"Later."

"Have a good one! We'll have a drink on it, when it's all over."

The storm came back and drove across the island, hissing down rain. It whipped the palm trees on the shore about and blew sand inland, and then the great tidal surge came and the ocean rushed in. All day and into the night. No stopping it, no stopping anything. The low-lying islands put up no barriers; living at sea level, this was how it was—yes, and people said, how it would be, with global warming intensifying and climate change setting in all over the world.

The wind banged and roared, slapped things back and forth. Its voice was the voice of a mob. Martha and Tom lay all afternoon under their kitchen table with rugs and blankets spread over it, the solidest thing there was, and the baby, exhausted, slept between them. At one point Martha slept too, her hand in her husband's. The radio crackled on above their heads, people talking to each other, people joking, wisecracking, people crying, and the radio host like a savior, keeping them all together. So that anyone who was alone needn't feel alone, so that the human voice, reaching through all that hubbub of wind and rain, stretched out like a hand and brought comfort.

Afterwards people would say how amazing he'd been, that disk jockey, announcer, whoever he'd been, who'd simply kept on talking, as the phones had rung—amazing, that the lines had held—and the sobbing scared women in their homes, the men in the trailer parks, in the flimsy RVs that lurched where they stood, in houses where the ocean came in and carried all the furniture away, the people afraid of looters, afraid of trees falling on them, afraid of destruction, all

listened and heard a voice, words. Any word. Just to keep talking. As the island went under, as the houses blew to pieces, as people's lives were ripped up in a minute and thrown away, the steadiness of the human voice.

Night came, and by midnight the fury of the wind had dropped, and quiet came in. Nobody knew what the damage had been, but in their rooms in their houses, individually and in couples and in families, they were alive. That man should get a prize, a medal, for talking a whole town down, for a day and a night, for not letting in despair. Maybe he would never again say a word, after all that. Maybe he was talked-out. And who was he? Who had been capable of that calm, that ability to be right there, to give and keep on giving the right response?

MARTHA held her heavy sleeping baby on one arm. With her free hand she spooned baked beans out of a can into the pan on the camping stove. Tom opened a beer. He sat sipping from it, smoking a cigarette. The orchestra of the wind had dropped to its quietest note. A soaked tree tapped at the jalousies. The earth sucked up all the moisture and began to breathe it out, and when he went out onto the balcony, the smell of it was rich and warm.

When they had eaten he lit a candle from the one that had guttered out and left it in a bowl of water in the middle of the floor, to show that the place was inhabited, and laid his grandfather's old hunting rifle beside it, in case looters came. He sat beside it for a long time in the circle of soft light. The night outside was close up against the windows, the intimate sound of falling rain. The wind had dropped, and now there was just rain, steady, like a mantra, like a lullaby. He left the candle and the gun and went to join Martha where she lay across the bed, curled around Molly, her breath quiet and even, her lips just slightly apart. He lifted the baby and set her down in her cot, the heavy unmoving weight of her, and then he lay down carefully beside his wife and felt for her breast with one calloused hand inside her open shirt and squeezed it gently until she turned to him in the slow river of her sleep and pulled him to her.

4

THE GOOD NEWS, THE LAWYER TOLD SARAH, was that the house had not been destroyed or gutted by sea-water. The bad news was that it hadn't been in good repair to start with, had suffered some damage, and had probably not had hurricane insurance. He called her from the Cape, sounding strangely muffled, as if water had leaked into the telephone, the huge withdrawals and arrivals of the Atlantic heard under what he was saying. Johnny had died so soon after her visit that summer that he must have known then that he was dying. Or did one simply have an urge, towards the end of life, to give things away? In his will, the house was already hers, so that she would not have to pay estate tax, the lawyer said. He would mail the key to her, as Johnny had even wrapped it up and addressed it to her.

"How did he die?" Sarah asked.

"Dropped dead in his studio."

"He was painting?"

"I can't tell you. I know there was paint around, it was on him where he fell. It was a heart attack. Great way to go, at that age."

"So, it sounds like he was painting." It cheered her to know this; to imagine him, his brush full of paint and tipped towards a canvas, his vision running right through him and down his arm to the paint-brush, that moment, that fullness before life ended. A green jug, an apple, a bottle at the end of the brush, taking shape. She wanted that for him. She hoped that it was true.

"It looks like a shack, from the stuff they sent me. But everything down there's worth a fortune, you have to pay an arm and a leg for

something that looks like it's on Skid Row. So he's left you something worth having. A quarter million, probably, for the land. I guess you'll be selling? It's a good sized nest egg."

"No, I don't think I'll be selling."

"Well, the rental market's high. Of course, you'd have to remodel first. Worth it, though. A great little investment, I hear the rents are through the roof."

"Hmm. How much damage is there, d'you know?"

"Well, seems it had been empty for a while. He had tenants, but they took off to the Caribbean, Belize, somewhere like that. I think the realtor tried to get him to spend some money on it, but he didn't. So it was kind of a mess, is what I hear, before the hurricane got there. But nothing that can't be fixed."

"I guess I'll go down. Can you get there, now?"

"If the roads aren't open, they will be soon. I don't know about flights. They'll want to keep tourists out till the debris is cleared away, is my guess. Anything else I can do for you?"

"No, just send me the key. Better register it."

"I'll send it by FedEx. Excuse me asking, was he a relative?"

"No, not a relative. Just a friend. An old friend of my mother's."

"Well, what these old gay guys get up to, you'd be astonished," was what he said. "And I suppose you'll be coming to the funeral? There doesn't seem to be any next of kin."

THERE was a bleakness, in knowing Johnny dead. She remembered the meal he had given her, his hands shaking in the purple twilight, the smell of his Armani cologne in the summer-perfumed garden, his care of her. Darling, he had called her. How strangely love worked in the world. You loved people who didn't love you, you lost the people you loved, and then suddenly love came at you from quite another angle, out of the blue, out of someone else's past even, unbidden. She wondered how it had been for her mother, being loved by Johnny in her old age. Loving him back. What kind of love was it, when all the other kinds, passionate, fulfilling, angry, disappointing, had burned out of you, and you were alone, and quiet, and then so thankful not to

be alone after all? To drink cocktails together and talk about roses. Her mother, gone years ago, and now Johnny gone and a whole chapter of life over, a house closed, inaccessible, about to be sold, and those rooms, so easily entered, closed to her. But another house opened. Why was it for her? Because there was nobody else, he'd said. Just because of that, and her mother, and herself when young, running in and out of those Provincetown rooms in her mother's wake. She cried, for Johnny maybe; certainly for herself.

As soon as it was possible to go—for the airport and the road had both been closed since the hurricane which had come and blown everything flat—she would go down there, with her key, and claim her house. There was no need to think about it now, what she'd do down there in southern Florida, in what people said was a tacky, rackety tourist town a hundred miles from anywhere. She'd trust Johnny, she thought. He must have had something in mind for her, or he'd have just left her money. A quarter of a million, for a half torn-down shack? Surely not. But you never knew. You never knew anything, till you went to check it out. She was, had always been, a believer in what she saw with her own eyes.

THE funeral was more like a party, as Johnny would have wanted it. Gay men in flamboyant shirts and pants, most of them bald, passed the champagne glasses, welcomed her in. She'd flown out this time, on the little Cape Air puddle-jumper that settled down like a butterfly on asphalt wetted by sudden rain, and taken a cab to the house.

"So you're the heiress?"

"He left me a house. Or rather, gave it to me, before he died."

"The house in Key West? Not this one."

"You knew about it?"

The man beside her was very thin, with big features that jutted from his baldness like outcrops on smooth rock, and active hands that moved around her in the air as if ushering her in to a room. Many of these men, Sarah thought, would have been dead too, if this were still the last decade. The party was full of people who seemed to greet death from a tender distance, unalarmed.

"Sure. Most of us have been down there at one time or another. Hey, my name's Darien, I knew yours so I forgot to introduce myself."

"Like the peak in Darien? The one stout Cortez saw the Pacific from?"

"I guess, yes. Why was he stout, after crossing the continent? Surely he would have lost weight."

"Stout as in stalwart, I think."

"Oh. Yeah."

"Why do you think he wanted me to have it, and not any of his friends, or—" she gestured, to the men taking dishes from the oven, bringing flowers in, handing champagne.

"Or lovers?"

"Yes, or lovers."

"I don't know."

"I mean, a house in Key West—"

"You mean, it'd suit a gay guy down to the ground?"

"Yeah. I guess."

"Maybe because of that. Maybe because you're a woman. Because of Marion. Because of things we'll never know now. My advice is, don't ask. Just accept. Knowing how to receive is more than half of life."

SO when she unwrapped the key from its FedEx package, she thought of his words. Who had that man been? Maybe it was true that Johnny wanted her to know how to receive. Maybe he knew that this was something she had struggled with. Just accept. Don't ask, Sarah. It was the key to something; perhaps a future. She put it in her bag, and called American to see if there were flights to be had.

Then she thought of calling Jim Russo, to tell him that she was coming; only she didn't do it, not yet, because of the last phone call, the one in the middle of the hurricane, when she had had the sudden urge to find out if he were still there, and all right. There had been his voice then, sounding the same. She couldn't imagine him older, what he would look like. These days, with old friends, it was as if everyone were going about in disguise: wrinkles and sunspots drawn on faces

that had never been old, hair like wigs, or sudden baldness, clothes that the person would never have worn. She remembered Jim in blue jeans, skinny with a spidery length of leg, his hair falling into his eyes. Jimmy Russo. You remembered the outlines, the sketch of a person; but what else? The voice on the phone was more real than the visual memory. Smells did that too: the smell of flesh, so individual. And the touch, the smoothness or firmness or roughness of skin. Movement: the way you could identify someone at a distance, walking towards you down a street. What changed, what stayed the same? What is it in us, Sarah thought, looking down on the coastline on the brief plane ride back, that does not change?

Johnny, dead now, become grit thrown out in handfuls by still-living men, into the ocean. The last of him, a gray handful, settling on a wave.

THE small plane landed in Boston, and she ran for her connection. She would go home, get a change of clothes, and since there were no flights to Key West until further notice, begin the long drive south. In her mind, that long-ago other journey, and a girl walking, no, running down a tree-lined street to meet a young man at a sidewalk café. Panic rising in her: what have we done? His face, from a distance, still a blur; only his body shape, its long grace as he rose from his chair to greet her, his first lover as he was hers.

There had been no words for it, only their appalled silence. He'd been so hurt by her betrayal of him; she, devastated at what she had done. One of his friends lay dead because of her, and she had betrayed him with another. It had all happened in one terrible weekend, so long ago now that it was like a story she had once heard. He had struggled to speak to her, but in the end had turned away, and she had realized he was crying. She had cried too, later. But tears didn't bring forgiveness, or closeness, or any change. There were some things, she'd discovered then for a first time, which were irrevocable. It had been the last time they met, there in the golden gentle sunlight of the end of summer, on a foreign street.

5

IN THE DAYS THAT FOLLOWED, the streets with their drying broken foliage smelled of meadows. The herbal sweetness of it pulled him to stand on the porch, just sniffing. It was all the heaps of branches that people dragged out for the huge yellow government-sent machines to take away. The masses of leaves crinkled and grew brown. The sun came down hard and unmediated, no shade left. He opened cans of beans, meat, olives, anything he found, and ate straight from the can with the same spoon, savory and sweet. In the daytime hours he worked in the church, cleaning where the birds had spattered it with their droppings, and joined the gangs out on the streets, hacking and piling, sweat in his eyes, muscles aching from unfamiliar use. The warm quiet darkness of the first nights after the storm was gone. Generators snapped on and roared, keeping him awake. The peace he had longed for and had, in those last few days of September, was gone.

JIM saw the huddled shape on his porch as he came in, the night after the hurricane. He'd walked about town, glanced down streets entirely blocked by trees like fallen giants, royal poinciana and banyan, the pillars of this town that had held off the sky. Now the sun was on them all, drying the streets fast, shriveling the leaves that lay in heaps, striking his suddenly defenseless head. The sky was blue and clear, no pollution in the way now, cleaned by rain. The smell that day was still of hayfields, of harvest. Maybe a century ago, it had smelled this way.

Groups of people sat on porches by lamplight. The true darkness

of the sky was what you didn't see, in this era of streetlights and car headlights and the glare from televisions. It was a night of peace, he thought, and walked slowly, stepping over branches as he came home. He'd been down to the southern beaches that day, seen where the ocean had come in. Sand stretched inland, covering the road, the tennis courts, the little park. It was rippled, like sand in a desert. Concessions stands, boats, huts, everything was covered over. The tops of parking meters poked out, as if someone had planted them there for a joke. A beachside restaurant was caved in, filled with sand, a car stranded, its wheels invisible, half-buried like a tank in a desert. Houses close to the shore had spewed their contents out: couches had floated out on the tide, beds were halfway down streets, cars were underwater.

It was medievally dark as he came home to his house next to the church. It was the way people had lived for centuries. He had a pocket flashlight and shone it on the front of his house, to find the front door, fit his key. He saw the dark shape on the porch only after he had reached the door; as if the image had taken a minute to reach past his eye to his understanding. Someone was asleep there, in a heap of blankets or rags or possibly an overcoat. He coughed.

Many times in the past he'd said it, "Hey, you can't sleep here." Before that, when he was new here, he'd let them come. The church had stood open, and so had his house. He'd taken it literally, that what was here was sanctuary. Then things had begun to disappear, and once someone had actually defecated, and there were muddy footprints one Sunday leading to the altar, and the church board had told him, this cannot go on. Susan, too. Susan, angrier than the church board, refusing to let any of the homeless people sleep in the house. Finally, when his own study had been turned upside down by someone probably looking for cash to buy crack cocaine, he began to lock the door, to say no. It was the ones who stole, defecated, broke things that made it impossible. Others, with whom he had long philosophical conversations and shared packs of cigarettes late at night, he even missed. They still came by, he gave them money from time to time, and they gave back their occasional rambling philosophies, their

assurance that he was still connected to the world of the real, the poor. Frankie, for instance, or that incredible drunk, Hector, who when half-sober could argue the hind leg off a mule, prove to you white was black and anything else you thought was a no-brainer, make you see things, after you'd laughed and argued with him for an hour, in some new, absurd way. But this was all in the place between the house and the street, where he stood with them in the moonlight and streetlight, and waved to the cop cars slowly passing, yes, I'm okay, all's well. While Susan slept, and he wanted someone to be awake with, someone to shoot the breeze, these guys were company. Only not in the house, not in the church; because, he'd come to understand, neither the house nor the church were truly his. He was a guardian of something, he played a role even if it was a minor one. God's janitor.

But, the night after a hurricane, how could he turn someone away? Anyway, this person was asleep. His hand on the nearest part of him produced not even a shiver of movement. He wondered, was this person dead? But the slight rise and fall, a warmth told him no. He was just sleeping the sleep of the exhausted. Jim took his hand from the roughness of the material that covered the sleeper and opened the door of his house, flashlight in hand. The hallway looked strange, small and cavernous at once. The house stretched ahead of him, quite unfamiliar. We live off electricity as if it were free, he thought, it hums and beeps and sings and lights our way all the time, and when it has gone everything is completely different. There was no real air in here, with the AC off and no fans working. His hand went out to turn switches, as if it had not understood the message of his brain. Stupidly, one's extremities went on as if. The head is amputated, the power is off and the stupid stale reflexes go on. He found the oil lamp, raised the glass shade, wound up the little wick till he felt it protrude with his finger, snapped on his old lighter from his smoking days to light it. Immediately, the room was full of shadows. It had depths he had never before seen. He inhabited it, in silence, in depth, and noticed that he suddenly felt happily at home. He turned the wick down a fraction, shrinking both light and shadow, and set the glass bulb back in

place. The radio was silent, the phone didn't ring, there was nobody else in these rooms. Only an unknown person, dead asleep on the porch, breath rising and falling, in and out, exactly as his own did in this room, with no one to see. Conspiracy: a breathing together. That's what we're doing. And I don't even know who the sleeper is.

IN the morning, he went out with his coffee mug in hand and looked at the heap of bags, coats, and tangled dyed-blond hair that showed in the daylight. The day was like yesterday, hot and blue and windless, with that rain-washed clarity, that breathable scented air. His first thought was that the sleeper must be hot, under all those covers. He saw that what he'd thought was a very tall person was partly bags, stacked close. Then he saw a hand. It came out from under the coats, and uncurled like a snail in the sunshine. It was small, with bitten nails, and female. He stared at it. Its fingers moved just slightly, as if feeling the air. It opened. It was an opened hand, on its own, a vulnerable thing. The wrist was scratched on the inside, as if the hand had grappled with thorns. Then the whole hand pulled back under the covers, the coats slid about on top of the turning body, and over the top of some man's greatcoat, eyes opened and looked out at him. He couldn't see the rest of the face, but the eyes were narrow with fear. He smiled, so as not to look frightening; but this had no relaxing effect. The fear must not be of him, but of some farther provenance. He squatted down to the person's level, to be less intimidating, but the coats twitched away from him, the person bunched into a far corner of herself and the eyes went on flaring their message.

"Hi," he began.

The eyes flickered, blinked.

"This is my porch you're sleeping on. I'm Jim Russo. The pastor here."

A mess of blond-brown hair fell forward over the eyes and was pushed away by a hand. Still the woman looked at him as if he were lethal.

"Who are you?" he asked, friendly, trying not to sound professional. And then, "Hell of a storm, wasn't it?"

The woman propped herself on one arm, suddenly feminine with that turn of her body, so that he was aware of looking at a woman in bed, even if bed was a heap of old clothes on his porch. She held out a regal hand to him. "I'm Pearl."

Pearl? The name almost made him laugh, at the squashed-up little face, the feral eyes, the wildness of hair. But he didn't. He approached her cautiously, the way he would a wild animal if one were to lodge on his porch. He didn't want to scare her any more. He could see that had been done already, over and over, and it hurt to think of it.

"D'you want coffee? I have some made."

"That would be nice." Her voice, unlike her appearance, was precise, ladylike even.

He stared. Then said, "Okay, back in a minute." In the kitchen he poured dark coffee from the yellow pot on the camping stove, added creamer, tucked a sugar jar under his arm, almost sure that she'd want it, and a spoon in the other hand. Breakfast in bed for the lady. Well, it couldn't go on.

"The church was locked," she said, as if that explained everything. Perhaps it did.

"I know. I have to lock it at night." But the birds got in, he thought, they found their way. There are cracks, there are ways in; sometimes we need to find them.

"So I came here," she said. "They said you were a kind man, that you wouldn't turn me away."

"Who did?"

"People I met. Street people. I'm not one of them. Oh no," and she gave a little smirk. "Not at all. I'm an artist. Glad to meet you, what did you say your name was, Jim?"

"An artist?"

"I'm a portrait artist. I'll do yours if you want. And I write songs. I was going to Nashville, but things happened. I'm going there one day, to sell my songs."

"To sell your songs, huh?"

"Yes. When I have enough."

"When do you think that will be?"

"Oh, soon. I get inspiration here, you see."

He noticed a large bruise, spreading on the side of her jaw, as she turned her head, pushed back her hair to sip the coffee he gave her. "No sugar, no."

"I see," he said.

"So, I'm not bothering you, being here? It's only a porch, after all." She glanced around her as if she'd only just noticed her surroundings.

"Well, it's okay for now, I mean, for this moment, but you can't stay here."

"I can't? Not just till they get the roads open, the town connected up again? It won't be for long, I promise you."

She had a way of pushing you, he thought later, that belonged to women of a different class—women who were not used to anyone ever saying no to them, women who got what they wanted from men. This, with the bruise and the sudden look of fear, did not add up.

Jim looked at her. They were in a disaster area, a place hit by a hurricane. Everything had changed in a day, and nobody yet knew the extent of the damage. They were here to help each other. Weren't they? He shrugged, said to her, "Okay, but only till then," and saw her snuggle down under her filthy covers, the mug of coffee still steaming beside her, as if she were in a good hotel, and room service had brought what she needed, so there was no further need for talk.

THERE was only one night of such peace. The generators snapped on; everyone who had one had it rigged and roaring, and when the stores opened again, every one of them in stock was sold. Generators and chain saws. Generators, chain saws, and ice. That was all anyone wanted. The long nights of quiet and darkness were over, perhaps forever.

Rumors ran across town: so-and-so has a chain saw, there's an ice truck coming. The days and nights were long and hot, and where fans had stirred the summer air and air conditioners had chilled it, now it hung in the bedrooms and people slept lightly, tiredly, waking to sweat and groan. Then, the sound of other people's generators was worse than annoying. Jim thought, it was the haves and the have-nots

all over again, only now the Conchs, the ones who'd had generators in the family for years and so could have fans, iceboxes, cold drinks, and whole fish in their refrigerators, were the haves.

He lay, naked with a single sheet draped across him, through the hot nights. There was a curfew operating, so you had to be in your house by nine. Military helicopters whirred low over the town, making the palm leaves thrash. For a moment he hated it: the sound of Vietnam. Street parties, people sharing food, were chased back by the police, "Sorry, curfew time, got to get back indoors." So the parties went on, on porches and in back yards, people sharing food that would otherwise go bad in their refrigerators, passing bottles, killing time, enjoying in some strange atavistic way this throwback to past times, ones they couldn't even remember.

A shout went down the street, "Ice-truck's coming! Outside Fausto's on White!" and in the blazing shadeless afternoon, they all dashed out, on foot, on bicycles, because you still couldn't get a car down the littered streets, and stood in line for the big hard plastic bags thrown down from the tailgate spiky and steaming with ice, that stuck to your flesh and began melting immediately you'd caught them. People waved to each other, shouted. Jim saw half a dozen people he knew. Everyone looked dazed, tired, dirty. On the streets, the big yellow machines had arrived from upstate, from Georgia and beyond: the back-hoes, the diggers, like yellow dinosaurs, dwarfing everything, prowling down the streets and crunching up debris. Black men governed them, fit gleaming men from somewhere else. Federal aid began to arrive at this southernmost destination; fast, efficient, almost depressingly swift.

What if we'd been a poor South American country, Jim thought. Weeks in the sun, with no food, no water, certainly no ice. He was almost regretful to see the lawless peace of immediately after the storm splinter into this din of machinery, this remorseless need for control. Machines scooped the sand back to the ocean where it belonged. Machines swallowed the crushed trees. The days were a shriek of chain saws and the curious chewing sound the debris-swallowers made. The huge motors rumbled by like tanks, shaking the houses

once again. A man was killed, felled from his bicycle after colliding with the tailgate of one of the trucks. His blood and brains spilled on the street, he lay there crumpled and on the sidewalk the truck driver sat crying, his head in his hands.

The choppers churned too close, too low in the hot darkness. Making the trees whirl again, stirring the air to panic. That memory, that sound: how many others like himself had dreams which still took them easily back to the place of fear? Those engines, those blades, and the presence of death. The blood smell, metal smell, and the screaming of the air, the screaming of people, the thickness of whipped vegetation, the invisible sky.

THE woman called Pearl was fussing about the porch as if it were a house. She'd laid her clothes out on the painted rail, pinned a plastic lei of pink flowers above where she'd made her bed, had a stack of old newspapers and magazines there which she leafed through, leisurely, like a woman on a sofa in a magazine bedroom. She hummed, exaggeratedly at ease.

"Hello." For he couldn't come in and out of the house, could he, without greeting her? She was impossible to ignore.

"Hello, how are you?" As if they were neighbors, not as if she camped on his property.

He felt a sinking in his stomach. He wouldn't be able to make her go, now. That first time, he could have turned her out. If Susan had been here, it would have been easy to turn her out. But now, when she was settling and humming, clucking like a hen on her nest, pulling her little twigs and feathers and pieces of existence close around her, he feared that he wouldn't be able to say the words.

He'd told so many people before in his best robust cheerful no-bullshit voice, his adopted southern voice, man of the people, bubba, one of the guys—"Hey, man, you can't stay here, now, can you. Gotta move along. Want a smoke before you go? Cold beer?" He'd done it, and then gone back into his house. But now, with Susan gone, and with no power on, the house felt different as the town felt different. This was a frontier now, an outpost, and all the people

who'd stayed when the government told them to go, who had had in those hurricane hours no police force and no medical services, who had to get back into their houses before curfew, were perhaps no better than rabble, were perhaps all equal, in spite of what power tools they had.

He went down the steps into the heat of the late morning, not knowing where he was going. Maybe he'd better check the church. Sunday, he should open for a regular service, power or no power, they could sweat and pray by candlelight, in the dust of bird droppings and the dried leaf smell through the open windows, and there'd be no pretense at gentility or comfort. He took the key, opened the church door once again and let himself into the big airless space. He opened all the windows, letting in the cracked blue morning. A bird, another one, was dead on the floor. He cupped it in his hand and took it outside. A tiny black and blue bird, a foreigner, last of the storm birds. He began sweeping, with broom and pan. It was what you should do. Not call in the great machinery of distant America, but get down humbly on your knees, with a pan and brush. At the top of the aisle, he put down the pan and gave himself to his ongoing lengthy argumentative talk with God. I wanted a change, and one came. I wanted my wife to go away, and she went. I want justice in this town. I want greed brought down. I wanted the six hundred thousand dollar houses blown flat, or given to the poor. I prayed for change, and you brought it, but not enough, God, not enough. But what did I want then, annihilation? I pray for help now, and you send me a homeless woman who won't move off my porch. I want love, and I can't have it. I can't quit thinking about smoking, however hard I try. All I can do it seems is stay here on my knees in this building, and ask you, who am I, and where am I going, and how can I know your will?

In the seminary, years ago when he was young, a lecture had impressed him: an elderly man who had once been a missionary somewhere in Africa came to speak to them and asked that question, "Do you know who you are?" Nobody had answered. How could they? And the old man had told them that they were the children of Christ, as surely as if Christ had had children and they were his direct

descendants. At the time, Jim had wondered if this were not blasphe-my, thinking about Christ having kids. But it was a new way of think-ing. "That is who you are," said the old man in his Massachusetts accent to these southern boys. "Don't forget. The children of Christ." Funny, Jim thought then, nobody ever thinks of Christ as a father of children, only a son. The perpetual son. But everyone who was a son was a father too, in the end, and it was not the same thing. If you were human, you had to be a father, even a failed one like himself. Had Christ ever felt like a failure for not having actual children? He had at least been spared a parent's guilt.

After a while, he was silent, in his head and outside. Nothing moved. The movement had all been and gone, the violent breath of the storm had passed over him and left him here, alone, not alone, perplexed, doing the only thing he knew how to do, it seemed. Sweep and pray.

SHE told him, later that day, what had happened to her. Or rather, parts of a story swam up at him out of chaos. There was no coherence. The parts he heard were the parts that shocked him most; but there were others—highways, rides, bars in distant towns, meetings of alarming people at pit-stops on this circling aimless life of hers, that caught his attention like fragments of a dream he might have had.

"They upended me," she said. "They burned me with cigarettes. They all took a turn."

He was shocked, as if he might faint. The things that men did to women, that other men did to women, far off on the borders of life. The things he never even dared think about, but of course had thought about, because everybody did, because once these things were circulating in the air, like viruses, you had them in your blood-stream, no choice. He'd spent his life trying not to think of them, and now here they were, the facts, presented to him in a bald matter-of-fact way, on his own porch. *They upended me.* Men as predators, women as prey. He sat down, his arms folded, tried to listen. It sound-ed as if she wasn't blaming anyone, just telling what happened. He thought, all over the world, the same story, the same grubby and

pointless actions. He felt shame, hot in his core. Also anger: the more she told him, the harder it would be to tell her to go. He could give in to her, say, "You can stay here, I will look after you," make himself the opposite of those other, different, men.

Why did you go with him, why didn't you look after yourself better, why didn't you scream for help? The questions were all pointless, because the point was, this was the kind of thing that had happened to her, it happened, she didn't choose it, nobody would choose it, it was like the weather and it was just there. When you were unprotected in the world, it was what came to get you. Evil, he thought. Or was it just the extremes of bad behavior?

She'd tidied the porch, put all her bags in one corner, fastened the pile of newspapers with string. There were Christmas cards strung on a string, old ones, addressed to other people. Her clothes were in a neat pile, with a large alarm clock on top which wasn't ticking.

"Oh, well," she said, "it's over now."

"I'm so sorry. That it happened to you."

"Well, these things happen. Would you like me to tell you your horoscope? Look, I have all the horoscopes for the day. Mine says I should make money today. What is your sign?"

"Capricorn."

"Let's see." She folded the paper and brought the page up close to her eyes. "Capricorn. Oh, it's a good day for you. You're going to make some new friends."

"That's nice."

"Maybe I'm one of them?"

"Could be."

He caught once again the drift in her of some other life—a life of middle-class niceness, with doilies and lavender freshener in the bathroom and a Christmas card list. Had she just dropped through a hole into this homelessness? She was precise, almost prissy at times, in a way which seemed to him hopeless. Hopeless because the world out there wouldn't be tamed in that way; it was like having a tea party in a jungle. She reminded him of a little girl playing house, out here on his sagging porch. And there was the question, why shouldn't she

stay, why did she have to go? Why did he have to make her go? He hadn't figured that one out yet; there was just the panic he felt at having her there. It wasn't just the thought of the cigarette burns on her thighs. (Did he want to see them? No.) Or of the scent of danger she brought with her, the remnants of that male vengeance that he didn't even want to remember. It was having someone here, unasked. It was being out of control.

SUSAN called. "Are you okay? You sound weird."

"Being here's kinda weird all right. You know, there was a hurricane."

"No need to be sarcastic. What's going on? Are they back to normal yet?"

"Nothing's normal. Sorry, I didn't mean it, it's just everyone's nerves are frayed right now. It's hot, and there's no electricity, not unless you're one of these morons running generators. The streets aren't cleared yet, but they're making headway. Sometimes, a truck comes by with ice."

"Ice?"

"It's amazing how good ice can be when your refrigerator's off and it's ninety-five degrees."

"Oh, yeah. Well, Jim, they've asked me to stay on."

"Sherry and Jake?"

"Of course Sherry and Jake."

"Good."

"Why good?"

"Well, you wouldn't like it here."

"No, and there's really no point, is there, in trying to come back before everything's back to normal."

"No. So stay. I'm fine." Since she hadn't asked.

"Okay. Have you enough to eat?"

"Sure. The Red Cross is bringing us lunches. Free."

"The American Red Cross?" Her voice sounded disapproving, as if someone like him should not have to depend on the Red Cross for food.

"Of course. Same as they drop on Bosnia. I don't think they change the menu."

"Jim. You're okay, really?"

"Yeah, I'm fine." It was, in an unexpected way, true.

"Goodbye then, Jim. Love you."

He put down the phone quietly, so as not to have say the easy casual words, which people said all the time, not putting the "I" in, because they didn't want to be responsible for the rest. "Love you," like "have a nice day," had passed into the generic vague benevolence you were supposed to have for other people. He didn't think it belonged in a marriage. Maybe none of this conversation belonged in a marriage. It struck him, not for the first time, that he had allowed his only daughter to be called after a drink. He went out onto the porch to breathe cooler air, forgetting for a moment that Pearl lived there now and that he was not alone.

LATE afternoon: she was out; at least she was not here. What could she be doing, wandering the streets? He wondered what she did for a bathroom, as she'd never asked to use his. At the bottom of the street, near the intersection, long blades sawed a royal poinciana into parts. The saw screamed, hurting his ears. Big branches toppled, shook, there was a huge trunk that had hefted all this weight skyward, and then there were sliced sections and then there were simply pieces, to be reduced to chips and sawdust before his eyes, a hundred years of growth collapsed into a single afternoon. The sky slid down to street level. There was no more canopy to roof them with green and make deep shade. He wanted to protest. The ache in him was like crying. It was worse somehow than watching a house demolished; such grandeur existed only in tall ships, ancient monuments and trees. The town would never be the same, as nothing would ever be the same. He walked, lonely as Crusoe, through the wreckage. Something was breaking up in him, being crunched and shredded in his chest.

When the Red Cross truck came by the house an hour later and the shout went up, "Hot dinners, anyone want a hot dinner?", he went out to greet it and received the handout even though there were still

cans of food in the house and gas for his propane stove. At least there would be the driver to say hello to, and being given something for free never hurt.

"May as well have it," the driver said, "I've a whole stack of them on board."

He took one for Pearl and they sat beside each other on the old chairs on the porch, with their styrofoam packs opened, beef stew, lima beans, and crackers to eat, same as people the world over, he said to her, for whom rich America threw out its packs of processed hot food.

"This is real good stuff," said Pearl.

Perched on his chair with his long legs tucked up to make a table of his knees, he ate the slimy food and felt once again suddenly, strangely, happy. This was what was happening. It couldn't be otherwise. It was just what was. Islanded between past and future, the slight form of the present, this little battered rock of land that people pretended was Paradise, because they needed the pretense to live, as they needed restaurants and gas stations and stores and cable and the Internet and fancy outfits to wear and suntan lotion and cocktails and nude dancers and T-shirt slogans and all the rest of it. Gone, all gone. Just for the moment, in which he ate lima beans, which he'd always hated, with a crazy street person, and lived among wreckage, and was free.

He had been aware for some time now of small changes going on beneath the surfaces of life, but had chosen to ignore them as much as he could. Life had its rituals, its passages, and he was now in his late fifties, so of course some things would change. His own body, lanky and lean for so long, had begun to soften and grow a little bulge where his belly had been flat and hard, his skin seemed to hang more loosely, and of course there was the outgoing tide of his hair. When he looked in the mirror with his chin up, he saw dark hair only streaked with gray, but he knew that others—everybody else, in fact—could see the bald spot dotted with freckles and possible skin cancers that he wore like a skull cap, a natural tonsure, or a sand bar barely coming up out of the sea. Of course one changed physically; but there

were other changes, less natural ones perhaps. Susan, who was always asleep when he climbed into bed beside her and always up and gone when he awoke. God, who forgot to speak to him for days at a time. His daughter Sherry, once a skinny spring of a girl made in his own image, a kisser, a hugger unlike her mother, seemed to have forgotten his existence. Sherry's husband didn't like coming down to Key West, and since the church had its fixtures and duties spread evenly throughout the year and paid him a miserable stipend, he didn't often get up to Georgia to see them either. The most serious of these departures, and the one he liked least to think about, was God. He knew, it is not God who deserts man, but the other way around. Man forgets, is distracted, moves out of orbit. Ever since those days after getting out of the war when nobody wanted to know him and he hardly dared think about what he had done, Jim had relied on the closeness and attention of God. "Even if you don't believe in God," he had told his congregations, comforting himself each time, "God believes in you."

When he was a child, awake in darkness, dreading sleep because of the nightmares it might bring, he had fantasized a large hand coming out of the night to hold his own fast. It could have been a father's hand, but Jim's father never came to his bedroom to hold his hand. It was nameless, unidentified; and it worked. His own hand in this imaginary hand, he had been able to sleep safely. And when he came back from Vietnam, the same need had assailed him. He was too small, too terrified to live without that hand in his: and when somebody at an early AA meeting had told him that he could have any Higher Power he liked, he found the nameless one, the firm hand of his childhood still available. When he became a preacher, he found also a theatrical pleasure in the pulpit, in pulling from himself a strong rhetorical voice, a Biblical voice, a voice that rang out above doubt and fear and could also come close and quiet in sympathy with other humans; he enjoyed the range of it, but also the clarity of what came through him and was not just his, a tapping into something older and wiser and more reliable than he or anyone could be. His mother's father had been a preacher in the old hellfire and damnation

days, and though he had never heard the old man preach and had been brought up in his mother's total rejection of the Southern Baptists, there was maybe something genetic, something that lay in wait for him in his own DNA, which the hell of Indochina and the pain of the postwar months and years had brought out.

But these days—and the hurricane had brought these days, it seemed, to a head—it all felt effortful, forced. The moment in the church when it had been dark, warm, and full of birds had been the first for some time in which he could feel the closeness, the rapt attention even, of what he called God. Then, it hadn't mattered that Susan was gone. It didn't matter what he said to his parishioners. It had been a new moment; and he wanted more of it, that difference, that newness; in which his own breath and the twittering of hidden birds was all he heard, and there seemed to be an existence in that pregnant darkness that was other than all he had known till now.

Sitting on the porch eating warm lima beans out of a styrofoam container seemed to be still part of that existence. Pearl, for all her strangeness and ability to irritate him, was part of it too. But he didn't know how, after everything was put back together and normal life, so-called, began again, he would be able to have access to it again. Perhaps he was a hobo at heart, a vagrant, a nomad, someone not made for this safe hygienic end of century. Perhaps he loved chaos, was moved by disorder. Perhaps he had been driven crazy by the helicopter noise and the boat engine noise on the rivers, and the screams of dying men, and it had never come out until now. Whatever it was, he felt suddenly light, free, as if everything heavy in life had dropped away from him, leaving him thin as a dry leaf, weightless, pleasantly insubstantial, absolved of responsibility at least for now.

PEARL, when she had finished eating, wiped her mouth with the paper napkin they kindly had given out with the dinner, and accepted that he was no longer at her side. It didn't matter. She was here now, she had arrived where she needed to be. The more she studied astrological charts and the clues that lay hidden in the papers, the more sure she felt. He was the one. When she had walked here from the

highway, struggling through darkness to find his house, she had felt straight away that she was home. Home was where God sent you: it could be a porch, a bus shelter, a beach, it didn't matter. The Lord always found you a place, as long as you were in this world. The Lord also sent food—this good dinner, heaven-sent—and a place to lay your head. And he told you whom to save, and whom to spurn. Jim was one of the good ones, she knew that at once; but he was in need, and it was her duty now, her mission, to save him.

She checked to see that there was no one around and then lowered herself behind a bush at the side of the house and let her warm stream of urine out; what a blessing. She gave thanks, for food and the satisfying of other bodily needs, and went to curl in her corner, eyes closed, hands clenched before her, knees up against her stomach, to rest before her next instructions came.

6

SARAH DROVE SOUTH IN HER OLD SUBARU. At last she crossed the Georgia border and faced the interminable length of the state of Florida. Florida, a state she had never even thought to visit: its flatness and heat, the ugliness of its buildings, the sugar plantations that went on forever, the orange trees in their straight lines and then the tomatoes and the avocados and the roadside shacks before the shifting green-brown distances, water mirroring clouds, clouds touching water, of the Everglades. Places where people wrestled alligators, ate frog legs, did real estate deals in the swamp. Hangars, air strips, highways, malls: the careless use of space, the rawness of it all to a northern eye. She drove, sang, listened to books on tape and public radio when there was something on, argued back at politicians in her mind; her shoulders grew stiff, her calves ached, at night she lay down in flimsy roadside motels with empty blue swimming pools because it was out of season. When she came to the Florida Keys and the highway over the bridges, their pale concrete against the greens and blues of the water, she was tired. But the road flew on, lifting her above water, propelling her to its end.

All the way down this road to nowhere, trees were broken sharply in half, seaweed matted chain-link fences, houses were tumbled over on their sides or gutted, their insides blown away clean as a sucked egg. She saw where the ocean had come in, and what it had done. Along the Atlantic shore, wreckage was piled high as if for bonfires; boats hung in trees; trees were stripped of their foliage. Broken signs flapped their exhortations, visit this, buy that, stay here, go there. She

saw the flimsy uselessness of nearly everything people had made here. It was as if the efforts of human life, the ones you were urged into and told were vital, no longer counted. There was something much bigger, which cleaned out all that in a gust, in a single wave.

She had been listening to NPR, with Garrison Keillor's facetiously slow voice drawling on. She turned it off, began to imagine what she would say about this place in a broadcast. Then she began making up the report she would send back to the paper. The series of reports. Post-hurricane Florida, the resort that nobody wanted to visit. It would have to be done right away, or it would be over. Then she thought, no, not report: article. Long, in-depth, the results upon people's lives. Where were they, the people who had lived here, boated, shopped, made dinner, listened to radio, watched TV? The landscape told her, gone. Gone, and not about to return.

By the time she reached the Lower Keys, she had it mapped in her mind. The stuff about water and the Florida aquifer and pollution reaching underground could wait. This, the hurricane's careless track and its aftermath, would come first.

It was evening when she reached Key West. The road had been open only a few days, and she was waved down by waiting highway patrols and slowed several times by black men working their huge orange machinery to clear the way. Was this a privileged high-paid job, or an echo of chain gangs and slavery? Why was it that African-Americans exclusively had these jobs? Or were they Haitians? What was the law these days on Haitian immigration? Her journalist's mind ticked over, asking its questions, as her foot hovered over the brake. Ahead of her the sun slid lower, and clouds rose up to meet it. She tipped down her windshield visor to shut it out, and saw the world through narrowed eyes and darkened glass. West. Southwest, then due west. Slow, through this torn-up landscape, with the men grinning to her, waving her on. Not much other traffic, possibly just returning natives, going home to find out what had happened to their houses. She pressed the button to roll the window down and leaned her elbow out. The smells were of burning or drying; salt and ash. The salt had killed the bushes and trees it had covered, it had been left to kill off what had not been swept away.

She imagined arriving. She'd spend the night in a motel, get something decent to eat. Then find the house in the morning, contact the realtor whose address she had from the lawyer on Cape Cod. One thing at a time. She didn't have to stay. If it didn't work out, she could go back the way she'd come, and according to the map, there was no other. This was as far south as you could go and still be in the United States of America, where things were supposed to work—telephones, email, FedEx, UPS, where food was delivered and milk was brought from the other end of the country and you could get a lawyer and use dollars and buy anything you wanted and get it delivered next day. Only, as she saw, these things were not working here. There'd been a hiatus. The diggers and back-hoes from upstate and beyond were working as hard and long and fast as they could to restore to this place the amenities that people needed and demanded in this country, but they were not yet there. She passed closed gas stations—lucky she'd stopped and filled up further north—and closed, shuttered, battered-looking convenience stores, and restaurants with battened doors and roofs curling off into the air. Everything that had been put here for tourists to play with had been blown away or smashed. There were no snacks to be had, no beach toys, no tropical drinks or little thatched shacks or bright umbrellas. All that was here were piles of debris, and somber men lifting them into trucks, to cart away—pieces of houses, pieces of boats, trees, gate posts, lawn furniture, even a dog house. She saw a wrecked boat in a scummy swimming pool, another in a tree. Couches burst their stuffing from splits, mattresses sagged and grew green mold. And everywhere there was the dried mat of seaweed, fastened on fences and the stumps of trees, on a wrecked car, on a porch.

When she came down into Key West, everything looked more normal. The streets were cleared, for one thing. There were even lights in some of the houses, a Publix open, a gas station, a Wendy's. The so-called signs of civilization. She found a little hotel on a downtown side street, with lowered prices because of the hurricane. The foyer was empty, the rooms locked and quiet, but a young woman came out of a back room when she pressed the bell and looked surprised and relieved to see her.

"We've only just reopened," she said. "You are our first guest."

Sarah fell down on the bed in a narrow room. Outside, there was a pool in which small branches with white flowers on them still bobbed about, among mats of blood-red petals, and a boy was fishing them out with a long-handled net. The windows were open, someone walked down the balcony outside talking in Spanish to the boy in the pool, the air was cool and still after the burning daytime, and she fell instantly asleep.

SHE stood the next morning in the street with the realtor beside her, locking at what had become of her house. It looked half smashed to the ground. A large tree with mottled green leaves lay slicing into its porch roof, making most of the rest of it invisible.

"Hell of a time to get a house here," the realtor said.

"Can I get those guys down the street to get the tree off?"

"Well, it's on the property, see. They're only clearing the streets, is what I hear. If it's on the property, it's the owner's responsibility. That is, yours." He picked up a large bright green avocado from the gutter. His polished loafers looked like sudden shining nuts among the foliage and his bare brown legs were hairless. His shoes, she thought, were the only clean thing she had seen here; he must be gay.

"Oh, it's an avocado tree?" Sarah felt as if she needed an explanation for everything; everything looked so foreign, unrecognizable. Nothing here looked like the rest of America. It was like having migrated much further away, to an unimagined, unbelievably messed-up place. You could be used to thinking of damage as manmade, therefore stoppable; but this was simply the result of weather.

"Yup. Not in good shape; look, the leaves are marked. They've had something wrong with them, probably why so many are down."

She looked at the mottled, brown-patched leaf. "So, can I get someone with a crane or something? And how do I get in?"

"Here." He pushed his way under the low canopy of dried leaves. She followed him, bent double, under low branches, twigs scratching her arms. He took the key from her, opened the door with a shove, stood back to brush dried leaves from his tropically colored shirt.

"Jesus." In the little front room, there was junk everywhere and the carpets were wet and newspapers and plastic bags stuck to the floor. Leaves crowded up at all the windows.

"How long since anyone lived here? You're sure this is the house?" It was so unlike Johnny and the civilized house he'd kept in Provincetown, she could hardly believe it.

"I found out they left in ninety-six. So, a couple years. But nobody's done anything to it in decades, by the look of it. D'you have any idea when your friend was last here?"

"No idea. I didn't even know he had it. He was very—well, orderly. He wouldn't have lived in anything like this."

"The ones who took off to Costa Rica," the man said, "they were into drugs. Or the people after them. It was a crack house, that's what we knew it as. It was either get out of here, or jail. Nobody knew who the owner was. I thought it was maybe someone who'd died, or maybe was in a nursing home somewhere. You know, it happens here. People don't want to sell, because their relatives'd lose out on the house. Sometimes houses are empty for years, because nobody can find out who actually owns them, or there's a complicated family deal, you know, they had a black sheep relative down here, never made a will. Believe it or not, these places are worth a stack. Nothing goes for under a quarter million, not anymore. My advice to you, ma'am, would be to sell it, unless you've got another hundred grand to invest. Total remodeling, that's what this one needs. They leave the facade, because they can't pull them down, and then you just put on a whole new house at the back of it."

Sarah walked through the front room into the back. There was a stained brown kitchen with wine bottles full of cobwebs on the floor, a sagging refrigerator, and beyond it, a back door. She pushed it open. A tiny back yard steamed and throbbed in the sun. Huge white flowers, she supposed they were hibiscus, frilled and trumpet-like; clusters of honey-colored frangipani bursting from strange blunt stalks, among the pale green of their leaves. Overhead, surprisingly upright still, a tree whose remaining red flowers had turned rust-colored, shading the right side of the yard. A mockingbird

sat on the chain-link fence, above sagging timbers, and sang like a nightingale.

"Royal poinciana," said the realtor, when she asked. Sarah saw immediately where she would put a table, to sit in the shade. She turned to him, dazzled.

"Let me think about it. I've never had a house before, and somebody just gave me this one. I'm still not used to it. I'll have to figure out what I want to do, okay? I'll be in touch. Thanks for showing me." Now, she wanted him to go; she couldn't wait to be alone here, to walk about and peer behind the sagging sheetrock wall coverings and peel back the linoleum; oh, and find a chair, to try sitting under that tree.

"Most likely he didn't have hurricane insurance," was the realtor's last remark, as he ducked out under the branches.

She left the door open behind him and sat down on a wobbly chair in the front room. Green leaves came at her through the doorway, as if the fallen tree were trying to get inside. Vegetation pushed up at the windows. Through the open back door, she saw more foliage, those astonishing flowers, and a slice of hot blue September sky. There were stairs leading to an upper room, and she went up nearly on all fours, they were so steep. The room turned out to be an attic, with headroom only in the middle, and a cracked window looking out over the cemetery. White buildings, stacked like condos, with coffins in them she supposed, and a bunch of plastic flowers, a headless angel, a column of cracked stone. The dead would be quiet neighbors. An electric wire sagged outside the window, leading somewhere. One side of the house was a thick hedge of some tall plants, bolted into giants. On the other, beyond the chain-link, she saw a young woman with a baby in her arms, staring into space.

She scrambled back down again, covered with dust. At least there was a place to sleep, with a decent roof over it. Downstairs in the little bathroom she turned an old-fashioned porcelain faucet right round till water trickled into the small cracked sink. An old tub with its feet through the linoleum and possibly through the floor gave up a similar trickle. The wires that drooped everywhere, tacked back against

walls and ceiling, wouldn't work anyway, since the power was still off. But she had water, could buy cleaning products. In the bathroom, with its wooden-seated toilet, which she tried for size and comfort, she could sit and look out at the battered hibiscus bush with its plate-sized blooms. It was possible. It was entirely possible. Johnny had wanted her to have it, and now it was hers. It was the first house she'd ever owned; a lifetime of apartments and roommates, the brief house-sharing of her marriage, a career woman's ease at packing, unpacking, making unlikely rentals look something like home, had left her unprepared for this yet also hungry. In its total inadequacy, this house was hers, and it was enough. No mortgage, no rent, no obligations. She could live here like a hobo if she chose; or she could lock it up and go straight back to New York. On this stifling hot afternoon in this town that was still a disaster area, she dragged her one chair to the back door, legs stretched out to the yard, half in, half out, relishing the freedom of it, her extraordinary gift.

In the house next to hers, she heard the rising wail of a baby's cry, then music. Someone was playing Enya. She had neighbors, and from these two clues they were real people, who had a life.

AFTER she'd made a start, hauling her own debris—yes, it was hers, this matted wet carpet, this torn linoleum, this broken-legged table, the sheetrock sagging from these walls—she left it all heaped on the sidewalk for one of the trucks to pick up, and went back to the hotel for a shower and a nap. This was the time, probably, to call Jim. To say, guess what, I'm here! To surprise him. But possibly people in this town had had enough of surprises, perhaps that was not fair. Would he want to see her? After so much time, surely he would. The hurricane, the strangeness of Johnny's bequest to her, the story she would tell of her drive down the destroyed islands of the Keys, all that would make it easy. We live, she thought, in interesting times; and Jim was a man who was interested, in life, fate, the courses of events, in what people thought and did. How odd, that he'd become a preacher. What had brought that on? Political disillusionment? Sudden conservatism in middle age?

It was all long enough ago, surely, for there to be no bitterness, no blame. She remembered now a lanky dark young man, long-haired as an Indian before the war, his slow smile as he listened to others talking, his way of delivering abrupt conversation-stopping remarks. His way of eating salt on dry bread, of pacing up and down while he ate. His passion for jazz: Mingus, Monk, the MJQ. Pieces of how he had been came back to her. She remembered octagonal red tiles on a swept floor, the smell of lavender polish, a mattress with buttons that poked you in the spine. Windows that opened like concertinas. Jazz running on like water, all those faces of black men she had never heard of till now. Boys' clothes strewn across the room. Coffee cups, cigarettes stubbed out. The sour yeasty smell of their sweat.

There'd been that café. The two somethings. Not Les Deux Magots, that was in Paris. Les Deux—Garçons? No, something else. Les Deux—she'd ask him, see if he remembered. Surely it was Les Deux Garçons. Sitting in the twilight on that marvelous street, with the huge peeling trees lacing their branches overhead and the big fountain, wet and green with moss, and their drinks in front of them, the sour constant smell of their cigarettes. How adult they had felt, sitting there, young Americans in Europe, making their ties with the old world, so proud of themselves, so in love with it all, with each other. She and Jim Russo and Patrick Mellon, in the sixties, in a café, in France. Before the war, before everything else.

He would want to see her because of that, that memory, that moment, that unforgettable time. It was before they'd caught him with the draft and he'd been shipped off. Patrick, a little older, had volunteered, so as not to be drafted, and had spent his time in the military playing basketball all over Europe. Patrick had the best of it, then. Or she did, Sarah, the girl they were both in love with as they sat there playing with their tall beers, their glasses of pastis clouded with water, their cigarettes dangling from their hands. She'd been doing a French literature course at the university of Aix; there she sat in her black pants and her black sweaters, her hair long and blonde and straight, her feet in ballet slippers, her French almost perfect with the slang of that time, her fingers only shaking slightly upon her current cigarette.

They'd played at being Jules and Jim, when the movie came out, with her as Catherine, the Jeanne Moreau part. She'd practiced her sulk, her sudden smile. How fake and how inventive; able to be anyone, making yourself up as you went.

All that. And now, she was here after a hurricane, blown in on the wind of someone else's fantasy for her, an owner of piles of useless debris; and here was he again, a preacher in a tourist town on this rock of an island thrown down at the very last point in the U.S.A. Perhaps that was the point, for him, its remoteness. He'd never felt able to come back to America—wanted to live in France, she remembered, but had had for some reason—a sick mother? some family crisis?—to come home. Patrick had managed it. Patrick had lived for years in Paris, spelling America with a K on his mail, hating all through the Nixon years, the Reagan years, when all he'd ever had to do for his country had been to play basketball.

Now, Jim was only a street away from her. In another town, in another time, what would they say? Amnesty, she thought: it was time.

7

HIS BULK BLOCKING THE DOORWAY out on to the narrow deck, Tom leaned his arms against the frame.

"It's definite, I heard today. So now what do I do?" In the next house, he noticed out of the corner of his eye, someone had opened windows and doors and stacked a pile of old carpets on the sidewalk. Martha came out of the kitchen and glanced over the fence too, before she came close to him. Neither of them said it. "Someone's moving in."

Today had been his first day back at work after the storm, and all he'd done was clear up, stow stuff away, wash down the deck on the big gray navy ship that took scientists out to do sonar tests in deep water.

"They're going to the Med in October." She heard an unusual hesitation in his voice. They are going; not we.

"Well, Jesus, honey, go! The Mediterranean!" She folded her arms, was looking at him too brightly.

" And leave you and Molly for almost three months?"

"We'll be okay. Hey, it's such an opportunity. Think of it! Where would you go ashore?"

"Italy, Sicily maybe. There's some deep water between there and Africa."

"Italy! Tom, you have to go. Anyway, what's the alternative?"

"Could be being laid off. That's unofficial. They're going to lose some people, end of the year. This could be the last big contract. The government's cutting back on defense. That means the sonar stuff too."

"So if you don't go—"

"I could be out of a job. I could be out anyway. Thing is, Mart, we won't be able to stay here forever, in this apartment I mean, not with a family. We'll need a house. And we'll not be able to get one here, the way things are. And I'm not leaving this island, you won't catch me heading up to Ocala with all the other goddamn starved-out Conchs. No way."

"Hey, sweetheart. First, there's room for us here. Second, nobody said you had to move to Ocala. Hell, I'm not going to move to Ocala, or anywhere else. We're okay here, Tom. What's up?" That flat tone, as if his life no longer engaged him, he who had always been so full of it. They were tired, as everyone they knew was tired. The tension of the storm and the wreckage after it, the lack of electricity, the irritation that came after fear and made everyone snap at each other: it all led to a sense of exhaustion. And what was it all for? Simply, survival. What others, in other places, could take for granted.

"Since the hurricane. I've been thinking. It really wasn't safe, I mean, it could've been bad."

"You said it was safe. So I believed you. And it's over now."

"We were damn lucky. You know, even with the cross-boards and the few nails I hammered in, this treehouse could've just blown away, with us in it. With kids you should get a house, you know, live in something solid."

"You mean, poured concrete, up in New Town? With a mortgage? Or are you talking about Ocala?" She knew he would never go for that. Or, the old Tom, the one she'd thought she knew, wouldn't.

"Something like that, yeah."

"Tom, Molly doesn't know what a house is, anyway. Let's not worry about stuff we don't have to."

"If I don't go on this Med trip, I may have no job, that's the other thing. And what if they put the rent up? Which they will, eventually. What're we going to do then?"

"I can go back to full-time on the *Cat*, as crew. McCall would have me in a heartbeat, I only really stopped because of Molly. Anyway. We deal with that when it happens. Okay?"

Silence. He stood in the doorway, as if he needed to lean some-

where. A big man, muscled shoulders bare in his sweaty tank top, a slight belly rolling over his belt; one hand tracing the contours of his own face as if feeling for what had changed. Then, "Are you sure it's okay with you if I go? It's a long time. Molly won't know me when I come back."

"Of course she will. She'll know she has a sailor for a father, and that it's the way things are. She may not recognize you if you get too fat and happy on all that pasta."

Tom patted his stomach, grimaced. "Mart." He moved to put his arms around her, her head on his chest where the hair that tickled her ear was turning gray. She heard the deep-down thud of his heart. She knew what it was like to be at sea, to have nothing solid beneath her feet but a rocking deck; she'd been there in storms at sea herself, and also in childbirth, feeling herself split and opened the way no storm ever could.

"I don't want to leave here," he said into her topknot of hair.

"Neither do I. So we won't. It has to be possible, to live and work here, whatever people say. We'll talk to Frank. He hasn't said anything about rent, has he?"

"Nope. But it's happening all around. Or landlords are selling their properties and the tenants just have to get out. People are coming in, buying places just for investment." His voice was sour. "I don't think he'll do that, but you never know."

"Well, let's just stick with what we have."

"I wish to God my grandparents had never sold the old place on William."

"You and all the other Conch survivors."

He felt guilty, she knew, for not providing for his family the way his forbears had, buying up whole streets, building their little empires on depression and change. His grandparents, his parents in their youth owned this place, they belonged here, while he had to come back, rent an apartment, scrape a living in the place where he was born. But he was stubborn, too, and a worker, and she knew that hardness in him that wouldn't give up; no matter if the town was transformed into a rich people's playground, he'd never give in to

working in a kitchen or hotel bar in what they called the hospitality industry, running round after them picking up tips.

"So you don't want another kid? Hey, Mama?"

"One's enough for me right now. Maybe when the sailor comes back from the sea, who knows, all tan and horny and full of Italian sauce. No, Molly's enough of a handful for the next couple years. Really."

Molly woke where she was lying face-down across their bed, her head came up like a turtle's, her hands clenched, and her little body was tight with energy; she sprang awake and let out her sharp cry of excitement for the next thing in life to be lived. Molly was herself and Tom put together, Martha thought: his determination, her optimism. She went to pick her up, her daughter who buzzed with energy and expectation, for whom the world was simply a place to explore. Martha stood on the balcony holding her, and looked down into the yard of the next house, where the avocado tree was down, the one that used to hold roosters clumped in its branches at night. Somebody would have to get a crane to lift that off. She saw a woman with a cap of blond-gray hair and a yellow T-shirt and blue jeans come out into the tangled back yard and look up. Across the chain link and aurelias, the two of them exchanged glances. Martha lifted her free hand in greeting, and the woman waved back.

"Hey, Tom, there's someone in the next house, look!"

"Yeah, I saw. They're going to have their work cut out. It's been empty almost since I've been here, it's about fit to fall down on its own. Must've been 'ninety-five, 'ninety-six, wasn't it, when those two gay guys split. I wonder what's going on."

They stood together, watching, as the woman glanced up at them, smiled, waved goodbye as she went back indoors, dusting her hands upon the seat of her pants. The wrecked yards sang with cicadas, suddenly loud, as if the singing was in all their ears.

MARTHA went for ice, on her bicycle. The line spilled off the sidewalk into the street, the truck was parked with its tailgate open in front of Fausto's grocery, and people were shoving each other to get to the ice. Some were taking several bags at a time and slinging them

into the backs of cars. The heat bounced off the black asphalt. In the grocery store the shelves were still sparsely filled, there were gaps where plastic containers of water used to be, and toilet paper was low. All the days since the hurricane had been hot as this one, and the air was clear so that the sun burned sharply. It was nearly the end of September. The end of hurricane season was not until November. They were all tired, with the hot nights and the ceaseless work of clearing branches and chopping them up, and the chain saws' whine from early morning on, and the streets that were cleared of fallen trees were now blocked with the huge machines.

She saw people she knew, Danny the electrician, Sean who worked odd days on the boat, her friend Kirsten with her baby strapped to her back. Ice was making them all salivate: the thought of iced drinks, cubes clinking against glass, a vanished world in which people sipped cool drinks in the shade and kept fish fresh and refrigerators hummed and made ice in minutes and their insides were frosted white as a northern Christmas and cooled your face as soon as you opened their snow-white doors. The lack of ice, of cool water, was driving them all slightly crazy. Everyone looked dirty and disheveled and tempers were strained. Some people, as usual, demanded more than their share. Others were humble, grateful, received the armful of freezing white rocks that stuck to hands and arms, as if they were gifts.

Soon, the power would be back on; they were mending the wires all over town. The tourists would be back, the streets jammed with cars, business as usual. Electricity made it all happen. Remove electricity and millions would leave South Florida overnight. People who wanted to live in their air-conditioned caves and never feel the burning summer sun would simply get up and go.

We've been given a gap in life, Martha thought, cramming the ice bag into her big bike basket and swinging out into the empty space of White Street and back down to Truman. A gap, in which to see things as they really are.

WITH the yellow street lights glaring down again and the trees lopped back where they'd fallen, the porch was no longer a dark ref-

uge. The light fell on Pearl's face where she lay among her bags and Jim couldn't help seeing her as he came in late, though he was not sure if she was asleep or awake. He stepped past her and put his key to the lock. In a clear voice, she said, "Have a nice evening?"

"Oh. Yeah, I did."

"It's nice the electricity's back, isn't it?" Her social, brittle little voice; her careful use of language. It was like being handed a cocktail on a tray by a thoughtful hostess. It left him at a loss.

"A man came by wanting to speak to you. I told him you were out. He said he'd call back tomorrow. Oh, and somebody left a message on your machine, a woman I think, I heard the voice."

"Thanks." He opened the door. "Pearl—you could use the bathroom, you know, if you need. We have hot water now the power's back." Immediately, he regretted the "we."

"Well, that's very nice of you, Jim. I can call you Jim, can't I? I mean, Reverend sounds so stiff."

"Yeah, call me Jim." He went inside and shut the door behind him. The sour feeling he had was anger. Why? All she had done was be there, speak to him. Yet he felt furious, and then guilty. Was it her listening to his messages, her solicitousness, her politeness, her simply being there, tucked up like a child on his porch while he was in here in a whole goddamn house?

She called out to him, "Jim, maybe I'll use the bathroom tomorrow. If that's convenient?"

In the morning, he'd come out and make it clear to her. She couldn't stay here. She couldn't settle in, live on his porch. It wouldn't do. She was making him feel bad.

"Goodnight!" she called, on a little trill.

"Goodnight."

He played the newly arrived message back, on the machine that had winked back into action with the arrival of electricity. "You have one message."

"Jim? This is Sarah. I'm in town. You can call me at the Eden House." He wrote down the number. For the first time he wished that Susan would come back and make things normal: he could not have

an unknown woman asleep on his porch and an ex-lover showing up out of the blue. He felt tired from his long walk across town, ignoring the curfew, or maybe now the power was back there wasn't a curfew anymore. The huge bulk of parked machines on the cleared streets, a dearth of foliage now, and the bald yellow lights making everything too bright, too crude; he longed for darkness and silence, for the narrow time they'd had of peace, for the unlit emptiness of his house, for sleep. Sleep would do it. And prayer. He'd pray, listen to the reaching of his voice into that particular darkness, wait for a response.

THE next day was Sunday, and he remembered only just in time. All the people going to church would walk past his house and see he had a homeless woman sleeping there. He came out early, to wake her. Set a coffee mug down beside her where she lay curled and still, to make it easier for her. Squatted down close to her and said, "Pearl? You have to wake up. It's Sunday."

Again, the ritual with the waking smile, the stretched arm for the coffee. Her arm, he saw, was white on the inside, with scars on the wrist. Her sleeve, the dirty shirt she wore, fell back to show him this. "Oh, Jim, how kind. You brought me coffee." Again he was the servant, he was room service, or worse.

"You can't stay here. You have to get up. People come by here on the way to church."

"Oh, you want me to get up? No problem. I'll stash my stuff away too. Look, I wanted to show you this, what d'you think?"

It was a portrait of himself. Long face, dark hair thinning at the front, large eyes, nose. Not bad. In fact, uncomfortably recognizable. When had she done it?

"I did it from a photo. The one that was in the paper. Remember?"

"Oh, yeah." He'd been at some fundraiser for kids, in the park.

"I'd like you to have it." It was drawn in black charcoal, slightly smudged. She'd scrawled a signature at the bottom, after "Love."

"Thanks. I'd appreciate it, yeah, if you'd get up. You know, how it is, I have enough trouble with my reputation in this town as it is."

"You mean, you wouldn't want them to think anything bad."

"I don't want them to think anything at all. I just don't want you here, is all. You'll have to move on."

"But you said—"

"I said, till the state of emergency's over. And it is."

"Is it?" She looked at him over the coffee mug. "Are you sure? It still looks like a state of emergency to me."

"Well, the choppers are gone and the curfew's off, and people are coming back into town, so I think, you know, it's time."

"I'll go soon," she said. "Promise." But on her terms, her firm voice said. He thought of what she'd told him about the men who'd burned her with cigarettes, what life could be like out there, and he was ashamed. He didn't want to think about it. He wanted it not to have happened. For her not to have told him, for her not to have even been here to tell him.

"Okay. We'll talk about it after church." But he'd lost ground to her, he knew it.

She put down the coffee mug. "Well, then, I'd better get up? Perhaps, if you're out, I could use the tub? I need to wash my hair."

HIS church was no longer the place of darkness and refuge that it had been, warm with birds, spattered with their droppings, in which sweaty people had come to be grateful for their deliverance. How quickly things went back to normal. They were back in the pews in their Sunday clothes, and he was up here still in his shirtsleeves with no robe over them, trying to make things different. Because they were different. You couldn't have a huge event like that happen and switch back to the way you had been.

He preached on change, its inevitability, its fearfulness and necessity, on how we must welcome it into our lives. He preached what he needed to hear himself. From the faces, he knew at once when they didn't want to hear him. There'd been too much change, their faces said. Let us go back to the way things were, let us clutch our old habits around us again, for comfort. He found himself speaking of the good Samaritan, the man who crossed the road and helped that bloody and maybe unconscious man who had been attacked, set him on his own

donkey and took him to the inn, where he paid for him to stay till he had recovered. Who risked maybe his life, certainly his time and money for another. Rhetorically, he raised the question: which of us would do it? He hadn't meant to go there, not the good Samaritan, but what you most tried to avoid came up even as you tried to avoid it. Maybe it was guilt about his feelings about Pearl. How long did the Samaritan, the man from Samaria, a foreigner, a traveler, not even a priest or a Levite or any kind of official person, have to go on looking after the stranger? Not forever, that was clear. Just until the man was well enough to get going again. It wasn't a lifetime's commitment, just a one-off occasion. But the Samaritan must have been used to behaving like that; maybe it was in his culture, his family. Maybe he had been helped like that himself. The story didn't say. Jim heard his own voice, a sentence ending in a question, a question he couldn't answer for sure. It hung in the air above his congregation. They shifted in their seats and a faint collective sigh occurred. They thought he was blaming them for something. He thought, I'm lost. The Samaritan obviously had enough funds to pay the wounded man's hotel bill; was he a rich man, or simply a generous one? How much, in order to be a good person, did one have to give? Or was it a question of attitude, of looking out for someone who needed help? They could all do that, find someone to help. He opened his hands to them, let them draw conclusions, if conclusions were there to be drawn. He switched just in time from the gospel story to the realities of the hurricane, the opportunities it gave everyone to be of use.

Jessie struck up on the organ, everyone sighed with relief, and he announced the hymn. The hymn was easy, it was a relief to lift their voices all together in the known tune. "How great Thou art, how great Thou art." The voices, most of them old, cracked, but singing for all they were worth. In their shorts and T-shirts, the few members of the choir who were still here, strong voices, leading the way. Jim felt an ache at the backs of his eyes, a catch in his throat. He thought, God help me, I'm a worse hypocrite than any of them. And, something's got to give. And, I'm going to see Sarah again, this very day.

8

YOU. IS IT YOU?

"You've been given a house? How come? Nobody's given houses in Key West."

"I know. But I was. It's in terrible shape, but it's a house."

"Whatever kind of shape it's in, the dirt it stands on's worth a fortune."

"I know, that's what the realtor said, or the lawyer, or both," she said, letting him know how banal his statement was. Was this what you said to each other after a gap of decades?

He couldn't get used to her hair, that blond gone gray, the way she'd cut it short. She was getting her mind round his creeping baldness, he could see, and the wrinkles in his face after years in the sun. You saw a stranger who reminded you of someone, then you saw the someone through the stranger's mask, and finally the mask was gone, and you were back where you were, with the known person. The marks of age, an unsubtle make-up. She studied the new Jim and knew herself studied in turn.

"How are you?" Meaning, talk to me about something other than houses and lawyers. It was unreal that she was here. He opened the door for her, but she noticed the piles of bags and clothes on the porch. "Are you having a yard sale? Or moving out?"

"No, it's a weird story, just a homeless person showed up here after the hurricane and I couldn't say no. She's going soon."

"Looks to me like she's settling in."

Since that morning, Pearl had stowed her belongings and gone off

into town, but the line of Christmas cards was hung back in place, she had a little pot with plastic flowers in it, and three pairs of panties, presumably washed in his bathroom, were pegged to a line she'd rigged from the mailbox to the porch post. There was still the pile of old newspapers from which she liked to cut out horoscopes and read them aloud.

"Well, she's not important. Take no notice. The amazing thing is, seeing you again."

"I knew it would be strange," she said. "But don't rush it. Can't we just do chitchat for a minute?"

"Of course. Excuse me. But you know, nothing's normal these days, everything's strange, and I've probably been alone too long, we all have, we're probably suffering from some kind of stress syndrome, like people who've been in an air wreck. We should probably have some kind of counseling, I don't know, the whole town's probably in shock." And here I am face to face with my first love, the girl I was nuts about, the one who made me suffer like nobody else. And I'm gabbling, he thought, like an idiot.

"Well, slow down. It's okay." She sat on the arm of a chair, her legs crossed in blue jeans, feet in scuffed loafers. She was slim, he saw, and lithe, and unchanged. People didn't change. He hadn't changed, damn it. He'd only pretended to. That gray hair in its feathery short cut suited her, you could see the shape of her head; and in a second the memory of long blond hair falling about shoulders vanished and was replaced. She was looking around her, her glance quick and light, irreplaceable.

"So, your wife's away?"

"She didn't want to be here for the hurricane. She's gone to our daughter's."

"So, you have a daughter."

"And a grandson."

"My."

"What about you?"

"I don't have anybody. I'm single. I was married once, but not anymore."

"Well, we've time to catch up. Especially if you're coming to live here. What are you going to do, if your house is a wreck?"

"Oh, I don't know, I haven't decided. I'm staying at the Eden House; it's pretty nice, but of course I can't do that indefinitely."

"You could stay here. I've plenty of rooms."

"You seem to have a knack for getting stray women to move in with you. What about her on the porch? Are you going to put me there?"

"No, of course not. I said, I have room. For guests that is, not for homeless people I don't know from Eve."

"Aren't you meant to treat everybody as if they were Jesus?" She looked at him with a glint, a challenge. He remembered that, thought, she hasn't mellowed then, life has not been particularly kind.

"You'd be amazed how many people show up here pretending to be Jesus. I get them all the time; I'd be snowed under if I believed them all."

"So, this time it might be true. A woman can be Jesus, can't she?"

"She isn't Jesus," he said.

"You're sure?" She mocked him, her eyes shining. "But she might be. She might be your big opportunity, had you thought of that? And even if she isn't, Allah favors the merciful. It's in all the religions. You're supposed to give what you have to the poor."

"Hey, quit, Sarah, will you?" They'd been talking to each other for fifteen minutes, and already he felt an argument brewing. "Can I get you something to drink? Coffee, tea, root beer, whatever? I've no alcohol. Had too much of that in my life already."

"Water would be fine. It's hot out there. Sorry. I didn't mean to bug you. I guess, you know, I never quite got why you were in the Jesus business in the first place. Was it the war?"

Now he wanted to tell her, slow down. He went into the kitchen without answering, took cold water in a bottle from the refrigerator, which still smelled musty after its weeks of disuse. There was mildew on the door. What could you use to get rid of mildew? Bleach? He came back to her, the glass brimming.

"Thanks." She raised it to him, a mock salutation, but smiling. Her eyebrows raised in a way he remembered.

"I hope it doesn't taste of mold. Everything's so dank around here. Sit down, Sarah, you don't have to perch."

They sat in the deep worn armchairs that had come from the Salvation Army in the first place, and the fan turned above them. On the street a yellow bulldozer roared by, driven fast by a young woman with a blond ponytail. The saws buzzed.

"It's noisy here!"

"You should hear it in season. Deafening."

"When's season? Winter?"

"After hurricane season. A million people come down and rush about the place having fun. It's the fun capital of America. Naked butts on the street and underage drinkers and little suicidal kids on scooters."

"Sounds like a great place to be a preacher."

"Yup. Move over, Sodom and Gomorrah."

"Seriously, Jim. Why? It seems so unlike you."

"Got time for the long version?"

"Of course. Hey, it's good to see you."

A quick look at each other: there, then away.

"Good to see you, too. Well, now. The Jim you knew and loved was a wild kid, right? Something had to happen. Doesn't something have to happen in everyone's life, isn't there a fault line that cracks open and suddenly you have to change, to stay alive? Know what I mean? Well, there was one of those."

"A conversion? Come on."

"Yeah. Not quite Saul on the road to Damascus, but something like that."

"After the war?"

"After the war."

"Well." She sounded baffled.

Perhaps after so much time you simply had to plunge in, say whatever it was that seemed to be the truth on this particular day. There were other stories he could have told, other paths he could have followed to get to the present moment, Sarah sitting opposite him, asking him about what had been his life. This would be today's. Because

really there was no line of events, no one thing after another, one thing leading to another. There was a mass of things, and there was passing time, and your own face changing just slightly in the mirror, day by day. When people told their memories, they made up stories, filling in the gaps where nothing had been. They tried to explain the inexplicable. They tried to give human shape to the big story, which was out of sight.

"What was the name of that café we used to hang out in? The two somethings?"

"Funny, I was thinking about that. Les Deux Garçons. When I first thought of it, I thought, no, it can't have been that, but I think it's just because these days it would have had to be gay, a gay place. And it wasn't."

"Les deux garçons. The two boys. Two boys and Sarah, hunh?"

"Three boys, counting George."

"Correct. If you count George." It flashed past him once again, the body falling through space, the suck of gravity felt in his own body, the feeling of nausea. There had been bodies falling out of planes, after that, bodies hurled from the roofs of houses in flames. But that first death, the shock of it: someone of his own age, his own generation, a boy he knew well.

A morning on a dappled street, when he heard the news. When he knew she'd left him, and everything they had lay in ruins. Death had come among them, the fault-line cracked open, and they fell apart. Appalled at what had happened, not able to talk about it, they had run from each other. All of them, the tight little group blown apart by what had happened to George, and none of them able to make sense of it, or forgive themselves. He'd been so angry with Sarah, so hurt. Patrick and he hadn't spoken to each other for years. It had been the end of youth.

"I'm sorry. But it seems, we either have to bury the past and let it lie, and never talk about it, or we have to dig it up and take a look. We don't have to do it now, of course. We can take our time."

"The past we dig up—if we dig it up—is it the truth, then, or is it what we've made up in between, the stories we've told to people,

friends, shrinks, whoever, the way those stories got changed along the way? Or is it something that never changes, but just kind of lies there, like archaeology, like bones?" She was always, he remembered, the one who set the pace; now here she was doing it to him again. "We can take our time," she'd said, as if she knew the right way to do things, always had.

"I've never really told anybody." She made that sound right, too.

"Well, I have. I believe in the confessional, I've borrowed that from the Catholics. I believe in the talking cure, I've done it. I believe in standing up in front of a group of other lost guys and spilling my guts and knowing I'm forgiven, because I can forgive myself. That's what AA gave me."

"Ah, but can you? Can you ever, really?"

"We have to," he said, "or we can't live. I know."

"What, all the stuff you did in the war?"

"Yeah, all that. Everything."

"It sounds too easy," she said. " I don't get it. Isn't it just too easy, Jim, to say I forgive myself? What if what we have done is unforgivable?"

"Nothing is unforgivable," he said. "But yes, it takes time."

They were in deep again, like wading into water over sand that suddenly shelved underfoot. Irritated, fascinated, maybe out of their depth. He remembered just how it had felt.

"It's us humans who do things," she said. "Surely? I don't see what God, if there is a God, has to do with it."

He looked at her; no, he could not explain, just like that. "Well, shall we go to lunch?"

"Sure. Good idea."

"I just have to lock the church."

She stood in the doorway and watched as he closed windows, tidied things on the altar, and then stood back on the steps as he locked the big door. From down the street there was the rocking chorus from the African church with its wide-open windows and peeling pink stucco. *Halleluia! Yeah, yeah!* And a man's voice, calm and strong as a river, rising and falling above the rest. People came and went down there, African Americans, Bahamians, all of them well dressed as if

they'd ironed everything that morning, the little boys in their bow ties and white shirts, girls in patent shoes and frills. Together, she and Jim passed them, heard the swell of song, the sure voices through the wide-open windows. In the doorway, a huddle of people, black men and women with the accents of the South and the Islands, talking as the singing went on, and the door open on it all, as if anyone could come inside. She'd never heard anything like it, she told Jim as they went on down the street.

"It's like the end of the world could come," he said, "and they'd still sing. But you know, the service we had after the hurricane was like that. It had that kind of feeling, like things were urgent, and mattered, and you could be saved. Only, they have it all the time. We need a disaster."

"The apocalypse, to make everyone behave?"

"Not quite as bad as that."

They went on down to cross the street to the Bight and Turtle Kraals and the smell of the ocean came to her, its clean saltiness. She walked beside him, noticing from decades ago the difference in their height, which hadn't changed. It all seemed easier than she had imagined. Odd, that he should be so hooked on religion. She glanced sideways at him. In this strange, wrecked landscape, you could say anything, perhaps, and have it be all right. Even the past: even that.

SHE and he and Patrick. And George. Young Americans in Europe in the early sixties, finding their way. Their favorite café, on the Cours Mirabeau, in Aix, where they lounged in the shade of those incredible plane trees that made cool darkness even at noon, the light of the south of France splashing through between big hand-shaped leaves. She'd been happy, in the way a young woman courted by several young men at once is happy; she remembered tipping chairs back as they sat and talked, argued, everything friendly and upfront but somehow more passionate than it might have been, because they were all competing with each other. Competing to be the best, was it? Or was she the prize? Patrick had spent his time in the army playing basketball all over Europe. Jim, who had been drafted, had been sent to Vietnam, but that was later, must have been. Jim was slightly younger.

And she in her beatnik clothes, black everything, long hair, flat shoes, was busy being a student at the University, busy pretending not to be American, unless she could be Jean Seberg; pretending to be French.

What was George doing there? Studying something. She couldn't remember. Perhaps didn't want to. Oh, but it was a long time ago, decades. Life was so extraordinarily long. Most of it now stretched out behind them, there was so much of it. The past was over, couldn't matter anymore. Except, she thought, that it was the reason they were here now.

HE was short, shorter than either of the other two. He had lank black hair, and round glasses. She'd known he was in love with her, but he never said. That was what happened, though, when you were a young woman, good-looking, available, with three young men always at your sides. She had done nothing to make it happen, just been there, that was how it seemed. She had been with Jim, and then with Patrick, and George had killed himself. When you were young, you didn't have to do anything, things just happened around you. George, surprising everyone, had fallen or thrown himself out of the high-up window of the rented room he had on Rue Boulegon. None of them had seen it. But she'd dreamed many times since of a body falling fast downwards through empty air.

Any of those young men could have been killed; there was the machinery for it, they were its fodder. Yet the other two, who were in the military, had survived. It was George who had hidden out in Europe for years, who thought his phone was tapped, who feared CIA on street corners and in bars, who had died. Who had been killed; by the times he lived in, by his own decision. For if you launched yourself out of a window to fall thirty feet and crash onto cobbles in a courtyard, in those days, all you were doing was agreeing with the times, that decreed that young male Americans should be killed.

She would talk about it, in this different time and place, with Jim. Whom she'd left, to run off—why?—with Patrick Mellon. Perhaps it was safe now. Perhaps, like buried nuclear debris, it had at last come to the end of its half-life, its toxic power.

"Jim, do you know why George killed himself?" This was the question she'd have to ask. She rehearsed it in her head. Was it because of me, was the question she didn't want to ask. Was it really because I turned him down?

They'd never spoken of it, because by the time she and Patrick came back from the weekend in Marseille, Patrick and Jim weren't speaking, and then Jim had come back to the States and it must have been then, or soon after, that he was drafted. They didn't see each other. It was the end of that particular time. Patrick had gone to Paris, and she too had come home. There'd been no future for her and Patrick, because there couldn't be, not at that time when men were given to the military, even if it was only basketball, and women were supposed to sit home and wait. She'd seen him once, years later, when she visited Paris, and he was married to a Frenchwoman and had a little boy. They had never again mentioned their weekend fling.

But there was George, forever flying in free fall from a high window: George with his conspiracy theories, his complex ruses with telephones and changing addresses, his wish to be addressed as Georges and to blend into France. Everyone in town knew him, he was "Monsieur Georges," the stocky young American with rather long hair for those early days, that fell in dark bangs over his eyes, his eyes behind those round glasses, his eager way of speaking that sometimes ended with a stutter, his political fierceness. He was the first person to tell her about CIA involvement in foreign countries during the Cold War. He knew about plans that were being made, for invasions, for coups. She didn't believe him. She let what he said waft over her, she turned her head away, tried to look mysterious, was afraid. She thought, they all thought him paranoid; that it was "just George." He spoke fluent French with a heavy American accent, but didn't know it, thought he could be taken for a Frenchman. He was Jewish: the only one of them all. His parents had escaped during World War II, making him somehow more European than American, in history, in outlook.

He was studying archaeology at the university. He made friends with the French professors. He lived in fierce seclusion, austere as a monk, on the top floor of that narrow house with stairs winding

upwards, Rue Boulegon. The steep stairs and the low-ceilinged room, with the plastic curtain that hid the tiny bathroom, and a corner to cook in. His hands, too, clammy on hers. One hand, suddenly taking hers, and she pulling away from him, to light a cigarette. The way she knew she couldn't. There was Jim, there was not yet Patrick, but above all there was herself and what she couldn't even out of friendship force herself to do. There could not, by any stretch of the imagination, be George.

There had been his accusation, unforgettable, even all these years later. "Sarah, you are just a bourgeois professional virgin." Cock-tease, frigid, the words they used, that you would do anything, or almost anything to disprove.

She'd been young, they had all been young, and love, or sex, or whatever potent mixture it was, had been so important. She'd taken to it all like a duck to water, the sixties, the new decade, freedom, contraception, the dramatic overturning of all they'd learned from their cautious parents. In France, where the biggest compliment of all was not to be taken for an American. They all drank pastis as if born to it, and stuck untipped Gauloises to their upper lips and called each other—the boys anyway—"mon vieux." They'd seen Belmondo in *A Bout de Souffle,* they listened to Juliette Greco and quoted Sartre, and they loved the new cinema, the *Nouvelle Vague* and all it told them about the falseness, the idiocy of their upbringings in 'fifties America. Free sex, easy sex, sharing oneself was part of all that, as was talking about it, being upfront. She had not been a virgin, even then. But still, you could not—she could not—override her own instinctive feelings to that extent, give in to the urgency, the bitterness of George.

"Jim," she said, "could we talk about it sometime? You know, I think I have to, even if it is such old history."

"You mean, in Aix?"

"Well, what happened with George."

"Monsieur Georges. Well, sure."

"You see, I—" She stopped, wanting him to stop walking, for them to sit down. "Can we go somewhere? Or sit down here?"

They were down by the Bight, where the metal masts and halyards

clicked and sang with the late afternoon breeze. There was nobody about. At the edge of the land, with pelicans sitting on posts and gulls flying up around them, they sat down on the damp wood of the dock. There was time, she reminded herself. That was what was different. When you were young, you had no time at all; the paradox of it, that what seemed limitless felt as if it were scurrying by.

"He died, Jim. He killed himself. He was what, twenty-four?"

"Old George, or Georges as he liked to call himself, was crazy. Nothing you could have done could have saved him, not even if you'd thrown yourself into his bed like some sacrificial maiden; he was depressed, he was lost before ever you came on the scene, and you can't make it your fault."

"When you say 'crazy' do you mean mentally ill? Or was it the times? He was right about so much of it, that's what I've realized, and we never even credited him with any sense."

Time telescoped itself; there was that time, and now this, and what was in between seemed flat, inaccessible. Words, terms changed their meanings, everything shifted; the past became history, even if it was where you had lived. Yet she remembered that in 1967 when the Colonels had taken over in Greece, she had interviewed a young Greek in New York. Christos: she had met him at a café in the West Village, had written a piece around what he had said, that the CIA had been behind the coup in Greece. So, thought Sarah at that time—tapping her pencil, listening to the Greek, checking to see if she had his name right, and the dates—George was right. "There was more going on then than we thought: things we were never meant to know."

"I know. It all seemed so excessive at the time. Paranoid, you know. I still think that whatever the CIA were doing, he was nuts to think it had anything to do with him."

They were both silent for a moment. Maybe, Sarah thought, there was no point in talking about any of it. He sat beside her, an inch away, their hands beside each other but not touching on the splintery wood of the dock. There was a feeling of constraint between them: having raised the ghost of George, what was there to say? She had felt, all those years ago, that they had all blamed her for George's death.

She had taken the blame and lived with it; it had seemed to be what made her suddenly adult. It had certainly made her cautious. What had been true?

The silence of memory, in which they searched for clues.

"Well, we seem to have quite a few things going on in the present. My disastrous house, your porch person, for a start. What are you going to do about her?"

"Ah, my uninvited visitor. The one you think is Jesus, huh. Ms. Pearl."

It was safer to move back into the present, where they did not know each other. Here, they could listen to each other's problems, lend their attention to each other, offer helpful advice. Back in the past of their distant childish love affair, there was only the mess of things that neither understood.

Jim sat up straighter beside her, smiling at how much easier it was to return to the topics of the hurricane, homeless people, his life with Susan absent, and what to do with a smashed-up house when you had received it as a gift. He watched her as she spoke; noticed her precision, the way her jaw jutted when she made a point, the way she moved her lips, which had now produced a little line at each corner. It was all familiar, yet transposed. For thirty years he had forgotten what she looked like, really, had kept a vision of light hair and slim legs, had never imagined that lips moving in a certain way for decades made little track-ways across the smooth skin of a face. The way a person spoke, thought, saw things: all this could be drawn upon skin. Nothing was invisible, the way it had been when they were young. Now, as she talked of getting contractors in and clearing garbage, he simply watched and listened. He watched the way her lips moved, and the pursed lines came and went, and the deep places at the corners of her mouth grew deeper, and her frown left its marks like drawings on a beach. After a while, he suggested lunch, and savored the feeling of her strolling along beside him beside the boiled-up seething water of the Bight, to see what was open and what they could find to eat. He didn't want to talk about George, or Patrick, or any of it. He wanted his escape from pain and confusion to remain permanent.

What did it mean, to find your first love again when you were fifty-eight? Something? Anything? They were not the same people, anyone would tell him that. If life were no more than snapshots in an album—what an old-fashioned image—then he was safe.

On a damp bench, under a changing sky. "What'll you have?"

"Oh, a beer, I guess. And a fish sandwich."

"There's been no boats going out," the waitress said, at the only bar that was open, a wood deck above choppy water, with pelicans waiting to dive from posts. "We only have chicken."

"Okay, I'll have chicken."

"That's all there's plenty of, in Key West," he said; and enjoyed her mocking smile, the corners of her lips going into those deep little pockets that could have been made with a pencil. Her eyes were still clear, greenish, under slightly drooping lids. She saw him looking, raised her eyebrows, turned away.

BACK at the house, Pearl was still absent, though her belongings spoke to him of permanent occupation, or at least intended occupation. Each time he came home, there was more stuff on the porch, so that now it was quite full. Jim dreaded coming home now, having to see them. The more things, the more firmly she was attaching herself to him. Clothes from the Salvation Army, a battered cardboard suitcase, more newspapers, a candle in a holder, toiletries, a man's hat, a chair she must have found on the street. Pearl's stuff, her only life.

He'd said to Sarah, "She'll have to go." But he had no idea now how that could happen.

"You mean, you'd kick her out?"

"Well, I can't keep her forever."

"No, I suppose not. Reverend keeps homeless woman on porch. It doesn't look very Christian, does it? You could at least have invited her inside."

He felt the sting of her on his skin, like an itch. She infuriates me. I love her. I still love her. I feel exactly the same way about her. It is a habit I have not lost. What she says pulls me out of the past like a line going down to the bottom of my ocean, dredging me up into the light.

9

WHEN PEARL CAME BACK, A DAY LATER, he saw that she was without her front teeth. He stared at her, suddenly become an old woman before him. The dark gap where teeth had been, and her whole face threatening to fall in around it. Entropy. Teeth held a face together, nailed it in place.

"What happened?"

"Somebody kicked me in the face last night." She sounded calm, as if this were what happened easily, anywhere.

And he'd wondered where she was, why she hadn't come home that night; home to his house, that was already her home.

"Somebody? What somebody? How?"

"I don't know their names."

Jim thought: dentist, money, fill that gap—but it was probably too late. Her lank streaked hair drooped around her face, she clasped her hands around her knees and looked at him. There were people in town who kicked other people in the face, just like that. Casually, as if it were normal.

"Where were you?"

"Down by the beach."

"What about the police, did nobody call the police?"

"No, or we'd all have ended up in jail."

We all? Who all? Was this the mostly peaceful community of homeless people who hung out in the daytime down at Higgs beach under the roofs of the picnic tables and at night hid to sleep where

they could? He knew several of them. Some of them were vets, like himself, and on Memorial Day they'd find themselves together, members of a ragged marching band, on Duval Street. He didn't know anyone who would have done this to Pearl, but then he didn't know everyone in town. It could have been villains from somewhere else. A flash: Pearl, limp, held down by several men. (They burned me, they upended me.) A boot in a face. How could anyone, ever, do that? But, people did that, they did it everywhere.

"Can I help?"

"You mean, put my teeth back?"

"Well, do you want to see a dentist?"

"No, it doesn't really matter. I'll be okay. Just chew on the back ones."

The population was divided in this town into those who could afford dentists and those who couldn't. You looked at mouths if you wanted to guess income. Teeth disappeared from the mouths of people you knew as the years went by, like trees felled by wind.

"I'm going to be moving on soon," she said. "So you won't have to worry."

"Where?" His gut released with the relief of it; she wouldn't be here forever, he wouldn't have to make her go.

"Nashville."

"Nashville, Tennessee?"

"Sure. I'm going to sell my songs. I'll do portraits too, if anyone wants. Did you like the one I did of you?"

How could somebody get her front teeth kicked out one minute and be cheerfully talking about moving to Nashville the next? He stared at her. Guilt still lived in his lower stomach like an illness. She smiled her terrible new gap-toothed smile. It was like war, he thought. Refugees everywhere, trailing across America, trying not to be noticed, trying to get a life. If you didn't have an address, somewhere which belonged to you, you couldn't have an existence. Perhaps what you had instead was a fantasy, a dream.

"Don't look so worried, Jim," she said. "You are a good man."

Nobody had called him that, even though he was the pastor. A

good man. He liked that, the way she said it, so seriously. He didn't feel like a good man, most of the time.

"But will you be all right?" Obviously not; but what could you say?

"I'll be as all right as I ever have. But you, will you be all right? You are in need, Jim, I can feel it."

Silence. A good man, in need, in need of what? He felt as out of his depths as he had earlier, with Sarah.

"Where did you come from, Pearl? Where was home?"

"I've forgotten. I don't remember."

"Really? How did you forget?"

"It wasn't worth remembering. So I don't."

So that was how amnesia worked? He thought, it must have been bad, not to have been worth remembering. Then he thought of what he remembered, and how some of it had been bad, but he had never considered it not worth remembering, because memory was all you had, to make you who you were. Out of memory, its very sharpness, came redemption.

Pearl had no memory, because she had erased it, like pressing a delete button. She had no past: only streets, highways, places on the way to other places, a dream of Nashville, taken from who knew where in the shared unconscious of the nation. She saw herself there, singing, selling songs. With no front teeth, and a body marked with burns and that radiant upsetting optimism about her that was almost mindless. He wondered, was she crazy? How did you know? When did simply hurt become crazy, and was there anything in between?

"Don't worry, Jim," she said again, as if he was the one who needed to be consoled. He put an awkward hand on her, her upper arm near her shoulder, and felt the thin rigid tension of her, bone only slightly veiled by flesh. Squeezed just slightly. Then removed it.

"I hope it's okay for me to stay here a little longer, till I go?"

Then he realized what had happened; he'd let his relief show, he'd opened himself to it in her presence, just because she'd mentioned leaving, but it was all a setup, because she had still the upper hand.

"How long?"

"I don't know exactly. Not long. I'll let you know."

The space between them was full of what couldn't be said, because she wouldn't allow it, and he'd be too ashamed. He went into the house with an angry sense of defeat.

"Thank you, Jim," he heard behind him, as she settled down among her heaps of possessions, snuggling in, in that proprietary way he suddenly couldn't stand.

HE dreamed that night, and woke at four with the dream fresh in his mind. She was sitting at his table, in his house, and she was part Pearl, part Sarah. She was decomposing before his eyes, shriveling, losing parts. He had to stop her, it was in his power, but he couldn't move. Then Susan came in to the house and called his name. "Jim! What's going on in here?" and he had no answer. Three women, in his house, in his dream.

He went outside, through the kitchen door, into the back yard. The tick of the tropical night: crickets in the smashed and battered trees. A cackle of frogs, hidden, living off wetness. There was one that lived across the fence in the yard next door, or thereabouts. Its cry was a three-times knock on wood. Rat—tat—tat. Then, clear as a human voice: "Fuck you! Fuck you!" Jim laughed, it always made him laugh, and he hadn't heard it since the hurricane, but now it was there for him like a mocking but familiar friend, that no-bullshit ally, male-sounding somehow, light relief.

"Fuck you too," he said aloud. It was what he'd been wanting to say to somebody for days. Alone in his own dark yard, talking to frogs, who was he to say who was crazy?

SARAH asked at the hotel for one more night. The man at the desk, who was one of the owners, was giving her a deal. It was still the hurricane's aftermath, and everything was reduced in price: restaurants still offering one-price meals where two weeks ago they'd been giving food away, hotels which had closed up abruptly once the tourists were evacuated, glad to open for a guest or two. She sat by the abandoned pool, where scarlet flowers sailed like little flaming tears on the eddies from the long-handled scoop a boy used, trying to

catch them. The chairs had been put out again but were still dirty from rain and mud.

She took a drink from the bar, a margarita with ice and extra salt, the island drink. When she'd taken one salty mouthful, she shucked off her dress and slipped in her swimsuit into the oily rain-warmed water, after a wave from the boy to say it was all right. How wonderful to swim among red petals, the sky cracked by branches overhead, the air humming, today's heat just beginning to shrink back into the slightly cooler air of evening. She pushed the flowers away with her hands, red wet curtains, and hung in the deep end, thinking about Jim. He seemed determined to avoid her questions about the past, and maybe he was right, she thought, maybe they should just let it go. Then, she thought about her wrecked house, where soon she would have to settle in, cook, sleep. This hotel living could only be for now, and she didn't want Jim's house, not with all that was going on there. That woman on the porch. Susan, about to return. And she had her house to inhabit, to make whole. All the construction firms were busy, roofers were booked probably for the next year. The shriek and whine of machinery went on everywhere, operations on other houses, not hers. She'd only managed to drag out soaked carpets to the street, pile broken linoleum on the sidewalk, scrub the bathroom till she could bear to be in it, boil up water for tea in the little kitchen that seemed to be sagging into the back yard as if it wanted to be buried there. She'd worked, sweating, for all the hours of yesterday, and had then spent the rest of the weekend talking to Jim.

Swimming laps now among flowers, moving her body through the water, she felt tension shift and leave. The boy went away, his task unfinished, the net full of leaves and petals and twigs thrown down on the tiles. There was nobody about. She stretched and floated on her back, wet flowers in her hair and clinging to her skin and suit like soaked confetti when she hauled herself out at last.

Jim Russo, after all this time. The boy with the Indian black hair, the shy grin. Who did handstands up against the wall, who walked with bootlaces trailing, talking, not looking where he was going. The one who had held her all the long length of his body, when neither of

them knew exactly what to do. Who had wept before her. Now, a long face mysteriously covered with lines, a mouth compressed on something he had never told; she felt it, his secret locked inside him, for all his talk about confession.

Those boys, sent off to be killed, coming back as men, or parts of men, their youth destroyed out there, something in them already dead; she'd met others, known them, their cagey adult selves closed upon the gap of what had been torn out of them, in boot camp, in transit, in the unimaginable places of war. Now they were middle-aged, looked old. She saw them on streets, at street corners, in bars, the obviously wounded, missing a leg, an arm, an eye, some portion of the brain. Even yesterday, that guy sitting outside Fausto's where she'd gone to buy scouring powder and a broom: no legs, and a greasy veteran's cap pushed back on his head, a grin for her, a bottle in a brown bag. Not even any prosthesis, just wounds, just stumps, here in rich America, just his lack out there on view for anyone to see. What was missing, his life.

With Jim, who'd come back whole in body, she guessed at rather than felt the lack he wore inside. He'd gotten religion. Strange, but maybe not surprising. It must have been a way to survive, to start again. She imagined him preaching, his manner. It was a way to be above it all, perhaps. She thought of his hands, his eyes. His mouth, again. Parts of people did not change, others did. Herself, for example: skin slightly loosened, breasts still young, hair unequivocally gray now she was letting the blond grow out, feet and hands showing long wear, stomach no longer flat. Inside herself, swimming, the girl she had been. And in the dark, under the touch of her own hands when she brought herself to orgasm, the same; a little slower, perhaps, a little less violently jolted by the spasm, but essentially the same.

She sat dripping on the dirty white plastic long chair, by the blue-green thickened water, her feet on the tiles, hair streaming rivers to her shoulders. Jim's hands, the graceful bony spread of them, like a dancer's. Did he use them when he preached, did they undermine him as they did in conversation, speaking their own language in spite of what he said? His hands on her, they were a part of memory: his

gestures already inscribed long ago on her skin. She wrapped her head in a towel, rubbed it dry, rubbed her arms and legs, stood up, forgot her drink, then carried it with her to her room. Some thoughts you couldn't have. They had to be cut away, like parts of a body that no longer functioned. You had to have the gap, instead. But how could you go through life with the gaps, the lacks, appallingly on view?

In her room, she drank the rest of her salty stinging drink and felt it reach through her body to her genitals and toes. She lay down on the bed. Broken linoleum, sagging soggy carpet, the weight, the dead drenched weight of the remains of others' lives. Roofs caving in. Branches dragged on to the street. The fatigue of that movement, back and forth, back and forth, in the sun's eye, moving things from one place to another.

When she woke, it was dark. The fan on her where she lay naked, her wet suit still in its puddle on the floor. She was hungry now. She thought of going to find a restaurant, then thought of calling Jim to see if he had eaten. But the ringing tone only ended with his answerphone message. He was out somewhere in the night streets, walking as he'd told her he did at night for his insomnia. In the emptied town, still stepping around the piles of debris that remained. Thinking, talking to God? How did you do that, she wondered, get on chatting terms with God? How invent a God solid enough to talk to? Was there ever any answer? Surely it was just to console him, after the war; but then, it had been a long consolation. Sarah looked at her watch. It was one-thirty, too late for restaurants, she'd hold in her hunger and sleep till morning. Her mind followed Jim up streets into darkness. But of course, he was in bed, asleep, that was the reason he wasn't answering. She lay looking at the shadowy fan turning, listened to the effortful sound of it, until she slept again.

NOBODY would work on her house: it was clear to her now. Roofers laughed at her when she asked them, they had work for months, if not years. The man with the crane, whom she'd called several times, only said he'd make it when he could. Carpenters were like kings. Even a handyman was impossible; they were all out there being paid

what they wanted by people who lived here, who'd gotten in first. Guys were coming in from out of town, from all over the state, and there was still too much work. She bought a sleeping bag, a camping stove, lamps to plug in to the wobbly wall outlets, some hedge cutters, a shovel, a table, and two chairs, and was dragging them out of her car when she heard a voice from the other side of the thicket of aurelias, "We could have loaned you some of that. D'you want tools? Come on over."

She looked up and saw a round face between the palms, with light brown hair in a loose ponytail, squirrelly eyes.

"So, you're our neighbor. Hi, I'm Martha. This is Molly."

"Sarah. Hello. That's kind of you." They shook hands, Martha's spare one to her own.

"Did you buy the house?"

"Well, no. I was left it, by a friend."

"Left it? Wow. Lucky you."

The child in Martha's arms, who had the same bright brown eyes, let out a little shriek, as if she were surprised too.

"Come round. Ours is at the back. My husband's got a bunch of tools, you can take what you want. Are you really living there? What kind of shape's it in, inside? No one's lived there for a couple of years. Did you expect you'd been left something livable? Oh well, I guess if the roof's okay, you'll be all right. You know no one can claim hurricane damage if there isn't a tree through the roof. They take all this money off of people for wind, storm, and flood insurance and then give them zip when they try to claim. It's happening all over town. FEMA gives you next to nothing, and it takes a year to even begin. Hey, look, all the stuff's here I think. Tom's out, or he'd give you a hand. Well, I could, if you want, if Molly sleeps, but she hardly ever does sleep and with her around I wouldn't be much use. But, um, you know, you could have a cup of coffee if you want. Or would you like a cold drink? I've got some iced tea."

"Iced tea would be great."

"Since we're neighbors, huh?"

"Sure."

"Well, look, have a seat." She hitched the baby higher on her right hip, her arm curved around her, and went off to the kitchen. Sarah sat on the old couch in the yard, under the porch overhang.

"You know, I can't get over you getting a house in someone's will. That's wild. Was it a relative, d'you mind me asking? Whoever it was must have liked you a lot."

"An old friend of my mother's. A gay man. I guess everyone else he loved was dead."

"But, a house!"

"Yeah, I know."

"Will you live down here? What'll you do?" Martha poured tea from a pitcher. Ice clunked in the glasses. "My, the thrill of it, ice again."

"I don't know yet, I haven't decided."

"You could sell it for big bucks. Quarter million, even in that state. That's what they go for in Old Town."

"I know. People keep telling me that. But, you know, I haven't decided. It's all new, I've never had a house before, not even a falling-down one."

"You're lucky he didn't have any kids, or they'd be someone contesting the will. It happens all the time, now these houses are worth such a stack."

"I guess."

"One thing about living here, it doesn't really matter if you have holes in the walls and the floor. Only the roof matters, really." They both looked across the straggly hedge at the roof of Sarah's house. The old tin shingles shone in sunlight, under a scatter of dried leaves, only the wooden edge was ragged. "You kind of change your attitude. I mean, some people don't, they have to have it like in New York, like something out of a magazine, you should see what's been done to some of the old shacks. But there isn't really much point. I mean, everything can be blown away. It's all only wood, mostly plywood these days. It's like make-believe. You get something like a hurricane and you know it doesn't really matter, you just need a roof over your head and someone to hold on to, is what I think."

A roof over your head and someone to hold on to. Sarah smiled at Martha, who blushed a little and smiled back.

"I know, it sounds sort of basic. But that's what it comes down to, in the end."

THEY went together back to Sarah's house and wandered through the rooms, Martha holding the baby now dozing on her shoulder—"She'll wake if I put her down"—Sarah leading the way. It was an aimless, friendly wandering. Martha talked in a long stream and then was silent. Sarah heard herself voicing thoughts she didn't know she'd had. "I thought I'd use this for a study, you know, eventually. Or what about knocking part of this wall down so I could have one big room?"

"Big? The whole thing's not exactly big. But yeah—or what about, hey, it's so cool, you can do whatever you like!—moving the kitchen, having a sitting area, or study or whatever back here?"

It was like walking through an imagined place, reconstructing it in words and gestures in air. They were conjurers for an hour, pulling up reality from a hat of imagination.

"Cool," said Martha again. "Doesn't sound like you're going to sell it, not when you talk like that."

"No, it doesn't, does it? Pity the termites are real and the rotten wood's real and I have to get a real carpenter."

Martha patted a wall. "You know, I bet there's Dade County pine under there. I bet there's some real good wood. The really old ones were all built of it, yellow pine, very hard and resinous, there isn't any left now. It's what all the realtors go on about, and the ads, "Dade County Pine"—in a mincing voice—"but seriously, it resists termites. In here, you could just get rid of this soggy sheetrock, scrub up the wood underneath, slap some white paint on where it needs it, put down some rugs. You really won't have to do much. Those guys out there are just out to make a buck, right now. You'd do better to wait. Tom and I can give you a hand."

"Really?"

"Really." She looked back at Sarah, her face radiant, hair escaping, the baby stirring and beginning to struggle on one shoulder, a patch

of wet on her T-shirt where the child's head had been. "Yeah, really. We'd be pleased to, him and me."

WHEN Martha had gone, Sarah stood in the middle of her house and realized that what she felt, unusual, unasked-for, was happiness.

In her own apartment, only feet away, Martha picked up the phone and dialed the number of her doctor, whose name was Kim. "Hello? Yeah, I want to speak to Kim, please. Is she there? Kim. Hello, this is Martha Sawyer. Yes. Do you have it? Yup, I'm okay. Yeah, I can wait a minute." She was twisting a strand of her own hair, twisting it and straightening it again. The silence lasted. Then, "Oh. Oh, no. Are you sure? There can't have been a mistake, can there? I know the instant ones from the pharmacy can get it wrong. They don't? Oh. Okay, thanks. I'll call back for an appointment. Yes. Yes. Okay, bye."

She put down the phone, stood still in the middle of the room. "Oh, shit." And again, "Oh, shit. Oh, no." Suddenly, she was alone; alone with the news, the knowledge. Positive, Kim had said. That meant she was pregnant. She'd known at once, in a way, just as she had with Molly; you couldn't help feeling it. Pregnant, with a baby Molly's age, and no money for anything more than they had already; a life stretched to its limits, strained to the edges, only just making do. Inside her there was growing, certainly, unstoppably, another child; a life, coming out of her whether she wanted it or not. The apartment felt all at once even smaller, the piles of paper on the table looked more chaotic. Tom's shoes, lying by the door, monstrously big. She kicked them out of the way. The kitchen, small as a galley, overflowed with dishes, cups and mugs, tins of baby food, Molly's toys lay everywhere, underfoot. The broken blind tapped at the window where Tom had not had time to fix it. And inside her, out of her control, cells growing, multiplying, a baby making itself, too fast, too soon.

She flung herself down across the bed, the cover with its designs of fish and shells screwed up into fistfuls in her hands, her face buried in it. The walls held her narrowly as her own flesh held the scrap of life that would eat up her own. The tree branches tapped and scratched, too close, at the windows.

She let the despair of it take her for that long moment, and then got up and walked about, paced, breathed deeply in and out. You can't start this child's life by letting it feel how deeply scared you are. Whatever you decide, you must make it, free of fear. There are choices. There are things you can do. You don't have to go through with it. You have that right.

She stood out on the back porch for a few minutes, just breathing the air, just being, for now, trying not to imagine it happening, so remorselessly fast inside her.

10

JIM CROSSED THE STREET AND PICKED HIS WAY across the littered sidewalk, "Hi! Anyone home?"

"Hi. Come in. Door's open."

"Where were you?"

"Here. Where else?"

"I called the hotel. They said you'd left."

"Yeah, I moved in here. I was going to call you. I guess I've been busy."

"Sure looks like it. Are you okay here? I meant it when I said you could stay at my place."

"I know. Thanks, anyway. I had to move in here sometime, so it may as well have been sooner as later. Look—"

"Whew." He sat down on the chair in the middle of it all and wiped sweat from his forehead with the back of his hand. "Looks like you're settling in."

"I keep hearing about how I could get a quarter of a million bucks for it, and each time I hear it I get a little more determined to stay. The people next door have been helping me, they're nice."

"What about your job and everything, Sarah, and your place in New York?"

"Oh, I took my vacation and some time they owed me. To come all the way to a disaster area. People thought I was nuts."

"People are always moving down here and other people always think they're nuts. It happens all the time. There's a high proportion

of nuts in Key West. Trouble is, they think they're going to make a living here."

"You're kind of a Cassandra this morning, what's up?"

"I'm exhausted. Everyone's exhausted. These damn machines everywhere. Pearl's lost her front teeth. My life is chaos. Plus, I keep feeling afraid that Susan's going to appear at any minute."

"You don't want her to? And what's this about Pearl's teeth?"

"I don't want Susan coming home before Pearl's gone and I don't know how to make Pearl go, especially now she's lost her front teeth. Someone kicked her in the mouth. Yeah, I know. Unbelievable."

He put out a hand to her, and she took it and held it. Their fingers wrapped each other around; part comfort, was it, part promise? A grip, like shaking on something. Then she pulled hers away. He looked at her. Sarah, the one he'd known nearly all his life, the first girl who'd mattered, the one who had made him cry.

"Jim. What can I do?"

"I don't know. I don't know, I can't sleep. I'm out there at night with all the winos and crack heads and dealers, wandering around like a lost soul. I need to sleep."

"What stops you?"

"Dreams. I pray not to have them. But it seems you can't not have them. I sometimes feel like I'm dreaming for the whole of the rest of the world."

She stood close to him and he held her with one arm hard against him just for a moment and then pulled away. It couldn't be. He knew that, so must she. But the past, he thought, we try to keep it out and it comes up through the present like water through the cracks in the streets, like the roots of trees that made the street move underfoot when the eye of the storm was on them.

"What about lunch?" She said it to make something normal happen. Her stomach growled, and they both laughed.

"Sure sounds like you need it. Come on, then, let's walk over to Finnegan's and fill ourselves up."

* *

ALL the way to the door of Finnegan's, he felt the need to say it rising in him, a tension in his throat like tears. But it was absurd, it could mean nothing. She would think him ridiculous.

"Here is a question," he said to her. "If you've once loved somebody, do you always love them after that?"

"In theory, yes. In practice, well, it may just not be possible. Especially if you've loved several people."

"Have you?"

"Well, yes."

"I'm not talking about acting on it. I'm talking about feelings. Knowledge. The holiness of the heart's affections."

"Well, in that case, yes."

"I love you," he said, "I always have."

"Well, I think I've probably always loved you. But in a way, it's history."

"What about when you were with Patrick?"

"I've been with many other men, not just Patrick. Patrick was just—oh, I don't know, escapism. I didn't love all of them. Some, I did. All I'm saying is that love doesn't go away. It just gets covered over."

"Layers and layers? Like archaeology?"

"Maybe."

"Or like dirt under asphalt. Like coral rock under dirt. Like caprock under that. Then like the aquifer, deep down, running under all of it, the springs of the earth?"

"I guess, like that. We're made up of it, don't you think? All our loves go to make us. They change us, so we become somebody slightly new."

"So this is not about doing anything, is it? It's about admitting a reality. Like you don't have to dig up the ground under your feet to see what's there."

Susan, he thought, Sherry, his absent family, suddenly hard to remember. The street that shook under his feet. The trees that had been there for years, even centuries, their roots vibrating in the earth. The clean strong winds of the hurricane, sheeted in rain, blowing in to his life and everyone's life here; making a difference.

This woman knew him. But what difference this might make, he couldn't guess. He wished he hadn't said anything about love; it could only make for awkwardness, or at best, be irrelevant.

Sarah said, "There are so many theories about love. It's hard to know what people mean by it. But something makes us who we are, and I think it's the quality or amount of love we've had. If I say, 'I love you, Jim,' it's because I always did; I was young when I found out what love felt like, and it was you."

"So it could have been anyone." It sounded, he thought, like being the person from whom she had contracted the measles.

"Well, it was bound to be, wasn't it? If it hadn't been you, it would have been someone else, in the nature of things. But it was you, and I ran away from it. You were my person, you filled that gap at that time."

"So what's it mean to you now?"

"Well, what I let it mean, I suppose. It could be, nothing."

"Or?"

"Or."

"And what if Patrick should show up?"

"You know, it's funny, I thought I saw him on the Provincetown boat this summer. Only it wasn't him."

"Well, what if Patrick or even someone who looked like him but wasn't, should show up?"

"Jim," she said, "this is stupid. Let it go." They were sitting at a table outside, against a wall, and there was no one else in the little courtyard. He leaned back, his long legs tipping a chair backwards, uneasy.

Then she said, "There was a man who wrote about hurricanes, you know, long before anyone else did. He was a pirate. His name was William Dampier. He wrote a book called *The Discourse of the Winds*."

"Yeah?"

"It was at the end of the seventeenth century. He was the first person to draw a map with dozens of little black arrows on it to show how winds come across oceans. They must have looked like dozens of swallows all flying in parallel lines. At the time, maritime atlases didn't show any instructions for making ocean passages. That was the

gap that Dampier wanted to fill. He wrote directions for using the Atlantic trade winds that were so accurate that they are hardly changed today."

"How did you know all that? And why now, apart from obviously changing the subject?"

"Journalists get a lot of strange facts stuck in their heads. But now," she faced him, standing stock still, blocking his way. "Because a wind brought us here, whether we like it or not, and it started somewhere else. It had its beginnings in another place, and it'll blow on past us, beyond here. So, be patient, Jim. Okay?"

AFTER lunch he left her and went back to his own place to work on his sermon for Sunday. He wanted to talk about what people were left with when everything familiar had been blown away. He wanted to bring the dry bones in the desert into it, the ones that Ezekiel had seen join together and come to life. Bone, blood, gristle, fat, skin, the stuff of a human. Then the mysterious thing, the breath, the movements of air in the body, the spirit rushing through. He wanted to think about that, about its implications. But before that there was Pearl, like a guardian at the gate. He'd have to get past Pearl. It occurred to him that, hurricane or no, his life was close to becoming unmanageable. These gusts blew through him—disgust, terror, then the gust of love. He was a wind tunnel, a mouthpiece. He was an irresponsible man, a ranter in the wilderness, but with no wilderness left to go to that was outside his own heart.

Pearl was not there; only her possessions, familiar to him now as Susan's, or his own. Women moved with their camps, their clumps of stuff. Nomads, he thought. Susan, the car filled high, had moved her camp to Georgia. This woman had moved hers here. There were all those scenes in movies when people walked out on each other, that involved stamping into the bedroom, throwing down a suitcase on the bed and ransacking drawers to fill it with random stuff. He suspected that when people really left, in real life, they did it slowly, carefully, with stealth. If you were really not coming back, you would not want random heaps of clothes. Pearl's stuff, even, had a crazy logic

about it, it was here for a reason: heaps of newspapers accumulated for their horoscopes, clothes in rotation, knickknacks to express aspects of herself. The jackdaw scraps and glitter that told her, in strange places and after fearsome nights, who she still was. He stepped over it all and went indoors. The phone was ringing. He let the answer-phone pick up, and heard the voice of his wife.

"Jim? Are you there? Pick up if you are. Jim, I want to talk to you. Call me, or I'll call again tonight. Okay? Love you."

Love you. Love me. That word again. He thought, do we love each other simply because we are there? Is that what it is, just a description of familiarity? Did he in that case have to love Pearl? But when he revisited his feelings for Sarah, that rocky gut-wrench, that longing to hold and not let go, he knew it was not agape that had taken root in him again, but eros, that ache.

He called Susan, at their daughter's place in Macon, Georgia, so that her voice would not speak emptily into his rooms again.

"Sue? It's me. You called."

"I know, I wanted to talk to you."

"Well, talk to me. I'm here."

"Where were you?"

"Out somewhere. I came home to work on my sermon, and heard your message."

"Oh, yeah, it's the weekend again." Susan, who never let go of time. He heard a strain in her voice, guessed at what was coming.

"What's up?"

"Well, you know, I just don't think we can go on as things were before. Or at least, I can't."

"Before what?"

"I suppose, before the hurricane. Before I left, anyway. This is difficult. I didn't want to say it on the phone."

"But my email's down and I'm a thousand or so miles away, so you're doing it anyway."

"Don't make it even harder." Was that a line from a movie, or a dozen movies, or what? It was like the suitcase flung down on the bed—fundamentally unreal.

"Are you trying to tell me something? Why don't you just say it, Sue?"

"Yeah, well, I'm trying to say, it's not that I don't love you, it's just that I can't go on the way we were, don't you understand what I'm trying to say?"

Three negatives, he thought, or was it four? It's not that I don't love you—was that the same, grammatically, as I love you? He felt exasperated. Then he felt scared.

"Are you trying to say," he asked carefully, "that you are not coming back? Could you just say it? Could you just say what it is you want to say?"

"It's not that I'm not coming back. I'll come back to get my things, of course, and see you, and sort things out. But I'm not going to live with you anymore. I've left you. I didn't know I was leaving you when I left for the hurricane, but I was."

"I see. So, if there hadn't been a hurricane, you wouldn't have left me?"

"I really don't know. It probably would have taken longer. Maybe even years."

"So it needed a meteorological event to get it going. It might have waited till the next tornado, or would that not have been enough, would only a Force Three hurricane do?" He was absurd, he knew it, and yet his anger and the fear at its heart made him go on like this, ranting, out of control.

"Jim. I'm going to hang up."

"Don't!" What was it he wanted to cry out—don't, don't leave me? But he'd been left, weeks ago. It had happened, it was a past event, she was telling him now, and all this time without knowing it he'd been living in its aftermath.

A shape passed the window, behind the half-open jalousies. It waved to him. It was Pearl, waving, jaunty, hi, I'm home.

11

OUR YOUNG SELVES STILL EXIST IN MEMORY, Sarah thought, as long as we don't meet in the present. As the present self approaches, comes close, becomes reality, the young one gets scared and flees. She couldn't see Jim in France anymore, with his thick dark hair, his gypsy look, his coltish grace. A middle-aged man, hair thinning, face lined, had taken his place. When she was young, it was easy to love the young Jim. He had no forerunners in her life. He was the first, the only one, she'd been waiting for him; he was her boy, until with the speed that caught one up in those young days, she had transferred what she called her love to Patrick. And another young man, neither Jim nor Patrick, had thrown himself out of a top floor window.

It was like having several lifetimes, with some of the same people showing up in each. She searched in herself for some true feeling, where once feelings had been so accessible. There was only fatigue, today, and the dried sweat that lay like a varnish on her body, and a wish to drink iced drinks, lie down, be cool. Her little house was like a furnace, but towards evening a breeze came in through its open doors and she lay still beside the only working plugged-in fan she had, that seemed to blow hot air back at her. What was she doing here? If life had meanings in it, she had been sent by Johnny to find Jim. But perhaps it was meaningless. She had a house that was apparently worth a quarter of a million dollars, but was nearly uninhabitable. She was camping in a ruin. Her real life, New York, the apartment, her job, awaited her thousands of miles away. She could go back: sell, leave,

forget this island that sweltered in the sun even in October, over-crowded, sticky, awash in warm salt water as if it were a womb one could slide out of and be born.

A man had told her once, to go to Key West. A French sailor, whom she had met in Morocco, and never seen again. In Essaouira, that city of wind, all those years ago. Where she had met and loved Aziz, the Moroccan, where sand blew along vast beaches, swirled into little whirlpools, where the wind had blown three hundred and twenty days a year. Sometimes it felt as if life itself was the wind, that blew them all around, as if this was what maps were for, and the white eddies of weather moving on TV screens: to describe what could not be described or explained otherwise. Once, people had had no idea what was happening to them, or what was about to happen: the weather had to be felt, a warmth on the air, the color of the sky, the behavior of birds and animals. You had to use your own body to ap-prehend it. A sudden silence, in which no birds sang; the smell of salt far inland; an ache, a scent, a stirring in the blood. In the same way as a pregnancy might be felt, or the first touch of death. Now, there were all these technologies to tell you, so you didn't have to feel it for yourself.

The wind blew on the west coast of Africa, it skidded along the sand and sent huge waves up into the cracks inside city walls so that stone cities were eaten away, a little at a time. Men watched the sea, for its messages. She remembered it, the sand blown sharp and sting-ing into her face so that like everybody else she had had to draw a scarf across her nose and mouth, for protection. How had anyone ever imagined that weather could be kept out, accounted for, that ig-noring its messages people could live their lives insulated from its touch? Of course the winds that boiled up on the coast of Africa would eventually come here. It would all come here. The palaces drowned in sand. The footsteps obliterated. The fishing boats that huddled in port, because the ocean was too fierce that day, it was "bad" as people said, it was "sick."

The fan ticked, round and round. She watched a gecko climb a di-agonal on the wall and disappear into a crack. With a finger she

traced the routes of termites on the wooden wall beside her, the little holes punctured where termite droppings like fine brown grain fell out and trickled onto her single sheet, making her gritty in the night. Everything was being eaten away. Nothing stayed the same. Life was entropy: termite dust, wrinkles, hair loss, the inability to remember what had been so exact, so sure. She sat up, took a swallow of slightly sweetened lemony liquid that had been iced tea in a bottle from the store. Then someone knocked on the open door.

"Hello?" Sarah called out. "Who's there?"

"It's me. Martha. Your neighbor. Mind if I come in? I'm not disturbing you?"

"No, no." Sarah sat up, moved the fan off the one chair so that Martha could sit down.

"I was going to ask you something, like, did you want to use our tools or something. But then I thought I may as well not pretend. You don't mind. I just need someone to talk to." Her voice caught, she was close to tears.

"No, it's fine, it's okay, go ahead." Sarah put out a hand and Martha took it, but only for a moment.

"I've left Molly sleeping, but I guess I could even hear her from here if she cries. You're sure you don't mind? Look, I'm not usually like this, you must think I'm nuts. It's just—"

"Go ahead," Sarah said again. She looked at Martha and guessed. Yes, that would be it.

"I just found out I'm pregnant. And I can't be pregnant. I mean, we decided not to have another kid, not yet, because we haven't the money to get a bigger place. I don't know, I just feel way in over my head. I'll be okay in a minute. Hey, I'm sorry. I just had to tell someone, I felt so bad, I saw your door open, you know?"

"It's okay. I'm glad you came. Hey. Sit down. Does Tom know?"

"No. He's going to sea for three months. They're going to the Mediterranean. His ship, I mean. He's down there now, they're getting ready, they'll be off, oh, next week, most likely."

"What do you want to do?" Sarah asked her after a small silence.

Martha cried then, hard, like a sudden rain shower. She dragged

pieces of tissue out of her shorts pocket and blew her nose, then began again. Sarah watched her. She thought, this is what it's like to feel something, to know how you feel. As the small pieces of tissue made their soggy pile beside her, she reached into the bathroom for a roll of toilet paper, tore off a long piece and handed it to Martha. The little house seemed to shake around them, the fan juddered on its unsteady base, a twig flicked back and forth at the jalousies, the door swung as a breeze picked up, a breath of air before evening.

"Martha?"

"I just want it not to be happening, I want to go back to how I was, just a sailor on a boat, you know, oh, of course I want Molly, how can I say that, but you know, it's like, too much altogether." She wiped the tissue across her face, scrubbing it dry. "It's the money. It's only having a tiny apartment. It's having to pay someone to be with Molly when I go to work. It's everything piling up, the way no one can find anywhere to live, the price of everything, the way Tom has to be away for months just to make a living. I just feel like I can't take it. I know, people have babies on boats, in shacks, all over the place, even here. The place we live in is like a tree house, it's that small. I mean, a small baby doesn't take up much space to start with, but as they grow, you know, they need space. I already feel like I can't turn round up there. If my belly stuck out, I'd just hit something. And we had this conversation about moving, so many of the Conchs have moved out of here already, you know, gone to places like Ocala, Clearwater, up in Florida. But Tom won't move. He's done that, and come back here. He says, this is where he was born and he'll see all the second homeowners in hell before he moves away. But it's hard."

"So, you'd want the baby if it was all easier? I mean, you don't want an abortion?"

"You know, I don't think so. When I first heard, I thought that was what I wanted, it seemed like the only way out. Now, I don't know. I guess I can live with it for a couple days, just think it out. I don't want to tell Tom, I don't want him thinking about it all the way across the Atlantic. He'd be against an abortion, I just know it. But you know what, I think it's my decision."

"So do I," Sarah said. "How far along are you?"

"Oh, a couple weeks. I just found out today. It must have been right around the time of the hurricane. You know, I hoped that was going to change things. I mean, more than it did. I hoped it would kind of sort things out. I think people had that feeling about it, you know, that things couldn't go on the way they were, life just getting harder, everything being to do with money, so if you don't have any you're just nowhere? And it did kind of change things. Look at me, pregnant, and look at your house, a mess. But not enough."

"You mean, you wanted a kind of apocalypse?"

"Is that the word? I guess so. But things don't work out that way, do they? It just gets dark, and you can't find your diaphragm, and you hope for the best, and next thing you know, you're up the spout."

"Hmm." Sarah, to whom it had never happened because she had never made it possible, felt an inexplicable movement of her own gut.

"There's something about working as a sailor that I miss, you know. When you're a deck hand, you just do what you're told. The captain makes all the decisions and all you have to do is the best you can. In the rest of life you have to be responsible for everything. It's too much. I wish I could just go back to working on a boat, sometimes, and being plain old me."

Sarah said, "It sounds easier than the rest of life."

"Yeah, you just have to go on watch, and then at a certain time you're off, and someone else takes over. But you know, it's steering that boat I miss. You just have to hold a course, and it's like riding a huge horse. The ocean, the stars at night, the wind, and you holding that wheel, keeping her on course. That, I miss. Hey, thanks, you got me thinking about something else."

"I didn't do anything."

"No, but you were here. Now I'd better go, or Molly will wake up. But you know, you could come over, in a while, if you wanted. Is that the only fan you have? It's hot in here. Why don't you come on over later and we could have a drink?"

"Sure, I'd like that."

"I'll get Molly fed first. See you later, then." And she went, leaving Sarah imagining a ship in a high wind and seas, and Martha, or someone like Martha, struggling to hold the wheel firm between her two hands.

LATER that evening, Sarah closed her door behind her, passed the rusted truck that was parked up next to the apartment house next door, and ducked under areca palms and bending aurelias to push through the gate leading to Martha's place. She walked up the wobbly wooden staircase and arrived on the deck. Molly was sitting naked there in a construction that looked like a lobster pot, a wooden spoon in each hand, her belly in ripples like a Buddha's. She let out a little shriek and waved her spoons.

"Hi, sweetie," Sarah said, and the baby stared at her, then rolled her head on her creased, fragile neck where the skin was so soft, so hidden, and smiled. "Hi, baby." Martha came out on to the deck wearing a sarong, her hair wet in rat tails, beads of moisture still on her brown shoulders.

"Just been taking another shower. Hi. Sit down, what can I get you to drink?"

"What do you have?" Since being in Key West, Sarah had realized that a drink didn't just mean alcohol here, but was often simply the necessary liquid to keep one alive, preferably with ice. People offered each other glasses of water as if it were wine.

"Well, I'm having Chardonnay. It's cold, I had it in the freezer. May as well, while I can."

"Okay, I'll have some too. And a glass of water."

"Of course, a glass of water. D'you believe this? It's still hot as hell out here, and it's nearly sundown. I thought we were getting a bit of a breeze at least. But this sky. Have you ever seen anything so pretty? It's been like this every day since the hurricane. It's like it cleaned all the dust and clouds away."

They sat and watched the sky darken over the white graves in the cemetery at the back of the house. Martha clinked her glass to Sarah's. "To good neighbors!"

Sarah clinked back. "To good friends." It was one week since she'd driven here down US 1 to find her inheritance.

Martha gave the baby a crust of bread to chew and a little plastic cup. Then she turned her solid damp shoulders back to face Sarah, hitched at the knot in the sarong above her breasts and said, "Well, why don't you tell me your story now? It's your turn."

"What d'you want to know?"

"Anything," Martha said. "Anything you want to tell me."

"Can I tell you a story from a long time ago?"

"Anything, I said. Anything you want." She leaned back in her plastic chair, tanned arms behind her head, damp hair in curls upon her shoulders, the shadow of slight fuzz in her armpits, her face so broad and peaceful.

Sarah breathed a long breath out, turned her cold wine glass in her hand, and began to talk. "As I said, it all happened a long time ago. But it seems to have come back into the present, I'm having to deal with it all over again. I was young. I was twenty, only a kid. It was in France. I was a student there, and I met a young man, another American, and we fell in love." She spoke into the gathering darkness, into the leaves, and the thick pink dusk over the graves, and the moon of Martha's face, and the rolls of flesh on Molly's stomach, and the time they were in: this evening, this place, an island where both came together, space and time.

"The reason it's come back to me is that I have just met him again, this man. He lives on this island. But what I have to tell is that I let him down, and not just him. I think I loved him, as much as I could. But I was scared. I ran off with his friend. In those days it seemed that you could do that, and get away with it. There was a third young man, and I was hardly aware of him, but I think he was in love with me, what we called in those days, in love. We thought love could be spread over several people, that it was endless, and could be almost endlessly shared. It sounds very arrogant, even boastful, to say that three men were in love with me. Probably it was just that I was young and blonde and all that, and I was the only girl there."

Surely, she had never talked this much, this easily about that time.

"Imagine, a girl in a tiny skirt, with long blonde hair and dark glasses, hiding who she really was, and three young men lounging around her. We were at a table outside a bar on a long street shaded with plane trees, in the south of France. The Vietnam war hadn't even happened, or at least, America wasn't overtly in it. All the young men were going to be involved in it, though. Their names were Jim, Patrick, and George. George was the one who killed himself. Or we think he did. He jumped out of a top-floor window and fell onto cobbles below. There was an inquest, and they said that the balance of his mind was disturbed. One of the other young men went off to war, he was drafted as soon as he went home. The other was in the military already, he stayed in Europe."

"And the girl?" Martha breathed, a question hardly voiced.

"She went back home and got on with her life. She put it all behind her, or tried to. She worked. She traveled. She married, and then got divorced. She didn't have any children. She had…" Here Sarah's voice cracked on the words, in the darkness, in the silence, in the beam of Martha's attention. "…a hard time finding happiness in life. It seemed to be hiding somewhere. It somehow wouldn't come out."

"And she was you."

"Yes, she was me. I was her. I was numb, pretty much. Things happened all around me, and I didn't know how to react. But now, I can't be that way. I can't do it again."

"And this man, the first man, is actually here, in Key West? That's amazing. That's really amazing. Have you seen him? What's he like?"

"He remembers me the way I was. I can't remember him the way he was anymore, that picture's gone. I had it in my head before I met him, clear as anything. But now I'm afraid that what we see in each other is just the memory, of being young."

"Does he still love you?"

"He says he does."

"What are you going to do?"

"I don't know. Probably nothing." She took a mouthful of the wine, which was no longer cold but woody-tasting, flat and tepid

against her lip. "Like you, think about it for a while. He's married. I can't break that up. I have a life in New York. You know, a real life. This one feels like make-believe by comparison. I have this little play house, this wreck next door, and here I am, playing at doing it up. I'm thinking about a man I haven't seen for nearly forty years. It's like being in a time warp. Am I really here, what am I doing here, you know, all that."

Martha said, "You know what I think? People come down here to play, and if they stay, they have to get serious. It's not Disney World. Do you understand what I'm saying? It's not like a theme park, where rich people can come and play tourist, play fisherman, play sailor, play whatever they like; because sooner or later, something real will get them. People get into accidents here, they go bankrupt, they get sick. Storms happen. Know what I mean? It's real life, and if you don't realize that, you'd better leave. I don't mean you personally."

"Martha—"

"You can't just be here one minute and then fuck off back to New York. The real world, people say. The real world is where you live, that's what I think. You can't be just here for the nice weather. You know? I want a friend who'll be here when the storms come in, when it's not nice, when it's damn hot and the air's not fit to breathe and you can't get any fucking ice in your drink. Sorry, Sarah." She went to pick up Molly and hold her close, flesh to damp flesh. She looked at Sarah over the baby's head. "I've said too much. I usually do. I mean it, though. It's not personal. It's just where I am."

"No. No, it's okay."

"Here—hold her a minute?" She passed Molly down to Sarah, her unfamiliar, surprising weight, her dampness. The child sat on her knee, unperturbed. Sarah looked down again at the white creases in Molly's neck, under her fine hair. She wanted suddenly to kiss her there, to breathe in her scent. Her nose just above Molly's head, she breathed in the hot sweet smell of her, peach only slightly spiced by urine. This was what a person was like before anything bad had happened to her. Then Martha came back. She must have been to take a pee; but later, remembering the sudden weight of the baby on her lap

as she was left alone with her, Sarah thought, so that was the message: there's nothing more real than a baby, is there, there's nothing more present.

AT night here, the frogs croaked in the undergrowth around her house. Cra-a-ak. Sarah lay awake. Only feet away from her, Tom and Martha and Molly in their tree house, with its platform floating above moonlit graves. Above her, a broken roof, then the stars of the southern sky. All around, water. The warm salt ocean, sloshing in and out in the dark, night after night, its changing tides. She felt like an island herself, with the tug of what was outside her. Tides in the night. A life, brought here to be resolved. People awaiting her, expecting things of her, pulling her in. She could leave, tomorrow; just get in the car and drive back north, with the house put on the market. She was used to it, just moving on, it seemed to be what life was, moving on from one thing to the next, a succession of years, a line leading somewhere else. She imagined leaving. In the street, among broken branches and huge machines sweeping up debris, two little figures, Jim and Martha, Martha holding Molly in her arms, watching her go.

Then, with the thought of leaving, came the image of her house, the way it had been when she found it. It could not go back to that state. Someone must live in it. Martha, with her babies. Martha and Tom and Molly and the other one, whose future was in the balance. Sarah got up, wrapped herself in a sarong like Martha's, and walked barefoot across the floor that was full of holes and cracks to her little kitchen. The idea came to her as she stood, arms folded across her breasts, waiting for water to boil for another cup of herb tea to help the dawn hours pass. Outside, there was a faint grayness, a beginning of light. Steam rose from the pan on the stove, water boiled, she filled her cup, breathed in the scent of dried flowers from somewhere else that was oddly similar to the one of Key West streets at the moment, and held the idea in her mind. She would give the house to Martha. There was a cleanness to this thought, cleaner than renting or lending or some other half-measure. Her own life seemed to her now to have been made up of half-measures: leaving, not staying, promising love

where it could not be fulfilled. Going back to what was safe. Leaving France, then Morocco; leaving a marriage, a love affair, a place full of friends; moving, always moving on. The only continuity was her work. It was listening to what the world said, analyzing it, writing it down. For so long a lightweight, a person blown on any wind that came; now she wanted weight, substance. But not through owning: through giving. To weigh through giving. Like being a mother, like having a child, passing on what had to be passed on, for the world to continue. She stood with her steaming cup and watched the light increase on the street, and heard the first roosters' shout and the coughing start of a car. A new day, another day, in her life which was passing without leaving any trace, except for words on paper that would be read and then thrown away. A few thoughts, ideas strung together, others' words repeated, her legacy. Johnny had thought about her as a daughter, passed on his house to her so that she could live her life. Had he imagined her living here, settling down? Probably not. His gift had been two-edged: a chance to keep the house, a chance to pass it on. But the hurricane, or whatever this disturbance in her life was, had moved things along, and Martha had come to her door. It was already time.

She went back to her mattress with its mess of sheets and sat sipping her tea. She felt old, older than usual. But it was not an unpleasant or frightening sensation, just calm.

12

JIM SKIPPED DOWN THE PORCH STEPS past the heaps of Pearl's stuff and walked down the street beside the piles of cut logs to the corner, to pick up a café con leche at the Cuban grocery on the corner. The yellow diggers rested at the sidewalk like sculptures of dinosaurs. The town was still full of the machinery from upstate; it still had the look of a stage set, with everything being moved around. He'd been up since five, thinking about what to say to Charlie Flaherty, who was in the hospital. There'd be a funeral; Charlie was dying, knew it, it was why he had done what he'd done. The thing was, how to integrate that fact into some kind of eulogy, that could be spoken at an open grave, later in the week. The thing was, to be at Charlie's bedside in time, to behave like a human being. It was also to forget about Susan, just for the moment, to put that fact on the back burner, and not to think about Sarah, and not to worry about Pearl and what the parishioners were saying about the heap of old clothes so visible on his front porch and the woman nesting in among them. It was to do one thing at a time. If he did this, focused his mind, he might get through the day.

A good man, she had called him. But where was the evidence? What did she see in him? How could she know?

"*Buenos dias, José.*"

"Good morning." They always did this, speaking each other's language, so Jim's Spanish never got much further than a greeting. José slid the styrofoam cup down the counter. "Any bread today?"

"*No gracias.* Just coffee, is fine. A big con leche, one sugar."

"Don't forget to eat, friend. Come back later, I'll have *bollitos* and a good *sopa di pesce*. You don't eat. Your wife still away?"

"Still away." He joked, "So, looks like I'll be relying on you, José."

"You do that. Here, we eat well. Cuban men, our wife never go away. Always here, always here." He winked at Jim, pulled a face. Jim shrugged and grinned. It was little exchanges like this that got you through the day, he thought; people with whom you could simply be an easy fraction of yourself, trade a joke, a greeting, and move on.

CHARLIE Flaherty, an old friend, had robbed the bank on Southard at gunpoint only yesterday. He'd taken the wads of money and given them away to the poor and homeless down on Higgs Beach, and then given himself up to the police. Django Boone, who'd been at school with him way back, was the cop who actually slid on the cuffs when they took him away. Out at the Monroe County Jail, he'd collapsed. He was close to death, already, and they shipped him across the road into the hospital, where he was now on life support. He'd always wanted to rob a bank, he told the press before the police van took him away. He'd made sure to do what he wanted before he died.

Jim drove out there, sipping hot coffee from the styrofoam cup in one hand, steering with the other. It was early still and the road was quiet. He turned off US 1 and swung a left down past the jail, the college and the recycling plant, to the palm-tree planted hospital. To have all this on one street, one spit of reclaimed land, institutional life propped up on the fragile edge of wetland, where nothing but mangroves should be. Now there was a new bunch of condos stuck in between the jail and the dump, their windows turned resolutely out over the water. Paradise, we call it, thought Jim: how hard the concept dies. Ending your days staring out to the Gulf of Mexico, pretending you aren't living between a jail and a refuse mountain. What strange obsessed creatures we are.

He parked between torn palm trees and walked across the squeaky floor in the hospital towards Intensive Care. He'd been here so many times before, hearing unasked-for confessions, praying over bodies which had never spoken in prayer in their lifetimes, his arms around

people he'd never see again, eyes used to the sights—the IV drip in the wasted arm, the shrunk brown flesh marked with tattoos, the pasted-over wounds, the faces twisted with pain or grief. It was like a continuation of what he'd grown used to in the war. It was what he had discovered he could do.

"Charlie Flaherty?" he asked a young woman in raspberry scrubs, carrying a covered bedpan.

"Oh, him. Down there, on the left. I think you're just in time, reverend. He's not gonna be with us for long."

Charlie was another of them, the vets of his age scattered gray-haired and wrinkled now across America. Who knew what Charlie had done in his lifetime, had seen? He'd been in Key West as long as Jim could remember, sometimes homeless, sometimes shacked up with some woman. They'd shared time on street-corners, outside Jim's house, lighting up cigarettes, wisecracking, slapping at each other and laughing, the way you did with someone whose past was like yours, only there weren't the words to say it. Charlie never did get why Jim had gotten religion, as he put it. Christ, man, he'd say with the vigorous use of that name that only the irreligious can manage, what d'ya see in it? Load of mumbo-jumbo, ain't it? Still, if it gets you a house and a nice wife, who'd blame you? Got yourself a good billet, eh, man?"

Under the wires and tubes, lying still with his tan only just draining from his face, life going out of him, the low tide of it showing deep fissures, clefts, protuberances, scars and moles, Charlie Flaherty. Who'd done the one thing left that he wanted to do, and damn the consequences. Who'd taken money, wads of it, out of a bank in the middle of the afternoon and handed it out in green handfuls to the people down on Higgs Beach and Simonton Beach and under the trees in the little park off White Street. Who'd made a brief difference, redistributing wealth. They couldn't do anything to him now, he'd known that. There was no point in throwing him in jail, there was no punishment to fit this crime, nothing that could be meted out. He was beyond human justice, he was his own justice, his own system, his own man. Jim sat down next to the bed on the chair offered. The

man's face was a whole landscape, revealed. This body had been a boy's, unmarked; it had been started on in boot camp, shipped out to Vietnam and worked on there, and homelessness in the sun of South Florida, wind and heat and salt had done the rest, along with booze and cigarettes, nights awake in the open, nights buried in the flesh of women. It was the story of the lives of men of his generation. Jim, his head bent at the bedside as if in prayer, let tears slide down his own cheeks, didn't even bother to wipe them away.

The raspberry nurse came back and said gently, "You know, we tried. But he's too far gone. It won't be long now."

He was far gone. Gone to a far country. Missing in action. POW/ MIA. One of the hidden, maimed, forgotten ones. Sent home never to be spoken of again, never to be counted. Who'd ended his life, as he'd been taught, with an action. The man who robbed the bank and gave the money away, because where he was going it was useless, it was not even currency. When Jim began to pray, he prayed for the easy passage of Charlie's soul, where nothing had ever been easy before. Then he saw a flicker of something, like leaves just moving in a wind. It passed across Charlie's face, shivered in the big hands that lay upon the sheet, and was over. It was life. Once again, it was life, leaving, shuddering through a human body and away.

He walked out of there after he'd sat with the body, feeling the room empty itself; once again, the fact of death, somebody lying there who was not himself yet was part of himself, a fellow participant in life, and then that somebody gone. There would be a gap where Charlie had been—on the street-corner at sunset, at midnight, on the benches by the beach. In life. There'd be a hole in life, another one. He drove his car, hands burning on the hot plastic of the wheel, feet bare on the controls. The morning was another hot blue blazing one, no hint still of cloud or rain. He thought, I can't go home, not yet. He parked at the roadside, stared out over the blue-green water of the Gulf. He needed to be with someone, a friend who would understand, without saying too much, who would shoulder some of this with him, as men share shouldering a coffin, carrying life on into death. He would go visit Rick.

He stood outside, in the sun on the deck, after a bell had rung deep in the house; this house which had depths, solidity, the breathless quiet of money. Rick Hanley lived on Key Haven, where the rich hung out, their villas and swimming pools and new cars arranged for their comfort. Richard Hanley he was now, but to Jim would always be Rick, even if now he was a surgeon and lived in this fancy spread.

"I know, I should've called, could've called you from the hospital, but hey, if you'd been out, that would have been okay."

"Come in, Jim. It's my day off, as it happens. I've a golf date later, but now is all yours."

The hallway was quiet, cool, padded somehow. He went further in, Rick following. Beyond cool rooms, outside big glass windows, the Gulf of Mexico in today's sun.

"Drink? Iced tea? Damn, it's a hot one. Have you been here all through it all? You look done in."

"Yeah, I've been here. And if 'it all' means the hurricane and its aftermath, yeah, been here, done it. Rick, Charlie Flaherty died this morning."

"Hey, I'm sorry." Though Rick too knew death up close, though the two of them often enough met at its bedsides. "I heard about the shenanigans down at the bank. What a way to go, eh? I guess he knew he was dying. What was it, cancer?"

"Yup. Strange, isn't it, how a person can keep going while they still have something to do? Rob a bank one day, die the next. I've just been to see him. He died while I was there."

"Jim," Rick put a hand on his shoulder, pushed him down on to a soft leather chair. "I know, it doesn't get easy, however often it happens."

He knows why I've come, Jim thought. It's that link, between us. He knows that otherwise I'd never come calling on a surgeon who lives on Key Haven. Without it, our lives would have been too far apart. For Rick had been another one. In Vietnam, a medic, going in where the bodies were torn apart, trying to stitch them together. Later, in the eighties, he'd been in Rwanda. There, he had helped a man, one of the Tutsi tribe, die. He'd written this up and actually published

the article in a medical journal. Some of his colleagues had thought he should leave the profession. But he had survived, and now people who knew this strange fact about him—that one night, in the middle of a civil war, in Africa, he had given a black man medicine to help him die—trusted him with their lives. He needn't have told anybody, needn't have written that article. He could have kept the secret of that night, that only one nurse and he had to know.

"I guess I came to see you because everything's falling apart."

"I thought people came to see you because of that! Hey, I'm only a doctor. But seriously, man, spit it out. What's up? You need a buddy, I'm your man."

Iced tea in tall glasses on the glass-topped table. Outside, palm trees hardly moved.

"Until the golf game."

"Well, yeah, until the golf game. Never liked golf, did you? Pity, we could've played a round or two. What's going on, then?"

"Where's Beatrice, at work?"

"Yeah. I'm home alone. Why?"

Beatrice was a lawyer, with a firm in town. No wonder, Jim thought, that money flowed around them, a tide of comfort that was rocking him now, as he sat on the padded chair in the air-conditioned room and looked out over blue-green water, that very same water they saw from the condos, the hospital, the jail. The only sign of the hurricane here was in the palm trees, bent against the blue of water, and a hibiscus torn up by its roots out there in the space between house and ocean.

"Well, I guess I needed to see you alone. Everything's gotten kind of unmanageable. Susan's left me, for a start. I've got a homeless woman living on my porch. And someone I was in love with years ago has just showed up in town."

Rick clasped his hands behind his smooth gray-blond head and grinned at him. "Women, huh? And you a preacher. What is it that attracts them all to you guys? Hey, it happens to doctors too, but with us we know it's the money that pulls them. But let's take this one at a time. Susan left you? Why? What's the chronology here?"

"She left because of the hurricane, you know, when there was general evacuation. But it was a way of leaving me. Oh, it's been difficult for a long time, you know, our lives drifting apart, no sex, a kind of gradual separation that you don't entirely know is going on until it's done."

"Are you upset about it?"

"In a way. In a way, not. It's given me time to try and figure out who I am. It's opened stuff up. I mean, Pearl wouldn't be there if Susan was."

"Pearl?"

"The homeless woman."

"She isn't in love with you too?"

"Oh. No. No, I don't think so. She's just—there. I didn't know how to tell her to leave."

"And the other one? The one from way back?"

"Sarah. She was my first lover. In France, before the war."

"God, man, you've got yourself a tangle here. Well, look, you'll lose your job, won't you, if you take up with another woman? Isn't that a consideration? We're not living in the sixties now. Any whiff of anything sexual and we're out of here, all of us, whether we're in medicine or politics or the church, isn't that so? It's like left-wing politics and McCarthy. A touch of pink, and you're gone. This stuff they're pinning on the President, it's going to stick to all of us in the end. So, my question is, what do you do when the church puts you out of doors? Go sleep on the beach?"

"You can't sleep on the beach anymore, it's illegal."

"Well, the salt-ponds then. Whatever. Do you want to be homeless and out of a job at your age? The house belongs to the church, right? It's bad enough to have a wife who leaves, but you keep your Pearl on the porch and another woman in the wings, and you're in for it, man, you know that."

They sipped, and set glasses down on the table, leaving little rings of wet. Jim noticed Rick's hands, strong-looking, their clean nails. The signet ring on the pinky, blue stone on gold.

"Neither of them is my lover, Rick."

"They don't have to be, buddy. It's appearances that matter, these days. Like I said, just a whiff of it, and you're out of there."

"So what are you saying?"

"If you want to keep your job and house, get Susan back, any way you can, turn this Pearl lady off of your porch, kiss your other woman goodbye. Wake up, Jim, this is America, land of the founding fathers. It won't forgive you. Especially not in the job you're in."

"You survived."

"I know. I killed a man, and I wrote it up in all the medical journals I could find, and I stuck by my version, and in the end they forgave me. I'm not banged up in jail like Kevorkian, and I'm not on the streets. But the man I helped to die, which is how I prefer to see it, was an African. He was in a place nobody over here can even imagine, if they can even find it on the map. You think if he'd been American I'd be here today? Forget it. It was a crazy little war on a dark continent, and because of that people can forget about it. And excuse me, but it was a different thing from flaunting your sex life in a southern church. So don't use me as your excuse. Okay? I'm not as tough on you as I sound, Jim, but you have to clean up your act here, fast. The only way Charlie Flaherty got away with it was, he was going to die the next day. The rest of us, who want to live to tell the tale—well, we don't have that freedom. I know, it sounds hard. But we aren't kids, Jim. This isn't the flower-power, make-love-not-war sixties. We're going to be old men soon, and we have that to consider. Do you really want to be kicked out on your ass at your age?"

"I don't know. I guess I want a life, not a sinecure."

"You think this is a sinecure? You know how many people I cut open and stitch up again, how many I see day after day crying because they think they're going to die, the women who think they're going to lose their breasts to cancer, the ones who go home thankful because they just have a tiny scar, because I know not to butcher them, because I've worked at it, Jim, out there in Rwanda stitching together what couldn't be stitched together, because I know how to do the damn-near fucking impossible, and I do it, day after day after day? You call that a sinecure? You think I care about this house, this—all this?"

That still-boyish look he has, that well-kept face. But still. "You're kidding yourself too, if you think taking care of all the Charlie Flaherties, all the people who come crying to you isn't worth it. It's useful work. What are you going to do on the streets, when you're old and homeless and nobody can spare you a dime, and all the women don't give a damn anymore, what're you aiming to do then? Wise up. I'm telling you. You did come to me for some advice, didn't you, not just to give me your sob story?" Rick, with his hands behind his head; that blue stare. "Get with the program, buddy, before it's too late. And don't give me that shit about sinecures versus a worthwhile life."

They sipped their cold drinks from the beaded tall glasses. It was time to go; Jim saw Rick glance so surreptitiously at his watch that it was obvious he did this all the time. The appointment was over. He'd had his lecture.

"Go well, buddy," Rick said at the door. His hand on Jim's arm somehow precluded a hug. But he screwed up his eyes in a grimace of affection, exasperation, old-friendliness, or some mixture of all three, and moved his mind on to golf. "Take care."

"You too," Jim said, although there was no reason he could see for Rick to need to take any more care than he was already taking. He looked like one taken-care-of man. And he thinks I'm a pain in the butt, Jim thought. But we go back. And Rick knows this, he remembered. It's why he stood at the door a moment letting the hot air in to his chilled interior, watching Jim walk to his old car and wiggle the handle till it opened. That, and Jim knowing what he did, back in Rwanda, that other war zone, and appreciating him for it.

SALVATION, Jim thought as he drove home from Rick's, slow in the traffic on US 1 that was now nearly back to normal. That's what it's about. You save someone else, or you kill them to save them from a painful death, and your own safety is immediately at risk. You let someone sleep on your porch because she's going to be roughed up if she sleeps anywhere else, and you end up scared to go back to your own house because of what people will think. It's impossible. You act

from love, or fear, or expediency, and it comes to the same thing in the end. None of us is whole.

He saw Charlie's face still, the flesh like ropes between the deep scored lines that life had drawn on him, the big hands curved empty and upward on the sheet. He'd given some people money before he died. But if he'd lived, he'd have stayed in jail. You didn't get away with that kind of stuff, not if you were among the living.

On the way back into town, he slowed and turned into the shopping mall across from a line of palm trees and the Gulf waters, to see if there was ice. In the emptied aisles of the big Publix, he saw armed National Guard soldiers, in camouflage, with rifles cocked. They were guarding the freezers full of ice. He left without even trying to get any. If they were so afraid of people—what, stealing ice, rioting, killing each other for it?—then he would go without.

He parked on the street, behind one of the huge trucks in which lopped branches were piled. He walked up to his own porch. She was there, as she often was not in the daytime: Pearl, who was not supposed to be there, who must go.

"Hi, Jim," she said, perky as she bustled about, tidying her little camp. "How are you?"

"Not great. I watched someone die."

"Oh, dear, oh poor you." Her face squashed into its center as she frowned her concern. "Of course, that must happen a lot in your job. Was it someone you knew well? I've never seen anyone die. I've seen a dead person."

He didn't want to know who, or how; so didn't ask. "Pearl," he said, "I have to ask you to leave. I know I've asked you already, but this time you have to go. You can't stay on my porch, the parishioners are starting to notice. There have been complaints."

"Oh, Jim, I know you must be upset, with having to watch someone die. I'm so sorry. Why don't you go and lay down for a while? Then maybe we can talk later?"

He went into the house and banged the door behind him. She'd done it again, ignored what he said, manipulated him into giving in. He thought, I'm going to have to get garbage bags and put her stuff in

it myself, and throw it out, I'm going to have to put her on the god-damn street. The phone rang and he didn't go to answer it, but heard his own recorded voice on the answer-phone in the other room, and a lighter, probably a woman's voice leave a hesitant message.

I can't deal with it, he said, whoever you are, just give me a break, just fuck off and let me be. At least Charlie Flaherty did the one thing he wanted to do before he died. At least he knew what it was. Jim flung himself down on the couch, his hand went to find the remote, he switched on daytime TV, some stupid soap without the sound, heads mouthing at each other, mouths glued in kissing, a hand slapping a cheek in rage. Then he switched it off and watched the blank square for a moment.

"Jim?" It was Sarah's voice. "Pick up if you're there?"

He lunged across, grabbed the telephone with one hand, rolled back on the couch with it held to his ear.

"Where've you been? I've been trying to call you."

"I had to go to the hospital. Someone died. I'll tell you later."

"Oh. Oh, okay. Want to meet later? "

"I'll come to your place, if you want."

"No, I kind of want a change from my place."

"You should've stayed in the hotel."

"Jim! What's up? Why that tone of voice?"

"What tone of voice? I'm bushed, that's all. Been having a nap."

"Oh. Well, look. Meet me somewhere. How about at the Bight somewhere, then at least we can sit by the water."

"Okay. Turtle Kraals, know where that is? I'll see you there at five."

"Okay, bye," she said in that quick New York way of hers.

"Bye." She would go, she would leave him, and he would beg Susan to come back, and Pearl would be out of here with all her ratty stuff, and everything would be back to normal. He lay back on the couch, and the taste in his mouth was of ashes, or metal, and he felt as if his life, the new strange life he'd had since he first found those birds in his church, was gone. There'd been a chance for something else, God only knew what, and now it was too late. Too late, too, he remembered that tonight was his Bible study class in the parish hall, so he'd

only be able to spend an hour with Sarah. Perhaps—ashes, metal, dust—that would be enough.

WHEN he saw her waiting for him, her face turned away, her gaze out over the water, he thought how eccentric she was, how odd. That cap of graying hair above her almost childishly pure face, the arch of her eyebrows as if in perpetual surprise, the clothes she wore, a shirt, pants, boyish only not, because her bone structure and her movement inside them were so feminine. The girl she'd been, skinny in her tiny skirts and faded blue jeans, was still here, in her bones, even her skin. Only the hair, that bright fall he remembered, had gone. He saw her before she saw him, her eyes on the pool where once turtles had been kept in captivity, her hands under her chin and her face in repose, and he wanted that moment to go on, so that he could watch her in her aloneness and not be seen. To give her that space, that time, before he broke into her thoughts and view.

"Jim," she said, with her peculiar vehemence, that little explosion of consonants. His name in her mouth, what he wanted to hear, over and over. He sat down opposite her at the rail of the turtle corral, at the bleached wood of the little table. Look, here I am, what else can I do? A young waitress in cutoff jeans and a tank top stood very close, told them it was Happy Hour, asked what she could get them. Sarah ordered a cold beer, Jim iced tea. Down in the green murk of the water a long fish moved closer.

"Look, a tarpon. People feed them, that's why they come."

"Doesn't anybody catch them?"

"Out there, yes. Not here. But you can't eat tarpon."

"What's that thin one, down there near the bottom?"

"That's a barracuda, a young one."

"Are there sharks here?"

"Out on the reef, sure. And they come in closer, sometimes, they like the warm water. They're nothing to be scared of, though. They'd be more scared of you."

"So much I don't know, about being here."

"Well, I guess I've had time." Twenty years, more, since he'd first

come to this church, this community, with the taste of the war still in his mouth, the stun of its noise in his ears.

"You never told me. Why."

"Why what? Why I came here?"

"Any of it. The church, here, Susan. All the things that make up your life."

"I went to seminary when I came back from the war, I guess because it was the only place left. I didn't believe in anything, but I wanted to. So I prayed for belief, for faith, and I got it. Belief is only trust, really. You don't have to know anything for certain, it's a decision, to trust rather than not to trust. I was a mess. So I began again, from the bottom up, starting with the smallest building block there was. A tiny decision, to trust something."

"So, it worked?"

"It does work, Sarah. I still have bad times, but I never have to go back to the place I was in. I razed all my old structures. I began again. The only thing is, now—"

"What about now?"

"I didn't mean to say this, not today, but it seems to be happening again. I'm not nuts, don't look at me that way. But since the hurricane, since Georges, nothing has been the same. I'm clinging on to something, I keep going, but I'm not sure that it's going to last me."

"Since Georges?"

"That was the name of our particular storm. They get names when they're over a certain number of miles per hour."

"But Georges was George, too, in France, remember?"

"So it was. So he was. Yeah."

"Don't you think that's strange?"

"It's a coincidence."

Sarah looked at him, very straight, her eyes gray-green like the water below, but clear. Her thin brows arched high. He wondered if she drew them on, these days. Her hands clasped in front of her parted when her Heineken arrived in its frosted bottle with a plastic glass at its side. She said, "I should leave. It doesn't make any sense me being here. It's a dead end. My real life is in New York."

His stomach lurched. "Why? Why do you suddenly want to leave? You've only just come."

"I don't belong here. I had a conversation with my neighbor today that made me see that."

"Anybody can belong here, who wants to. It's one of the most open places in the world. People come here all the time, fall in love with it, and stay."

"No," she said, "you have to be really here, not just on vacation, not just playing, that was what she made me see. You have to take it seriously. And I can't, my life is elsewhere."

"What are you going to do with it, then, sell it?" Their talk, which he had imagined peaceful, noncommittal, which he had wanted this way, was charged and full of implied threat, it seemed to him. It was always this way with them. Nothing could be easy. He looked away from her, over the water, to the pelican perched on the post, the island beyond with its dark trees bent by wind.

Sarah said, "Give it to my neighbor. She needs it far more than I do, and her husband is able to fix it up."

"You can't be serious. You can't give away a house."

"Oh, I am. Why not? It was given to me, I can pass it on. Is this the Bight that Elizabeth Bishop wrote about?"

"I don't know. It must be. She lived here for a while."

"D'you know what she said about it? Awful but cheerful. All the something activity, awful but cheerful. I always thought it such a strange, brilliant end to a poem. She wrote it on her birthday. How wonderful that it was here."

"You can't just give your house away, Sarah."

"I can do what I want with it. Anyway, don't you think, the rules have changed? The rules of property? If the wind can blow everything away in a few hours, I can give my house away too. D'you know, 'The Art of Losing'?"

"No."

"She wrote it. 'The art of losing isn't hard to master...'"

Elizabeth Bishop, losing, giving houses away: what reality did she live in? Then he thought of Charlie. And of what Rick said. We who

have to go on living can't do it, we have to think of ourselves. That. Something like that. "Okay, sure you can give it away, if you want to. But think before you do it. Be sure it's what you want."

She said, "I'll tell you why, if you want. It isn't pure altruism. I've never in my whole life done something big for someone else. I want to do it while I have the chance. It's an opportunity. I've taken from people, I've had what I needed, materially, anyway. I didn't need Johnny to give me this house, but I do need to pass it on. Martha and Tom really need a house, because she's pregnant, she's going to have another kid, she told me. I'll never be a mother or a grandmother, Jim. I'll never be asked to give in that way. So, I have my reasons. See? I haven't said anything to them yet, so don't you spill the beans."

"I don't even know who these people are, so how can I?"

"My neighbors, I told you. Now, do you understand?"

He looked across at her, there was nowhere else to look, whatever Rick said, whatever was sensible. She stared back at him as if she were being interviewed, hands on the table, palms down. The waitress came back to ask if everything was all right, and did they want something to eat? They blinked up at her, disturbed. Yes, everything was fine.

"I just want to say one thing," Jim said. "I don't want you to go. That's why I was being mean about the house. I don't want to lose you again."

"Well, even if I go, I'll still keep in touch."

"That isn't what I mean. Keeping in touch isn't it."

"Well, what is it? What can 'it' possibly be?"

"Something more. I don't know. Forget it. Hey, I can't stay long, I've got a Bible study class tonight."

"Bible study?"

"Yeah. I have it on Wednesdays." He saw her glance: how could he believe in that stuff, those old stories? But she made no comment.

She only said, "Can we meet afterwards? Come to my place. It's probably the best place to talk. As you have Pearl, and preachers aren't supposed to have too many women in their rooms, are they?"

"Okay. About nine?"

She was watching the pelican that sat on the post nearest to them, in among the masts and wrapped sails of boats. The pelican looked down its beak, little dark eyes close, stretched its wings, shook water off them, wrapped them tight again. "They look like old men, don't they? I know, they look like Leonard Woolf."

Jim thought, if I lived at her side, I would never be able to guess what she was thinking. Leonard Woolf? But, I want that daily mystery, to be enchanted, to be kept guessing, to have her turn to speak with that bright glance, that quick movement of her head. To hear her say that she'll give away houses, change lives. To be part of that momentum, that will carry me further than I can ever go alone.

13

HE WALKED TO HER HOUSE LATER in the darkness of the side streets around the cemetery. Not the total bible-black nights of after the storm, which had reminded him of his country childhood, but a tempered, yellowed, street-lamp-spotted darkness, in which he still had a shadow. The air was cooler, with a slight breeze. Clouds covered the moon and stars. At last, fall was coming, the brief season of it here when you noticed the air cooled at night, a freshness in the morning. He skirted the cemetery fence and walked up the narrow sidewalk of her street. The house next door—those neighbors, he supposed—was dark already. Perhaps the child was asleep, so the adults went to bed early too. The man, she had said, worked on ships. He wondered if he had seen them, if he'd know them by sight. At her door, which was slightly ajar, he knocked, knuckles on old scarred wood.

"Come in. How was Bible Class?"

"We talked about Noah and his ark."

"How appropriate. Do people still believe God is trying to wipe them out?"

"Some people see things as punishments. AIDS, hurricanes, even car wrecks. They think like kids being punished for bad behavior, I can't get it out of their heads. But the ark story is really about starting over, getting them all out on to dry land again and saying, go populate the earth. But more than anything, don't give up hope. It's about getting a second chance. I only had three people tonight, the same three old fogies that always come. They asked me if I thought the hurricane was an act of God."

"And was it?"

"It depends what you think God is, but that's a bit far out for them, they think he's still an old man in the sky with lightning coming out of his fingers."

"Like Michelangelo. I always thought that was the sexiest painting. Those fingers, reaching to touch."

"Sacrilege," he said, and came in. "But that painting is about creating, not punishing. They thought more about that in the Renaissance than about damnation. Damnation was out of date."

The low ceiling nearly touched his head, where it sagged down, soggy beaver-board dried now but distorted with damp. Sarah closed the metal jalousies with the turn of a handle. "For privacy," she said. "But we can always sit outside if we get too hot." A fan propped on a chair whizzed round, moved the thick air. Any coolness outside had not reached in here, where wooden walls were covered with swollen plastic boards and veneers and a limp curtain still drooped at the window.

"Yeah, let's go outside. I'll take these chairs out?"

The back yard was a jungle of aurelias, spiky areca palms, wild grass flattened by lounging cats. He set two chairs down in the grass. There was a scuffle in the undergrowth and the wail of a departing cat. Sarah followed with a blanket and a bottle of water.

"Did you hear, they say there's going to be another one?"

"Another what? Storm?"

"There's something called Mitch heading across the Atlantic. It's going to be a big one, worse than what you just had. Someone told Tom tonight, and he told me when I got in. They've been watching it on their computer. Sounds very butch, doesn't it? Mitch. Somehow I'd prefer one called Annabelle, I think. I just hope it doesn't hit here again."

"I'm not sure anyone could stand it again, not so soon. You know, everyone who stayed is still kind of in shock. I realized it tonight. We were in a disaster, after all. Everyone's lives have been touched. They're not the same."

Sarah laid the blanket out on the straggly grass and flattened the

clumps that stuck up beneath it. She lay on it, her hands behind her head, and stared up into the sky.

He left his chair and stretched his whole long length out beside her, not touching, his face turned up to where clouds passed quickly and the light between them was there and then swiftly gone. A small wind rattled the palm leaves. A door banged in the house. So now was the time. This was the place. Where it would all unravel, where he would put words to it if he could, where the one person he most wanted to tell would hear him. He had no idea what would follow from this night. He sighed deeply, lying there with his hands laced behind his head. A man on a tombstone, an effigy in marble centuries old; a man felled in battle; a simple body at last, with a true voice.

"I saw a guy die today, Sarah, he was one of us, a vet, you know; a messed-up guy named Charlie Flaherty. He died in the hospital, but only yesterday he was out there robbing a bank. They took him to jail, and he damn near died there, but they shipped him across the road just in time. He died having done the one thing he wanted to do, handed out money to the poor. I guess that was what started it for me, today. Thinking about Nam, where he was, and going to see another old buddy of mine, Rick Hanley, who's a doctor now up in Key Haven, big house, fancy furniture; but still, his heart in the right place. We were only kids when they sent us out there, that was the thing. Nobody knew really where we were going, what we were going to do." Breath, clouds, light, dark. "It's all so well known now, movies, books, there's been so much said about it, everybody knows, but still there's this fact. The men who were there. The ones who survived, and who didn't top themselves, or die of booze or drugs, well. We're stuck with it. Charlie, who people thought was nuts, and Rick, who made it in the real world, and me, and anyone you see sitting around in any VFW anywhere in the country, or even getting on with a job, making money, looking okay, we're all stuck with something we're never going to get rid of."

Her silence, thank God for it, that allows him to go on.

"We killed people, we shot them down in cold blood. We couldn't even feel it at the time. It's like being in a nightmare that can get you

anywhere, any time. I mean, I can't make you see or feel just how it was. It was outside any kind of reality that any sane person would ever imagine. So we're all of us alone, there's only each other. And people like Charlie are dying off because they've lived so rough, and people like Rick are operating on top of it all like there's this big mess of things underneath their façade that they're never, ever going to take a look at if they can help it. It's too much. It's too much for any human being. We were crazy, you see, stoned, drunk, out of our minds, and we were too young, and it was the things we did that hurt us this way, not so much the stuff that happened to us. Hurting others is worse than being hurt yourself. That was what we didn't know."

This night, time passing. A silence, a space in which to speak, at last.

"That's why I needed God so bad when I got out, why I mainlined on religion if you like. There had to be a God. If there wasn't a God, then we were doomed. We'd had it. I'd had it. I hung on like I was drowning, I see that now, and all I try and do now really is see when other people are maybe drowning, and try and throw them a lifeline, try and give them a hand out. I know you can't see why I believe in God. Hell, every time I mention it you get this look on your face, but you see, I had to. It was that or dying, spiritually, mentally dying. For Rick it was medicine. He was in Rwanda, he worked there in the middle of the civil war, stitching up people whose friends and neighbors had sliced them up. He went straight back in there, pushed his nose back in it, but he made a difference. Charlie, well, he dreamed of stealing from the rich and giving to the poor, and God damn, he did it, the day before he died. And what I can't explain, ever, is what makes people do the things they do when they're young and freaked out and in the military. Yeah, we were trained, we were trained like killer dogs. But the thing is, we were humans. How can we have forgotten that? How do we forget that so easily? That's what I'll never understand. Is it just part of us, is that what we are, animals, that can be trained to tear throats open? I think about it every day, and every day I come up against a blank, no answer, just this thing there like a

huge wave, coming for me, and I'm like someone trying to surf it, stay upright, ride the wave, and come out on the right side again. Over and over. Over and over again. Just riding the wave, staying upright feels like salvation. Did you see that shooting star? I haven't seen one in months. Some nights there are a whole bunch of them, one after the other. I used to walk the streets a lot, at night, and look out for them. What makes that happen? Are they souls, migrating? Who are we, us tiny little people with all this going on around and above us, and why do we find it so impossible just to live? Do you know? Do you know what I'm talking about? When I went into the church after the storm there were all these little birds, it was packed with them, and it was dark, all I could feel were these soft tiny movements, and all I could hear were the cheep-cheep of birds, and it was like I was a giant, an alien, coming into a world so perfect, so at rest, that all I could do was disturb it. But it was then that I felt something move on, it was change, it was a qualitative change, a shift, my life changing gear perhaps, I can't explain it. And then all this. This mess, this chaos. But something so harmonious at its center that I felt it everywhere I went and I couldn't believe other people didn't feel it too. And it didn't last, of course. I guess visions never do. But something was different. Something was new."

IT seemed to him that he had been talking for hours. Sarah had hardly spoken, only grunted her quiet encouragement as he spoke of coming back from the war, and the revulsion he saw on the faces of his friends, and the way nothing had worked after that; as he told of the drinking and drugs, anything to blot out memory, and then the day when he had known he was bottomed out, could go no further, and had called out for a god to appear.

"Can you conjure up God?" she asked.

"You can admit that you are helpless, and ask for help."

"And get it?"

"Yeah. Once I heard I could choose any God I liked, it was easy. Sounds very shallow, maybe. But it had not to be a God of judgment. I went back to the belief of my childhood."

"So it didn't have to be a Christian God? You could have been a Muslim, or a Hindu? Or worshipped a tree?"

"Really, yes. I mean, no, it didn't have to be a Christian God. Just someone, something, better than myself, and the world."

That was when, astonishing himself, he felt tears welling in his eyes and trickling down his temples into his ears. Sarah sat back on her haunches above him. Above them both, the white stars between clouds, and one planet that was large, pinkish, that must be Mars. One shooting star had passed tonight, sliding down the sky, as if it would land in the cemetery on the other side of the fence. The white blossoms from some wet bush above them shook down around their heads and smelled sweet and strong.

"D'you want to stay?" He heard her, but was surprised most of all to find his own ears full of water. It was what happened when you wept, lying on your back. She handed him some tissues from her pocket.

"It must be late. I've talked your ears off. I should go." Words reached back into the past and hauled it into the present. The person he had been and the person he was, meeting like gunslingers on an emptied street.

"I'm glad you did. You don't have to go."

He was passive, emptied, astonished. The sky above him scudded in darkness. Air on his cheek, the touch of wind. A softness on the wind, now suddenly the smell of rain.

She looked at him, smiled and shrugged and smiled again. He rolled to take her in his arms. Held her head against his chest and smelled her hair. His hands moved on her back, just slightly, feeling her fine bones, the wings of her shoulder blades, the knobby route of her spine. The smell of her, grass, damp earth, some trace of perfume, her skin beneath his nose as he sniffed her, hunted her to this point.

"It's not much more comfortable indoors, as you know," Sarah said, "but I do have a double mattress. Look, Jim, we're almost old. What can it matter to anyone but ourselves?"

He stood up with her, dizzy, a tall man limp as a puppet, all strings and joints. She put an arm around his waist. She only came up to his

shoulder, standing. He leaned upon her and she leaned back, so that they made a tottering but stable structure, two humans propping each other up. Then she took his hand and led him across the littered yard and into her house. Her hand was the size it had always been. He followed as he had followed her in another life. A siren wailed on a long up-down urgent note, as an ambulance or fire engine or perhaps a police car sped across town.

To go upstairs in her house you almost had to crawl, the stairs were so steep. This made them laugh and stumble, and when they fell onto the mattress together, it was easy. Then he was wrapped in safe darkness, with only a sliver of light sneaking in on him from the jalousie window, and he was pulling off his clothes as she did hers, finding his way back to a place that was both familiar and strange. A young man inside him found the way, an older man fumbled and was slow and scared at not getting there; the woman he found was not young, but he knew her, and when she touched him with the knowledge and patience of someone much older and wiser than he'd guessed, pulling him up with a sure hand from the depths of himself, he was able to move with her easily. She came seconds before him, her body knowing itself; they sang that song in unison. Then she laughed. She laughed with infectious giggles, rolling her head from side to side. Her laugh woke more memory, it was in a bathroom in France, where she sat on a bidet, he remembered, giggling. What was funny? Or, was it all funny, had it always been?

"I haven't done that for a long time. I wasn't sure I could." He'd felt some need to apologize. She could have been expecting the young stud he imagined he'd been.

"I know. Me neither." The snort of laughter, the wet lashes around her greenish eyes. "I'm not laughing at you. Just, two old buddies on a terrible mattress. Jim, wasn't that how we began?"

He couldn't remember the room, the circumstances. Just her slimness, the spread of her yellow hair, its texture in his hands, its smell. Her hair still had that smell, although now it was sleek under his hands, her head small. Had it been on a mattress on a floor? Probably, in one of those ancient apartments in Aix, with hexagonal tiled floors

and narrow windows opening over courtyards. He didn't remember. It didn't matter, to conjure it up exactly. Finally, it didn't matter. He was happy, with the present, where he was. Before, after, youth, age, it was all irrelevant. He lay on his back again and stared up towards the ceiling, across which bands of light played from occasionally passing cars.

"Jim? Do you really talk to God? Do you get any answers?"

"It's not quite like that. I talk to—someone. Or, something. It lightens my heart. I know that I'm not alone."

"I envy you that."

"Well, it isn't an exclusive club, you know."

"Yeah, but I don't think I could ever join it."

"It's enough to want to. It's easy. Sarah?"

His hand upon her, touch changed by lovemaking, a connection, an ease that wasn't there before. His fingers on her arm: the miracle of skin, and what passes through it.

14

PEARL WAS LIGHTING HER CANDLES. She'd stuck them
around the porch on various lids and saucers, some just glued on to
the wood of the rail by their own melted wax. She was doing it for
him, to make everything better. He needed it so, she could see. She'd
read about it in magazines, how in the cathedrals of Europe people
went in with reverence to light candles for their beloveds, both alive
and dead. Something about souls rising unencumbered to heaven,
something about sins forgiven. It was a beautiful picture. She'd seen
it, the dark altar, the banks of candles, wax running into smooth
sculptured lumps, dripping down like tears, the wicks with their shiv-
ering flames, the trembling of the air with the massed heat, the figures
in black on their knees, crossing themselves, heads bowed. She'd have
loved to do it in the church, only Jim kept it locked at night. But it
would be beautiful out here too, and it would be personal, from her
to him, she would be intervening directly for his soul. He was her
beloved. She would be saving him. She wrapped a dark scarf around
her head, sank to her knees. It was a pity that there were no pious
masses right behind her, chanting as her own humming voice led the
way. But she would just have to imagine them. It was easy, as she
swayed, as the candle flames swayed in the slight breeze, as the dark-
ness warmed and thickened, and the smell of wax melting came to
her nostrils, the scented candles, the pine scented, orange scented,
sharp lemon and gentle lavender. It was her entire collection of can-
dles that she lit tonight. She'd been collecting them for months, for
some really great occasion; and now this was it. She hummed what

sounded like a sacred tune, closed her eyes, saw the dart of red upon her eyelids, felt the candle heat upon her face.

He needed her intervention, she knew it. He was a soul in trouble, a tormented man. She knew she had been sent to protect him, it was why she was here, why she would not go away, however hard he tried to make her leave; she knew what she was here to do. His wife had left him, everyone had left him. He could not feel the force of her love, even though she thought of him day and night. When she wanted to read him his horoscope, he simply laughed. He would not be warned, or helped. But it was in the cards, it was in the code words in the newspapers, it was in the patterns of twigs, the way they fell, it was in the bird flocks that moved across the sky. She was a watcher, an interpreter, she was chosen, as guardian angels are chosen, she was a carrier of truth.

So she made her vigil, in among the lit candles, the guttering wicks and the flames growing tall in sudden gusts of wind, the dripping white wax, its hot tears. She felt the wind grow and the flames catch at things that had seemed to be out of their reach, and she saw the whole thing, her beautiful creation, grow and blossom, the red curls of it, the flowers of flame, smoke like wisps of cloud, sparks like fireworks, the sound of it all in her ears as her song grew stronger, as she shouted out loud to God, as she cried Jim's own name in the choke of heat.

LATER he realized that as he and Sarah made love on that mattress in her tiny back room bedroom, as they lay talking, his own house burned. As the second hurricane of the season made its way across the Atlantic, grew bigger and closer on all the computer charts, as he found his way back to Sarah, as the wind increased and banged over the rooftops, the house where he and Susan had lived, only streets away, burned. Nobody could find him in it. The fire chiefs went in, dared smoke and falling timbers to hunt for him. Neighbors came out on to the street to watch and told the firemen they were sure he was there, the Reverend always slept at home, although sometimes he did stay out late. Nobody had seen him today, though. The firemen, going through the house, banged doors open and hosed walls

down which only recently had been sluiced with rainwater. It was why more of the house had not burned. They found one person only, a youngish woman crouched and trembling outside the house, her hands and arms blackened but no burns on her, and a furious screeching cat which took off into the bushes. Pearl lay wrapped in a red blanket in the back of an ambulance, picked up off the sidewalk where a sudden blast had shot her away from the burning house. Nobody could find hide nor hair of the preacher, who should have been here in his blameless bed.

THE hard rain came in the early morning, before it was light. Jim woke to hear it still beating on the tin roof only feet above his head. A rattle of kettledrums, a fast tattoo. Sarah turned over next to him, slept on. She snored lightly. At the house next to the church, where he was not, rain came in through the burned places and made charred black liquid drip into the front room. But where he was, islanded in his safe dry present, all he felt was the unfamiliar singing along the wires of his body. He felt oiled, light, loose. His fingertips and toes, his joints and sinews, alert. He put out a hand, and found Sarah. Surely there was nothing safer than waking with your lover and finding her still asleep; with a new day, a new set of possibilities before you. He stared at the cracked and sagging ceiling above them, moved his feet very gently to find hers. Around them their clothes lay in close heaps. Against him, he felt her breathing, her slight sweat at his side, and when he looked down, the shape that they made together under a single sheet that she had pulled up over them at some point in the night when the rain came, cooling the room. His penis lay small and docile against his thigh. He had never felt so light, and yet so well-knit, so substantial.

THE smells he returned to later that morning were of smoke and the terrible acidity of burned furniture, things that had exploded or trickled as they fell apart, chemicals spewing out of them. The stink had reached down the street. Rubber, plastic, the worst; then the campfire smell of wet charred wood. He came home to a question

that was easy not to answer—where had he been? Each time he was asked this, he answered it with another question, so that soon the questioners lost interest. It was a technique he'd often used.

Pearl, he wanted to know, how was Pearl? He must find her, see her. A cop told him, "She's in the hospital, the woman who was here. She was shocked but not hurt." But who was Pearl? What was she doing on his porch? He dreaded the question. Perhaps he could pretend he didn't know she was there; she was a homeless person, a stray, a life that hardly counted. But no, she was Pearl. She was the woman he brought coffee to in bed, she told him his horoscope, showed him her bruises, her lack of teeth. He couldn't pretend she was nobody. Perhaps he couldn't pretend anything now.

He entered his house, even though people were already fixing yellow tape around it, making it the scene of a crime. He stood as if lost among soaked and still smoking wreckage. He had not the first idea what to do next. The only clear thought he had was that he didn't care. The house didn't matter. Pearl mattered, it mattered that she was alive. But nothing else was important, or even interesting: his house, his things, his wrecked soaked books, the mess made here by fire and water, the loss. He was outside it, as if he had never even lived here.

"Excuse me, sir. Reverend, is it? I'll have to ask you to go outside for now."

He looked around and walked out again, past the cop who was watching him as if he were dangerous, past the people who gathered to stare in the street. People would think he was in shock. But they were all too interested in his burned house to notice him. He walked up the street without speaking to anybody, thinking that he'd go to José's and get a café con leche and sit down on the bench outside the store to enjoy it. The rain still dripped, and more was in store. Last night's was just a beginning. If another storm was on its way, then let it come; he had already done what Rick had warned him about. It had happened this quickly. He was already outside, he was on the street.

THE knock at the door surprised Sarah, who was standing at the sink in the kitchen rinsing the mugs they had drunk from before he left.

She went to open it and found a young man in overalls on the sidewalk, a newspaper held over his head against the rain.

"They say another one's coming," he said, grinning at her, "but I don't reckon there's going to be a direct hit, whatever they say. Doesn't happen twice, that kind of thing."

"Uh, can I help you?" Sarah asked, meaning, who are you and what are you doing?

"No, but I guess I can help you. Tom told me to come. Said you were looking for someone to do some work here. I'm in construction. Looks like your roof needs some work, and hey, look at those timbers. Jed Hyatt. Nothing to do with the Hyatt Hotel, my bad luck. Can I come in? It's wet out here."

"Sure, come in, I'm sorry." She held the door wide for him. Outside, rain was running in rivers down the street already, and the wind banged the door behind him.

"Reckon we're just going to get the tail end of it this time," Jed Hyatt said, and stood as tall as Jim had under the sagging ceiling in the hallway. "Now, where would you like me to begin?"

"I don't know," Sarah said. "I'm living here. So that makes it a little tricky. Can you work around me?"

"Well, I don't know, I'll try. You want me to start right away, give you some idea of a price, that kind of thing?"

"Yeah. Why don't you just go round and see what you think needs to be done?"

"Okay." He got out a folding metal tape measure and began walking through the house, tapping on walls, poking beams and sills. Termite dust poured in a brown stream out of all the holes he made.

"Some people," he told her, "just tear the whole thing down and start again. But I guess you don't want that. So what I'd say we should do here is just patch up the holes, get some new timber in where the old stuff rotted out, fix the roof, give it all a paint job and let it go at that? That be okay? That's what Tom said you'd probably want."

"Oh, he did?"

"Yup. These old Conch houses, they ain't built to last. Poor people put 'em up, you know, they used anything they could find, there was

no money down here and no construction materials. You just used what you had. That's why you find bits of driftwood, navy surplus, marine paint, anything they could find laying around. These old tiles, they were what the Navy used, World War Two. All that gray paint you see, that was Navy paint. Battleship paint. And you see those bits of color there? That wood was boat wood. Salvage. Good stuff, too, the salt water's hardened it, you won't get termites in there."

"Oh, good." This house needed every small piece of luck it could find. Good beams were like good bones. She'd almost forgotten that she planned to give it away.

"Heard about the fire, did you? Hear those sirens last night?"

"No, where was it?"

"House next to the church, on Margaret. The pastor's house, I guess it was. Somebody torched it, was what I heard."

"No. Are you sure? Hey, I'm sorry, but I'll have to get over there. Can I leave you to measure up here? Leave me your number."

"You knew the guy? They stopped the fire, though, so half the house is left, it wasn't all burned up. Guess all that rain helped. Yeah, I'll take a look, call back tomorrow if you want. Maybe get that tree off of your roof."

"Thanks. I have to go now. See you tomorrow."

Sarah scuffed her feet into sandals, grabbed a yellow slicker off the back of the door, a relic of wet days on Cape Cod, and pushed past him to the street.

"You want me to close up when I'm done?"

"Just pull the door behind you. There's nothing in there to lock up."

The wind whipped branches about on the street and the sky was a heavy yellowish gray. She began running, up to the corner, sloshing through puddles, round the edge of the cemetery with the stark black fence on her right, the nine tall palms. He was all right, of course he was, because he had been with her; but that the house was burnt, how had that happened? Everything was so fragile in this world of water and wind, and now, suddenly, fire. Somebody torched it? One of Jim's parishioners, guessing at the depths their pastor had sunk to? Surely

not. But this was the South, and she'd heard the stories. People at night with fire in their hands, rings of faces in darkness, terrible things done.

She ran, sandals flapping in water, the yellow plastic bunched around her, her hair dripping runnels of water on to her face. Then she stopped, breathed, leaned for a moment against a house fence. There was no real need to run; whatever had happened was over. Jim was safe, that was what mattered. Safe, and now homeless. She walked on, paddling through the lakes that swished brown water across the street. It was like being a kid, soaked through for the sheer hell of it. On the corner of Southard, she saw him sitting on the bench outside the Cuban coffee shop, his long legs sticking out from beneath a dark green slicker, his black hair plastered to his head, hands nursing the styrofoam cup.

"Jim!"

"Oh," he said, "it's you. Did you hear what happened? Pearl burned my house down. Seems I'm homeless."

"Oh, my God, it was Pearl? The builder said someone had torched it."

"Well, rumors move fast in this town. Yeah, I don't think she meant to. She lit a whole bunch of candles, on the porch. A neighbor saw her doing it, he thought of stopping her, but for some damn reason he didn't. She told him she was having a service, and he let her go on."

"A service?"

"Yeah, candles, you know, like in Catholic churches. I think that was her idea. She's in the hospital now. She's okay, they say she didn't get burned. I'll go up and see her later, see how she's doing."

"Hey, are you okay?" She saw his hand shake, spilling some of the coffee.

"Yeah. Never better." He turned his face to her. "I guess it was a shock, first off. But you know, I don't care? I really don't give a damn. And the other thing, is you. I love you, maybe you noticed. Can you handle it?"

"I think I can handle it, though I don't know what to do about it." She laughed. His lips, warm from hot coffee, on her wet ones. The

taste of coffee and rain, and the wetness of hands, the slide of them on each other.

"Do nothing about it. Do me a favor. Just decide to do nothing. At least for now."

BLACK timbers bled their ash into the rain, into the puddles, and the porch roof buckled where the fire had ripped through it. The front room was a mess of half-charred furniture, papers, the TV which had exploded, cushions which had burned slowly from the inside like eaten-out fruit, and all of it soaked. They'd walked back to the house together, past the yellow tape, now that the curious crowd had gone and the cop cars had moved on to something else. Sarah stood beside him and stared at it. Never had she seen so much debris as she had since she'd come to Key West. First the hurricane damage, the blown-out houses of the Lower Keys, the snapped trees and fences covered with seaweed, then the streets of Key West itself, full of wood chips, garbage, discarded furniture, the stumps of great trees; then her own house, its yard full of rusted, broken things, its rooms like trash heaps; and now this. It was a world falling apart around her. It was hard to believe it was a tourist paradise, had been, would be again. It was as if nobody had any control over anything, when the chips were down. It was like living in science fiction, a time warp, a time and place where humans wandered among wreckage, trash, remains of all sorts, in which sudden rains came, and floods, and the wind could blow them all away tomorrow, and the ocean itself was an uneasy presence, always ready to invade the low-lying land.

"I hate it. I can't stand it. You know, I just can't take any more mess."

"Welcome to the world of entropy," he said. "It's what it is."

"I can't. I'm sorry, I have to go." She pulled away from him, close to tears.

"What's the matter? Sarah, hey, come back!"

THEN she realized where the feelings of hopelessness and loss came from. She'd been three when they left after the war, left bombed-out filthy wrecked London, to come to the clean, rich, successful, un-

scarred United States of America. There were the tall London houses with their roofs off, their floors fallen away, a fireplace halfway up a foundering cliff of wall, wallpaper hanging off in strips, broken furniture, sofas and chairs, tipped up among the wild plants that grew quickly over the rubble. Nettles, willowherb. You didn't forget something like that; even if your mother seized you by the hand and dragged you away from the sight, took you to solid well-built Boston, married a man rich enough to make sure you lived in a house which did not fall down. It stayed with you, surfaced at a time like this, when the next storm was forecast, the memory of the house next door that had disappeared, and a mountain of broken stuff lay where it had been. People's lives disappear in the night: all that's left of their efforts, their families, their world, is a few broken things. That had been the message.

She gripped Jim's hand, her throat aching with the smell of burning and the tension of tears. The past didn't leave you, but erupted at unforeseen moments, a lava spreading its black tide through the present.

I can't stay with him, she thought, not with his life in chaos like this. Not with that apocalyptic vision of his, burning everything in its wake. Last night was a mistake. I'm too old for lovemaking on stained mattresses, for wrecked furniture to be endlessly dragged to the street. I want to go home.

When it would be possible to tell him this, she couldn't imagine, for he was gripping her fingers hard now, like a man simply unable to believe he would ever have to let go.

15

SUSAN WAS ON THE ROAD SOUTH, driving her borrowed SUV on cruise control, heading for Key West. The car was her son-in-law's, and she was taking it down to pick up all the rest of her belongings from the house, in order never to come back. She sang along with the tape, golden oldies: "The Leader of the Pack," "Great Balls of Fire." The car was cool as a refrigerator, the way she liked it, and it was roomy, she could stretch out her legs, put it on cruise control and hum along, not doing anything much at all. It was a whole lot better than the Oldsmobile she had driven north and left in her daughter's driveway, its exhaust falling off the back of it and no temperature control. She liked to be comfortable and saw no reason not to be.

In Key Largo, she stopped for gas and ate a fish sandwich at a roadside café, washed down with iced tea. She sat on a high stool, sweat drying on her under the fan and smoked a cigarette in among the few sweating middle-aged couples and the big-bellied truckers and fishermen who came in. She thought about how well she'd felt, since she had left Jim. It was that realization—having left—that had been such a pleasant surprise. The relationship had ended, really, months ago, even years; but the physical departure to get away from the hurricane had made it real. She'd known, as soon as she got to Sherry's place and her daughter had hugged her, "Hi, Mom, great to see you. How long can you stay?" and she had wanted to say, forever.

It had remained her secret, her own evacuation policy, sanctioned by the public announcement that everybody, everybody with any sense who didn't want to be flattened by a hurricane, should leave Key

West. The hurricane had freed her—and how many others, she wondered—to get up and go.

When she arrived, she would check into a hotel and then go by the house, see Jim, take her remaining things, if there were any, and spend a night alone in the luxury of a hotel room, cool, clean, with a pool and fresh linen, which was what she deserved after her long drive down through the whole of Florida, a state she disliked. As soon as you crossed the Georgia border, Susan thought, you entered inferior country. The roads were worse, the place looked like it had been bulldozed, the air was hotter, the people you saw were freaks, either down-and-out or obscenely fat. It wasn't really even the South. It was south of the South, where nothing ought to be. As for Key West, with its termite-ridden shacks and crack addicts and Cubans, it was almost the Third World. She'd only gone there because Jim had landed what looked like an okay job at last, and they'd have a house; but it was like the end of the world in the late seventies and even now, with good hotels and restaurants and the tourist economy and millionaires coming to town, it was too hot, too small, too crowded and still too full of homeless people, foreigners, and drunks. And there were the hurricanes. The ocean was just too close, it could come in any time. On the mainland, up in Georgia, you could at least feel safe.

Susan took another Salem Light from her special purse for cigarettes, snapped her lighter, and took a deep cool mouthful that would last her from the café across to the cool of the car behind its smoked glass windows. She was not cut out to be a preacher's wife, never had been. He'd been cute, Jim, when he was younger. At the beginning, it had just looked like a job like any other, something she could ignore, that was just her husband's business. She went to church from time to time, because that was what she had always done, but then she found that Jim's sermons embarrassed her. It was not so much what he said, which was often over her head anyway, but that he spoke at length and other people listened. They listened to him, as if he were God. It made Susan twitch her leg up and down and long for a cigarette. The cool intake of menthol to drown out that feeling; it was the only thing that worked.

She discovered early on in their life together that she couldn't bear the sound of her husband's voice. His church voice, that was. It made her want to scream. The other thing she really couldn't like was sex with him. It had been all right in the very early days, when she wanted children and this was the way to have them, or at least to have one, who was Sherry. But lately—and Susan shuddered with the memory of this as she drove south, rain spattering the windshield, wind coming in sudden gusts across the bridges—she hadn't been able to bear his fumbling. Sex to her was a swift forgetful act, performed by a man upon a woman. As a young woman, she'd been able to lie there relatively undisturbed and receive his body with a sense of something accomplished, which was not exactly pleasure, more duty done. Pleasure was what she had alone, in the bathroom with her vibrator, when he was out. But as they aged, he had needed what he spoke of as "help." He wanted her to do something to make him hard, that was what he meant; and she hadn't wanted to do it, not at all. Penises, she thought, were not attractive things anyway; erect, they were a symbol of something, a man's honoring your beauty, as she'd been told when young; un-erect, or even semi-erect, they were pitiful things, slug-like, wrinkled, certainly nothing you would want to touch. The thing about being this age was that you could no longer really pretend about things. Reality had a way of leaking through. You were no longer that pretty, you sagged, your husband couldn't run his flag up the pole to honor you—so what was it all about? Separate bedrooms, she'd concluded. And now, thanks to the hurricane mandatory evacuation alert, separate lives. She'd thought it would be hard to leave, but it wasn't, it was easy as falling off a log.

When she'd met him, he'd been an eager young man, fresh out of the seminary, and what had charmed her was his sincerity, his way of talking: the very thing that later made her blush and twitch her leg, wanting him to shut up, to never say another word. He was good looking in those days too, with his neat thatch of dark hair, cut short for the era they were in when most men wore theirs long. He'd been in the military, perhaps that was why. He told her he'd never loved anyone before her, and that was charming. Sometimes you just

wanted to believe people, whether what they said was true or not. Susan, young Susan, had enjoyed being loved, the words that went with it, the actions. It was only in middle age that she had become allergic. People talked about allergies a lot, these days, you could be allergic to all kinds of animals, foods, even air. People sued airlines for having been made to eat peanuts. People moved to other states, even other continents, because of their allergies. So it was entirely reasonable, in 1998, to discover you were allergic to your husband as well as to the work he did and the place he lived, and that you probably always had been without knowing it.

"I'm just allergic," she imagined telling a judge, as she filed for divorce. It was the times they lived in. There was nothing to be done. She shifted her hands high on the wheel that was thick and satisfyingly solid to hold in this thoroughly satisfying vehicle, sang a few ironic notes of Tammy Wynette's "Stand By Your Man," and laughed aloud as she came down US 1 into shabby, tacky, ridiculously small and expensive Key West. "I'm outta here," she said out loud in a parody of her own voice, "I'm just hightailin' it right back where I came from, baby, soon as I done what I came here to do."

IT wasn't possible. Dear God, it was not possible. He'd burned the fucking house down in her absence.

She parked across the street, and where she'd been going to let herself in with her own key, take her own things, say something to Jim if he was there and if he wasn't leave a note, there was a burned-out wreck. He'd been drinking, was her first thought. He'd let winos in. He'd let go of any pretense of normality, any attempt at a sensible life in her absence, and this was the result. Then she thought, do hurricanes make things catch fire? No. Anyway, the hurricane was weeks ago. She'd talked to him since then. This other one that was threatening, Mitch, it seemed wasn't going to even make landfall here in Florida, even if today's clouds did look a weird color and the wind was gusting sharply and the water of the Keys looked soupy and a too vivid green. A crack of thunder made her jump as she stood there, but that was probably just a little local storm, the kind they had down

here in the summer months. Well, what the hell was she going to do now? She sat in the cool of the SUV and smoked another of her long cool cigarettes, rubbing the ash carefully into the ashtray. Go to a hotel. Call Jim. Oh, the phone must be burned out, that was why she'd gotten weird sounds when she'd tried to call from where she now thought of as home. The idiot, he'd really screwed up now. What would the church do, rehouse him? Surely they would get everything back through insurance. All she really wanted anyway was the money, not that shack of a house, which wasn't even theirs.

She sucked the last from her cigarette and through the darkened glass of the car window saw Jim come down the street. Jim, and someone else. He wasn't alone, he was with some woman. She saw, God save us, that for a moment they were holding hands. He was walking right past the church, holding hands with some woman. True, she wasn't young or particularly pretty, she even had undyed gray hair and was wearing jeans, a loose shirt and sandals. Susan wished she had a camera with her, so she could snap them together in front of the burned-out house. They stood there, staring at it for a moment, and yes, their hands were definitely joined.

"Here, your honor, is proof of my husband's total irresponsibility, a burned house, and him holding hands with another woman." Some men, she knew, went crazy in mid-life. This must be what Jim was doing. They didn't take hormones to calm themselves down and put them back to normal the way women did. They should probably take anti-hormones, female hormones, something at least to minimize the kind of wild surge of idiocy she saw Jim acting out in front of her this very minute. She thought of honking the horn, surprising them, probably making them jump out of their skins. But just watching was more powerful. Just getting her evidence, from behind the smoked glass of a borrowed car, getting what she needed and then making her getaway, quite safe.

It was weird, though, the first time you saw your husband with another woman. It made you want to wave something in front of him and yell, hey, it's me, I'm the real one, not her. Wake up! It made you feel a little nauseated. How had he found himself a woman, in this

short time she'd been gone? One he was holding hands with, as if they'd been together for years? It didn't make sense. If it was Jim, the one she knew, then it couldn't be that he was actually having an affair with someone she didn't even know. It meant that Jim had passed out of her life as surely, as smoothly as she had passed out of his, and this made her mad, because it had been her idea to leave him, not the other way around.

She leaned on the wheel, watching them stand talking in front of the half-burned house. The woman could be an insurance agent, perhaps. Maybe she had imagined the hand-holding. She peered, leaning on the wheel to see more clearly, and leaned on the horn which made its loud classy SUV honking sound and made them both turn around. Susan ducked. She saw them stare at the car, which was of course unrecognizable and had smoked glass windows and Georgia plates, and then go back to talking about the house. The woman moved away from Jim, waving her hands as if agitated. Maybe they were having a fight. Already, they were having a fight. Jim was trying to calm her, she knew those gestures of his, at once soothing and powerless. The woman was crying, Susan saw. This was fascinating. She was watching the end of something: her husband's affair with a strange woman was coming to its logical end before her eyes. There. The woman was walking off alone, rather small and determined looking as if there weren't puddles to be stepped through on the way. So. That didn't last long. Nice try, Jim, but you see what effect you have on women. Watching him from her safe place, as he stood alone with his ruined house and his finished, failed attempt at a relationship, Susan found she was even sorry for him. He couldn't help being such an asshole. He could be sweet, too, at times. But it was the trouble with men his age.

"SO," she said to him, when finally he called her at the number she had left pinned to the church door, "what are you going to do?" She was sitting on a large comfortable bed at the Hyatt, having used their shared credit card to book this pleasant room. The ball was in his court, wasn't that what people said?

"Tell me where you are. I guess you saw the house?"

"I'm at a hotel, having a rest after my long tiring trip. Yeah, I saw the house. What in God's name happened?"

"Someone set fire to it by mistake. A homeless person."

"I always knew one of your homeless people would do something like that."

Silence.

"Jim, what are you going to do?"

"I've no idea yet. I'm homeless myself. I haven't had time to think."

"I just came to get my things. Jim, you owe me for my things. I had a lot of good stuff in that house."

"The insurance'll pay, sooner or later. I'll send you a check."

"Okay. I'll keep on at you till you do. And I want a list, of what went. Make sure it's itemized, okay?"

"Susan."

"Yeah?"

"Why are you leaving? And why did you come back?"

"I told you, I left long ago, I wanted to, it was just the evacuation order that made it possible. Today, well, I just came back to get the rest of my stuff, and look what I find."

"I just need to get this clear. You had to wait to be told to go by someone else?"

"Something like that, yeah. Well, it's not so easy to end a marriage."

"No."

"But at my age, I can't hang about, you know, I've only got so much time left, I can't afford to waste it, know what I mean?"

"Is there someone else?"

"No. But there isn't you, that's the difference. Anyway, I know you have, found someone. I saw you." She couldn't resist it, now.

"What?"

"I saw you with that woman."

"What? Oh. Sarah, she's an old friend. We go way back."

"You were holding her hand, I saw. Don't try and deny it."

"What were you doing, hiding in a tree or something? She was upset, I was trying to comfort her."

"Yeah, I saw. Outside the house. I was in a car. Hey, I'd make a good spy, wouldn't I?" She laughed, bounced a little on the bed, looked out the window at the whipping palm trees, the coiled gray of the sky. "You still haven't told me what you're going to do."

"Because I don't know."

"D'you want to meet, Jim?"

"Why would I want to meet?"

"Oh, I don't know, to say goodbye."

"We've said it," he said. "Haven't we? And if not, goodbye, Susan. Give my best to Sherry when you get there. I guess you'll be living up there now, will you?"

"Jim."

"Yeah?"

"What will you do, with your one wild and precious life?"

"What?"

"It's what some poet said. Or wrote. It was in a book I read."

"Say it again, will you?"

"What will you do," she repeated, "with your one wild and precious life?" And then, "Jim, are you still there? Jim? Can you hear me?"

SUSAN called room service and ordered herself a Bloody Mary and a tuna sandwich. She knew him, she knew him so sickeningly well, that she'd delivered the very question he most wanted to hear, from the voice of a well-known poet, no less, and then he'd hung up on her, or the phone had gone dead. She didn't read poets, not usually, but this one quote was in a self-help book that Sherry had thoughtfully put by her bed, telling you how to leave your husband without feeling guilty. Perhaps the poet didn't even know it was there. Perhaps no one asked her.

When the drink, with its elaborate sculptures of ice, lime and celery stalks all lurking in the red juice, and the sandwich with its scatter of green stuff across it too, had made her feel luxurious enough, a free

woman, she thought about what to do next. She could go back to Macon, Georgia, or she could have some fun. Fun was not what she had had in her marriage to Jim. Being a pastor's wife, even a very negligent one, wasn't fun. You always knew that people were judging you, or wondering why you hadn't showed up at various church events. Looking back over the last decades of her life, Susan saw that fun had been very scarce. She had never even been in a hotel room on her own, not once in all that time. She sprawled across the pillows, drained her Bloody Mary to its sunset dregs, lit a cigarette, and thought about going to a spa and getting massaged within an inch of her life, picking up a man, watching an R-rated movie, or simply getting drunk. She thought about the president, who was getting into such trouble for just getting a blow-job. Though who would ever want to do such a thing to a man? Perhaps you just pretended you were eating an ice cream cone, and it being the president would make it seem okay. You could get into trouble for being bad, or even trying to be bad, or making a mistake. But it wouldn't apply to her, because she wasn't even a preacher's wife anymore, she was free. She'd been a good girl too long.

None of these things seemed quite what she wanted. When she really thought about what she wanted, it was curiosity about that woman that won out. She wanted to find out who she really was, and what Jim was up to, however much the self-help book, still at the bedside of the guest bedroom in Macon, Georgia, damn it, had told her the importance of letting go. If Jim was having an affair, she had a right to know. And anyway, there was nothing else to do in this godforsaken town. She waited while her pink-varnished toes dried, smoked another cigarette, and switched on the radio, as the remote on the TV wasn't within reach. The local station was on, and the weather report. Hurricane warnings in operation in the Upper and Lower Keys. Hurricane Mitch was approaching Cuba, might turn south before it could hit South Florida, and move towards the Yucatan Peninsula. Further news would be given at eight P.M., of this storm, whose speed was of seventy-mile-an-hour winds at present, which could drop if it made landfall over Cuba. Susan switched off before a Hispanic singer began

wailing a love song. Another hurricane, how could that be? You couldn't have two of something so violent, could you, you couldn't have all that happening all over again? She'd go out, anyway. On an island this small, she could even meet Jim and his woman, whoever she was, on the street. Then they could all be blown to pieces together, before anyone even had time to issue evacuation orders, close the bridges, shut down the town. Damn him. Damn Jim and his stupid lies, his "Oh, we go way back," his "She was upset, I was trying to comfort her." Damn him to hell. He was such a fucking asshole, excuse my language, he was—and Susan began to howl and beat the fluffy pillows on her comfortable hotel bed, because he was such an asshole, and because he was hers, if he was anybody's, he was damn well hers. She had never felt so miserable in her whole life as when she saw him take that woman's hand, and now there was nothing to be done but feel it; no drink would do, no self-help book, no affirmations, no amount of pink nail varnish and room service and spiffy hotel beds. No supportive daughter, no family, no clucking friends, murmuring, "He deserved it, you were right to leave." Nothing but another storm coming in from the Atlantic, its waves rolling close and closer, its winds building, and no time for any orders to be put out, no escape now, no evacuation, no safe road north.

"I hate this town," she muttered, but even that didn't seem to be true anymore. The sky outside the plate glass window darkened. She rolled into a fetal hunch on the bed, dragged a cover across her, and slept.

16

PEARL WAS SITTING UP IN A CHAIR beside the bed when Jim and Sarah arrived at the end of the corridor, Sarah carrying a wilted bouquet of pink carnations picked up at a gas station on the way. The appalling gap of her smile welcomed them in. She was wearing a pink robe, so the carnations clashed with it, but she put out a hand and took them to her breast, sniffed them and raised her face of delight. It could be the first time in her life that she'd had the opportunity to do this, Sarah thought: raise flowers to her nose, bury her face in them, look up with fervent appreciation at the giver.

"Oh, you shouldn't have," she murmured. "Oh, they're beautiful. Thank you. Jim, I'm so sorry about your house. It was a mistake. I didn't mean to burn it. I was saying prayers for you."

"Prayers for me?"

"You know, with candles, like they do in real churches. Is this your girlfriend?"

"This is Sarah, an old friend," Jim said. "She's visiting Key West."

"Hey, I'm glad she's not your girlfriend. That would get you in trouble, having a girlfriend. I'm so sorry, Jim, for burning your house, will you forgive me? I really didn't mean to."

He sat down on a wheelchair which was beside the bed and scooted about in it as if trying it for size. "It's okay, Pearl. Don't worry about it. It wasn't my house anyway, and you may have done me a favor by setting it on fire."

"But you won't have anywhere to live."

"That's right. I'm homeless now, like you. No more porch left for

you now, Pearl, and no more house for me. How are you feeling? Were you hurt? Did you get burned at all?"

She rolled back her gown sleeve and showed him a brown mark. "There and on my shoulder. Something threw me out of the fire. I just banged myself on the steps, must have hit my head."

"Something threw you?"

"There was a kind of loud noise, like a firework going off, and it threw me off the porch, away from the house. I was on the sidewalk, beside that bush, you know. They found me there. If I'd have been on the porch I would have been burned. So something saved me." She was proud, the recipient of a miracle.

"Sit down, won't you, ma'am," she said to Sarah, her best grand manner, her head inclined. Sarah perched on the bed.

"So, are they letting you out of here today? Where are you going?"

"Home," Pearl said. "They found my next of kin, my mother."

"I didn't know you had a home."

"I left a long time ago. My mother and I didn't get on. She didn't believe I'd ever get to Nashville. She used to drink, and beat me. But they say she's changed, she doesn't do that anymore. So I thought, I'll go back there and see. Then maybe I'll go to Nashville."

"Does she have a good dentist?" Jim asked. His long legs sticking out of the wheelchair, the squeak of the wheels on the plastic floor. Sarah frowned at him. "Because if she doesn't, I'd like to buy you some teeth."

"My mother, oh, she hasn't any teeth, she had them out a long time ago. It doesn't matter, Jim, it doesn't bother me, thank you all the same."

"I just thought you might get on better in Nashville with some new teeth."

"Well, maybe. I'll think about it. Thank you, Jim. You are very thoughtful. I will pray for you."

"Just so long as you don't do it with candles next time. You know, I think they're fireproofed, those old European churches. It's not the same here. I don't think you should try that again."

"All right. Do you want me to read your horoscope? I have the paper right here."

"No, I don't think so." He was beginning to feel the familiar helplessness. He glanced at Sarah, who simply raised her eyebrows and smiled.

"You can do mine if you like," she said.

"Okay. What sign are you?"

"Taurus."

"Taurus. Let's see. Oh, here you are. You have to take a risk today and it's going to come out all right."

"Sure," Sarah said. "Thanks. I do nothing but take risks these days, so one more can't hurt."

"That's right, that's what it says here. Now, they want me to get dressed, then the doctor's coming round to tell me I can go. So nice meeting you." She stuck out a hand to Sarah, who leaned forward and clasped its small warmth and roughness, felt the childish close-bitten nails.

"Nice to meet you too. I'm so glad you can go home again."

"Yes, if I hadn't burned the house down, I'd never have known, would I?"

"Known what, exactly?"

"Well, where my mom is, for one thing. Or about these pills they can give me, that make all the bad stuff go away."

"They're giving you pills?"

"Yeah, they work great. I feel really different. But you know, it was worth it. I know it saved him. I know it worked."

ON the way out, as she caught up with Jim and they walked down the bland corridors again, he said, "I just don't get it. D'you think Mom is some kind of bridge-playing aristocrat or what? Those manners of hers, and the look of her. What do you think? I wonder who's picking up the bill?"

Sarah said, "I think she's very polite, well brought-up and also she's completely nuts."

"Not completely," he said. "No, not completely. Just slightly—off.

It can happen to any of us, so easily—just one step to the side in life, and there you are."

They crossed the parking lot, rain in their faces, the wind dropped from yesterday. Hurricane Mitch, it seemed, had gone elsewhere.

"Well, you should know," she said. "But they are giving Pearl pills for it. She says they work."

Since she had arrived in Key West it had all been, as he put it, slightly off. The wind and sea had come in and gone out again, leaving this strangely altered landscape that she'd never even seen in its normal state. She didn't even know if it had a normal state. And had there ever been a normal Jim? She had known him young, passionate and grateful, lighting her up with his enthusiasm, inviting her to be maternal with him when she was young enough to find that flattering. Now, she knew that same intensity, this immaturity in him in middle age. He had not changed enough. Loving him was one thing, sleeping with him even, but throwing her lot in with his, quite another.

He was sleeping at her house still, sleeping with her. His nighttime self was delivered up to her, he turned and muttered next to her in his dreams, his hands were upon her, every night growing more familiar, every time awakening her more to him, pulling her in. They slept deep together, in tangles of dreams. Each night they went down into them, and woke entwined. Night was making them what daytime could not. His homelessness was making it all seem inevitable. She woke early, before him. The roosters in the tree down the street woke her but he only turned and burrowed deeper into the pillow, searching for a way back.

AFTER they'd been to see Pearl, he had to go and explain to the Church Board what had happened. He stared in the mirror, flattened his hair with a comb, straightened his collar and knotted a tie in place.

"They'll guess," she teased him. "They'll take one look at you and see. The scarlet A."

"You really think so? It's that obvious?"

"No, of course it isn't, I was kidding. Just remember, you haven't done anything wrong."

"Well, I can't say it wasn't sex, like the President. I don't think that's even going to work for him."

"Jim, they won't know. They just want to talk about the house, is all, probably discuss the insurance, offer you somewhere else to live. It wasn't your fault. It just happened. The fire, I mean."

"Then why do I feel so guilty?"

"Because you're having secret adulterous relations with a woman, of course! But for God's sake, just go in there and bluff it out. Think of Clinton. Go on, go! I'll see you later. Oh, by the way, Pearl believes she saved you."

"So she said. By burning my house down?"

"Something like that."

"Well, who knows, maybe she did."

THE truth was, she wanted some time to herself. When he'd left, she changed her shoes, slipping into the old wet sandals, and walked downtown to find somewhere to sit and have coffee and be invisible, if that were possible in this town. As she walked, the sky overhead began to clear, streaks of high pale blue appearing between clouds. The hurricane was heading south, they'd just had the tail of it. Someone else, somewhere else, was sitting waiting for it to hit: some poor Caribbean or South American country was going to get what had threatened this island again and then simply passed it by. She was free to leave, instead of hunkering down for some unknown length of time complete with blackouts, curfews and all that went with it.

She found a little café on Duval with a soaked back yard roofed by a huge banyan. A young man wiped a table for her, tipped a chair to shed its water, and dried it with a towel. "You okay out here? You do not want to sit indoors?"

"No, this is fine. Thank you. I'd like a con leche, please. Oh, and a pastry if you have one."

"Of course."

Alone in a café: how comforting this was. A waiter brought you

what you wanted, the world over, you could do this anywhere, just enjoy a moment of anonymity and peace. In a long life, she'd done it in so many places; often, either thinking of a man or escaping from a man. In France, in Morocco, at home in Boston, in New York. Cafés offered you these little respites, where you could sit alone and think about your life.

What is it I am about to do, or not do? Think, Sarah. You are not a hurricane victim, a poor helpless woman clinging to a tree above a flood. You are a sane person with a life elsewhere, a job, an apartment, people wondering where you are. You came to Key West to do something practical and now you can go. But, the answer came back to her as the young man brought coffee, set the big white cup in front of her, and the plate with the fresh warm pastry, you do not have love. What you have here is a chance for love in your life, companionship, warmth. A human body beside yours. Closeness, shared waking and sleep, connection. Which matters most to you? What will you choose? The choice may not come again. What is it you really want to live before you die?

She bit into the pastry, which had soft guava inside. Flakes dropped around her, on the table, on her clothes. She took a sip of the coffee, which was strong, a real Cuban brew. The same things came round again, there had been the café in France, in the southern town there, the one with the green tin tables and the swinging sign, the chairs all over the sidewalk, under the dark leaves of plane trees, shaded even at noon. Where she had stood up, left Jim, gone with Patrick. Where one day the other boy, George, had suddenly not appeared, because he was dead, because none of them had known how to keep him alive.

The same offers came round again: I love you, stay with me, join my life to yours. And you could accept the fiction, move into that picture and occupy it; or walk away, insisting on some other, invisible truth, the integrity, the point of your life alone. She remembered now exactly why she had walked away from Jim, even as it hurt her to do so. She could do it again. How could she live with a preacher, a man who talked to God as if he not only existed but lived on the next block? A man who had made such a mess of his life that a hurricane

only seemed to have added slightly to the damage? A man who had loved her hopelessly once, and was now doing it again?

"You like more coffee?"

"Yes, please."

The waiter, a dark boy in his twenties, moved away to fetch her another cup. To him she was an old woman sitting here alone, a tourist, an irrelevant person from New York. He probably didn't see her at all. People said that: after a certain age you became invisible, men no longer saw you as a woman. What if Jim, who saw her as her younger self, were her last chance to be seen?

It was not a good enough reason. She had left him the first time because it was not a good enough reason. There was a reason that she went with Patrick, it was not simply passivity, a young woman's inability to say no. She'd known that with Jim she would become entangled, that it would be hard: serious, maybe impossible.

And after Jim? The hunt for love: Patrick, for a weekend, Dave whom she had married and divorced, and then the others, Felix who had died, leaving her an invisible widow, crazy Bill the war correspondent, gentle unavailable Aziz. You didn't get what you had hoped for, but towards the end of a life, you found that mysteriously, gradually, as a result of gifts and challenges from all these people, you had changed. You took something, you gave something, and you moved on. On and on. With the strange sweet taste of guava in her mouth, she thought, I wonder how long I have left to live? What will I live in this unknown time? What will I give, and be given?

The branches of the banyan tree stirred and released a long spatter of water. She shook herself under its drops. The young man came back and mopped the table again. "Are you on vacation, *señora*? It is not yet the season. We have only opened the café again this week, but there are few people in town. It's the hurricanes."

"I'm visiting," she said. "But I may stay. I don't know. Is it a good place to be?"

He rubbed the table dry around her, carefully. "I think," he said, "that it depends upon you. Everyone who lives here has a different idea of it. Some are happy, some are not. Some rich, some poor. Some

enjoy life, some not. I think it's exactly what you believe it is. More than any other place that I have been. "

"Thank you," she said. *"Muchas gracias."*

"De nada, señora. Have a very good day."

SHE came out of the café, crossed the street, and saw a woman staring at her outside a sportswear store whose plywood hurricane shutters were only now being taken down. The wood had something scrawled on it in black spray paint. She saw "cane part" for Hurricane Party, then the wood was thrown in a dumpster. Another piece said "Looters will be Shot." At first sight she had thought it said, "Lobsters will be shot." She was smiling at it as the woman came close: blonde, plump, maybe fifty, with pink matching lipstick and nail varnish, her hand to her mouth making that obvious. She came up very close to Sarah, blocking her way. "Excuse me."

"Hi. Do I know you?"

"I know you. I've seen you, even if you didn't see me. I'm Susan. Jim's wife."

"Oh." It was all she could say. She had not imagined Jim's wife anything like this woman. She hadn't even tried to imagine her or find out anything about her at all.

"I saw you with him." She was close up, as if about to hit or embrace her. She spoke as if Sarah were deaf.

"Well, yes, I'm an old friend of his, from way back."

"So he said. But I saw you holding hands."

"Maybe—maybe for a moment. Yes. But it doesn't mean—"

"I don't care what it does or doesn't mean. I just wanted you to know I know. He's married to me, we're still married, and he's a preacher in a Church, and this is a small town, understand what I'm saying?"

"No, not exactly. Look, do you want to go somewhere, talk? I mean, we could sit down."

Susan said, "I just want to say, if you're serious, you know, about him, he's still mine. I'm not letting go. I mean, I could make life hard for the two of you."

"I thought you'd left him," Sarah said, suddenly hard. This was a woman used to getting her own way.

"That was just hurricane evacuation. Was that what he told you, that I'd left? That was only for my own safety, same as any reasonable person would've done. It was an order. It was mandatory." She pronounced the word with triumph. "Now there's no need for it, I can come back if I want."

"I see. And do you want? I mean, do you want him back?"

"I'll let you know. I know where you live. I'll be in touch."

"I think you should know, I've no intention of taking him from you."

"Well. Okay. Well, that's that, then." The woman seemed oddly affectionate, maybe relieved as she waved Sarah goodbye and went on towards the Atlantic end of Duval, tottering slightly on her heels. Strange. The last person in the world that she would have imagined. Only, Jim had always liked her blonde hair, and this woman, Susan, was going to give him that to the end of his days. If only she knew, Sarah thought as she walked up Truman and turned left on Windsor Lane, there really isn't any contest. I've come to my senses. Hurricane season's over, thank God.

SHE turned the corner by the convenience store and came up Olivia, walking now on the sidewalk, now on the street to avoid debris. There was Martha, outside the house parking her bike, Molly in the little seat on the back wheel. Martha locked the bike to one of the scraggly palms outside her house and lifted Molly out. Fat little arms waved in the air, creased baby legs stretched and folded again as Molly was briefly airborne.

Sarah called, "Hi!"

"Hi! How are you? I haven't seen you. Did Jed come by? I know Tom told him to."

"Yeah, thanks, he came by to measure and left me an estimate. It's been a weird time. A friend of mine's house burned. Then there was all this stuff about the hurricane that never came. But thanks. Tell Tom thanks for finding him."

"Oh, he's an old buddy. He's an okay guy. He and Tom go back. He's done stuff for a lot of people I know; he'll do a good job. Hey, I've got to go in, she'll start screaming in a minute, I've only just picked her up from the baby sitter, she always has a good scream when she gets home."

"I'll bring your bags." Sarah pulled two brown paper sacks of groceries out of Martha's bike basket and followed her through the gate. "What's up? How are you doing?"

"Well, Tom's gone, they went out yesterday. Soon as they knew the storm wasn't going to hit."

"What about you?"

"You mean, did I tell him? Yeah, I had to, in the end. We'll have to do the best we can up here, till something else shows up, which it probably will. Sorry I was such a wreck the other day." She flung the door open to put Molly down on the bed. "Thanks. You didn't have to. But you know what it's like with a kid, you just never have enough hands. I'm late back, I was late getting her. Captain McCall's getting the boat ready to go down to Honduras. The *Black Cat,* you know. I've been checking in all the stuff people are bringing, there's a ton of it, bedding, food, clothes, you name it. They're going out day after tomorrow, and there's more stuff coming in all the time."

"Honduras?"

"They've been wrecked by the hurricane. Mitch, I mean. Ten times worse than anything we had here. Of course, they don't get time to prepare, the way we do, and the international aid's so slow to come in. He just made the decision yesterday, he's taking the schooner down there as soon as they can with stuff donated by people here who are just so grateful to be alive. We were damn lucky here. I wish I could go."

She set Molly down on the wide bed and the baby began to yell. Martha began undoing her plastic panties and diapers, holding two plump legs together with one firm hand. "I worked for years as a deck hand on the *Black Cat,* I did some longer trips with them too, down to the Caribbean. These days I just work if they're shorthanded, and I do the accounts and bookings. That's beside my job at the Waterfront

market, but they're so close, I can just walk from one to the other. Maria Elena takes Molly, so I can clock up some hours. It works okay." She parceled the baby up in clean diapers and plastic, gave her a big kiss on her exposed stomach, and sat down on the bed beside her. Sarah set all the brown bags in the little kitchen and sat down too, on the battered wicker chair they had. The air steamed and sang.

"Martha, there's something I want to tell you. I can see this isn't a good time, so I'll call by tomorrow, okay? I've an idea I want to tell you about."

Martha glanced back at her, grinning. "An idea? Well, come by after dinner tomorrow, why don't you? I'm home alone, as you see. And I think there's some wine left in the refrigerator."

"I'll bring some," Sarah said.

So, she'd give the house to Martha, give Jim back to Susan, put everything back—she smiled, mocking herself—where it belonged. There was a curious sense about this, of lightness, of ease. When she saw Susan, it had come clear: nothing really mattered in the way it once had. Was this the effect of the hurricane on those who had stayed, and she had simply caught this insouciance from Jim, who seemed not to care that his house had burned down with all his possessions in it; or was it being at a stage of life where everything got lighter and thinner and more and more transparent until finally there was nothing solid left? In this state of mind you could see things as simply interesting alternatives. She had said to him: the rules have changed. You could give anything away, a house even, and not feel that anything extraordinary had taken place. You could imagine yourself to be Susan, with her strange little wave of farewell and her empty threat, or even Pearl, lying bruised, crazy, and yet indefatigable in her hospital bed. Or Martha, with her taut flesh stretched over another baby about to be born. Perhaps, this would be the gift of being old, this shape-shifting ability, this absolution from care. If this were so, then being alone would be enough.

17

HE WAS ON THE RIVER, AND EVERYTHING was so dark he couldn't see his way. There was no horizon. Trees moved overhead, the surroundings were jungle, or forest, and the river went on beneath the boat he was on, before him and behind him; and something was waiting for them up ahead, in a moment the darkness would be split by gunfire. He was up in the bow, peering into darkness. The sound of the sampans coming downriver: your ears stretched for it, you were taut as a bowstring, all the time. Sometimes when he woke he was afraid he had gone blind. Snakes went downriver and out into the ocean to breed and then came back up, so that there were sprawling entwined masses of them as far as you could see. If he could see, he would see the snakes. He hated the snakes. Sometimes there was simply the feeling, which was terror, the cold sweat of it, the waves of nausea it brought. He tried to move his arms and legs, but his whole body was weighted down. It was like the lead shield for X-rays they spread across you at the dentist, that heavy sag. He tried to move, a finger, a hand, panicked into thinking he was paralyzed. Only this time someone was shaking him, shaking him awake.

"Hey! What's going on?"

Who was it, he tried to see. The voice and hands came at him from darkness. He fought to be free, pushing with what little strength he had.

"Jim! It's me."

"What are you doing here?"

"Jim, wake up, it's okay. It's me. You're with me." Sarah.

He sat up, propped on his hands. Shook his head as if to get water from his ears, rubbed one hand across his face. Leaves? Cobwebs? Worse? "What? Did I wake you? Did I make a noise? Don't leave me."

"I'm not," she said. "Do you want some tea?"

"Yeah, good idea. Sarah?"

"Yeah?"

"Something I have to tell you. I remembered it earlier."

"Tell me when I've made the tea. Or come with me, maybe you should move around, get that dream out of your system. What was it about?"

"The river," he said. "We're trying to move forwards, and we can't see a thing. I've had it since the war—oh, just about once a year recently, but that's enough."

Wearing a long dark blue shirt, she stood at the little old stove and watched a kettle boil. "Herb or regular?" She thought, I don't need to be with someone who wakes up screaming because he thinks he's still at war. But it would not be for long. In a day or two, she would be gone.

"Oh, regular. I need the caffeine. Do you have sugar?"

"What did you want to tell me?"

"Something I knew a long time ago, and never let you know. It's about George. George in Aix. He didn't kill himself because of you, it was because he knew he'd been drafted and knew he was going to have to go home and face it. He was too scared. He jumped. I was so mad at you for going off with Patrick, I wanted you to feel guilty about George, even if you didn't about me. I've been thinking about it. I thought you should know."

Silence. A figure fell fast between buildings, it was almost graceful, before it hit the cobbles below. In the dark of the Key West night, nearly forty years later. Was there a difference, between falling and jumping? How could one know? If you jumped, your last act was one of will, of decision. You went to meet the ground which would kill you. If you simply fell, it would look no different, but you would not have chosen. Perhaps that mattered. Either way, your body became simple trajectory; you existed as purely as Galileo's ball did, dropped

from a galloping horse. The world moved on; but your fall to earth existed, a line drawn in space and time.

It was not a time for getting back to sleep, after all.

Sarah said, "I thought I was just about as bad as the government for a while, for sending one of my fellow Americans to his death. And now you're telling me I didn't. Well, thanks."

She poured tea, handed him a cup. "You know, Jim, if you're saying I should apologize for ditching you when I was twenty years old, well, I apologize. But it was in another country, and what's more the wench isn't a wench anymore, but a middle-aged woman."

"What?"

"It's a quotation. Anyway. The damn war is over, we're nearly old people, we simply aren't those kids anymore. I'm not who I was then. I can't be, and I don't want to be. By the way, I saw your wife today. She says she wants you back."

"I saw the Church Board today, and they want me back, because I'm so cheap; they said that was why they took me on in the first place, against their better judgment."

"What did you say?"

"Well, I resigned. So, I apologize for dreaming about the fucking war, I apologize for talking about it, I apologize for even mentioning the past. I'm sorry."

"It's okay."

"The only thing I'm not sorry about is that Pearl burned my house down. I'd have done it myself, only I never thought of it. You said you saw Susan? Where?"

"On Duval. She recognized me. We talked. She wants you back, she said."

"You know what she said to me on the phone? It was really out of character. She quoted that line to me, 'What will you do with your one wild and precious life?' Women threw these crooked balls to him these days, lines of poems he was supposed to catch and hold.

"Mary Oliver. Everyone keeps quoting it."

"But it was so unlike her. Unlike Susan. She doesn't read poetry."

"Perhaps she thought it was a good way to get you back."

* *

MARTHA said, like Jim, "You can't be serious."

"Oh, I am. I wouldn't joke about something like that. You need a house, I don't."

"But you could sell it. It's worth a stack."

"Hey, don't forget, someone just gave it to me. I didn't even know about it a few weeks ago. I don't need it, I don't need the money, I don't need to be here. I'm glad I came, but I should go."

"You should think about it some more," Martha said.

They sat in among the potted geraniums and herbs, basil, sage, mint, on the balcony outside Martha's and Tom's apartment and the air around them was still and cool.

"I've thought. Really. I want you to have it. If I'm down and out in my old age, you can take me in."

They sat for a moment in silence. Nothing moved.

"Isn't it great to feel cool again? I love this time of year. Hurricane season's over." Martha put her bare feet up on the rail and tipped her chair on its back legs. They both sipped their cold wine. "Well, I don't know what to say. It's like a miracle. I wish I could tell Tom. I guess I'll try him on the satellite phone, this news is worth a few bucks. You know, I'll miss you when you're gone. It's nice, you being my neighbor."

"I'll miss you too."

"D'you think you'll come back and visit?"

"Who knows?" Who, indeed? In the quiet dark up here, with a moon shining on all the graves that stuck up aboveground like so many little condos, she thought of Johnny, so suddenly dead. He had given her the house with no strings, no explanations. A free gift, like life. And an open question.

Martha said, "You know, I can't believe it. I stop thinking about it for a minute and then I have to try believing it all over again. It's like winning the lottery. And you could have had it all gussied up and sold it for a fortune, or rented it out to snowbirds. Sarah, I just won't ever know how to thank you enough."

"Well, you don't have to figure that one out, because you've

thanked me already. I just like doing this. It feels exactly right, you know, it fits. How often do you get that?"

"WHAT'S this about, a redistribution of property? It's like Monopoly in reverse. Some get to lose the houses they had, others get a half-million-dollar shack as a windfall. I still think you're being impulsive here, Sarah."

They sat across from each other at the rickety kitchen table, in the house. He had a heaviness about him, shoulders sagging, palms flat on the table: a physical refusal.

"Impulsive? You're the one to say it, aren't you? Mister Think-it-all-out-rationally. Anyway, is it your business?"

"You're my business," he growled. "Where are you going to live?"

"In my apartment, the way I always have." Her spacious basement, close to the river, was on a street of warehouses which were only just beginning to be thought of as fashionable, in an area which people had warned her against, years ago. Now there were wine bars, poetry readings, strange clothes flung across the windows of suddenly converted stores. "I've got somewhere to live. It wasn't what I needed. What I needed was to give something away to someone who needs it."

"You're leaving."

"Yes."

"So this—us—isn't anything?"

"Of course it's something. It's you and me meeting up after all those years and adding a little footnote to history."

"I thought it was more than that. "

But she put her hand on his, stopping him. "Jim, you really aren't much of a proposition, you know that? Homeless, jobless, married, what do you expect? Just what did you have in mind? You have a wife, had you forgotten? And you're just as crazy as you were at twenty. You haven't improved a scrap."

"You haven't, either. You're still selfish, willful, you act on impulses, you think you can have things all your own way, you're unreasonable, arrogant. I could go on."

"Well," she laughed at him, "that's us, then, okay? Unimproved, probably unimprovable. Too bad."

Silence. He didn't move, but said then, "Is it all one-way?"

"No. But I'm not the type to be a spouse, I already know that, and there isn't room in this town for me as your woman. There's too much wreckage still around."

"That's hurricane season for you."

"I know, I came here at exactly the wrong time, right after that mighty wind came through, that blew wives away and scruples and conventions and left horny old preachers running AWOL around the place. It was a season in our lives, and I don't regret it, but it's come to an end. It's too much, Jim. It's too crazy."

"You said the rules had changed. Remember? What about now? This minute, this night? Are you dumping me now?"

"Oh, you've got me there. Now's now. Let's make the most of it, and then behave like adults in the morning." She laughed and pointed a long finger at him and he brushed it away.

"Sarah—we have to talk." Like "Love you," that phrase should be banned, he thought. "I mean, there's something more to discuss, isn't there?" She was tying him in knots, now.

"No. Let's dance."

"Dance?"

HE wouldn't forget that last night with her. First they danced, barefoot on the rag rug that covered the splintery kitchen floor, moving just an inch back and forth because there was so little room, holding each other close and then moving away, their eyes upon each other. She hummed "Begin the Beguine." Her face was flushed and mischievous. Then she led him to the bedroom, to the mattress on the floor, and unbuckled his belt. She shook back her short hair and her eyes gleamed. Jim stood, letting her come to him. It seemed to him that at last he had arrived in the present, and that this, belatedly, was his life. The rules had changed, and would keep on changing, and if only he could keep up, he would be all right.

She was wild, and so was he, like a young man, laughing, eyes open

in the dark. He wouldn't have thought it possible. He groaned and poured himself into her. She hung above him, rode him, her breasts swinging white in the moonlight, her head thrown back. He rolled with her, threw the pillows on the floor, dragged back the sheet, ground her thin hips beneath him, heard her intake of breath. Her hands on him, finding him. Breath rushed through them both and left them gasping.

Afterwards she laughed. She lay beneath him laughing out loud.

18

THE SCHOONER *Black Cat* WAS MOORED down at Schooner Wharf, low in the water, being loaded with provisions. Martha stood on the dock, directing people to where they could stack their offerings. Trucks stood on the wharf, sweating men unloading them, cars parked with their trunks open. The crates on the edge of the quay had been brought in from up the Keys—food, tools, household goods, bedding, medicine. The appeal had gone out on the local radio and TV stations only yesterday morning, as news of the disaster had reached the island, and people had responded, individuals, stores, companies, and brought down all these supplies to the dock, more than anyone could have imagined. It was a fine windy morning, the breeze rattling shrouds and halyards, the sky blue with high cloud.

People in Key West had started collecting stuff and dumping it on the dock even before they had a destination, a port. They had brought blankets and comforters from the hotels in town, sacks of rice and beans from grocery stores, a couple of generators, tools, tents, tarpaper, plywood, nails. An old Cuban woman staggered down to the dock with two bags of beans and a carpenter's belt that had been her husband's. Two kids came down with a Christmas tree, and baubles to put on it. It took two days for everything to be stowed on board, and the crew would have to sleep on the cargo that was piled amidships. There were twelve tons of relief materials on board. And ice, which people brought in bags, like treasure. They took coolers full of ice on board, which probably wouldn't last, but ice had to be

taken, ice was civilization, it was rescue, it was what humans craved most.

MCCALL and his crew were stowing the stuff on board when Jim went down there; the young guys on the dock worked a chain, passing things down onto the deck. It was to be Key West's gift to Honduras, he'd heard, one hurricane-struck community passing on its riches to another, poorer, harder-hit. The bare bones of what it took to live a life. Aspirin, bandages, tools, dried milk.

Jim stood a little way away and watched the brown arms of young men and women stretch and flex in the sun as they threw bundles to each other. He saw the way the chain worked, recognized McCall in his captain's hat with his shirtsleeves rolled. The movement of things, objects, one box or bundle after the other passed from dock to ship. A young woman in cutoff jeans with her hair tied up on top of her head, pointing the way. She seemed to have some authority here, so he approached her rather than the captain.

"Hi. Excuse me. I heard you're looking for crew."

"Yeah. Go talk to McCall." She didn't take her attention off her work, frowned into the sun, directed men with a sweep of her arm. Jim thought, I know her from somewhere; then remembered that she was Sarah's neighbor, the one who was being given the house. Martha someone. The pregnant one. He grinned, waved thanks to her, but her attention was on what she was doing. He went on up the quay to tap the man they called McCall on the shoulder. "Excuse me, captain. I heard you're looking for crew for this trip."

McCall turned, his face almost hidden by dark glasses and the hat. "Can I talk to you in my office in five minutes? I'll meet you up there. Okay? Yeah, look, we can't take anything that's not canned. No frozen stuff, obviously. Jesus, what do people think this is, a container ship?"

Up in the hot little office, Jim sat under the turning fan and looked at sea charts pinned on the wall and blown-up photos of smiling tanned young women, who must be past crews of the *Black Cat*. He looked at the Captain's desk, littered with papers, an open pack of Camels, a brass paperweight of a mermaid on a heap of bills. He

heard someone coming up the stairs, turned and saw McCall with his hat in his hand and his glasses tipped up on his head. His long gray ponytail dangled over one shoulder. He was sweating and though his hands were tanned, his face was pale.

"Hi, don't I know you?" he said, putting out a hand.

"Jim Russo. Yeah, probably, I've been in this town a long time. I was a preacher."

"Ah, you're the guy whose house burned? I heard about it. So you're interested in sailing with us? We'll probably be gone a month at least. Our aim is to help them get started up again, there's been a hell of a lot of damage. What went through there was a category five. Hard to imagine, huh? You know, people helped us down here when Georges came through, it seemed a good idea to do something ourselves. You have any experience? We sail the hard way, it's like going back a hundred years, no luxuries, hard work, not much space on board. Well, you've seen the ship."

"I was in the brown water navy. I've sailed a bit since."

"Vietnam?"

"Yeah, two tours, mid-sixties. "

"Well, I wouldn't take on anyone I didn't know well, ordinarily. But one of our crew just broke her thumb. Trapped it amidships when she was hauling in the line. So she's not going anywhere for now. That leaves us shorthanded. You fit? You know, guys our age, we have to realize we're not young anymore, huh? Though I'd rather have wisdom and experience than brawn on my boat. Sure, we need that too. Our crew's on the young side, so far. But I need to know you can haul on a line, shift a box or two, move fast if the going gets rough. Know what I mean?" His small eyes, kind but ironic. A nest of wrinkles, the swatch of gray hair. Jim thought, he's my age, has to be. He's sizing me up, and he may decide I'm no good, too old, he may turn me away. He waited, feeling anxiety in his gut, realizing how much he wanted this chance. He needed now to get out, to leave this island, to sail away. It was, perhaps, a last chance to change, to become another man from the one Sarah had tried, and found wanting.

"I'm fit, yeah. Well, kind of. I've had a sedentary life as a preacher;

I quit, you might know that, everybody knows everything there is to know on this island. I need another occupation. That's why I'm here. I want to do something active, be some use. I'm good at deathbeds and burials at sea. I can marry people and comfort the sick. And I've put in a good bit of time on water, one way or another."

"So, you were on the rivers?"

"Yeah. PBR. Not this kind of thing. We were there to check sampans and junks, you know, VC often moved their weapons that way. We killed a lot of people who weren't doing anything at all, and a few who were."

"Where were you?"

"The Mekong, the Bassac River. It was early on, the boats we had were just fiberglass, they crushed easy. Then the engines fouled up all the time because weeds got in the water-jets. They improved them after 'sixty-six; my second tour they had aluminum gunwales, and Jacuzzi jets. We went faster like that, about twenty-nine knots on a good day. But you know, it was police action, always stopping and searching people. It wasn't sailing, that's for sure."

"Shit, man, you're lucky to be here. And now you have a hotline to God. Well, we may well need it, though I sure hope to hell we won't need the burials at sea. Praying never hurt, on board a seagoing vessel. You're on. Just don't let me regret this, okay? And go get your jabs, right away. Yellow fever, malaria, and cholera."

"Okay, cap'n. Thanks. I'm glad to be sailing with you." They shook hands across the desk, McCall leaning forward across his scattered papers, a cigarette in his mouth.

"We sail at dawn tomorrow. Till then, preacher. Pray for fair winds and a following sea!"

HE'D known it, since the day he opened the church door and let those birds out. Change was coming. You couldn't go through those days and not have them change you, you couldn't put yourself in the lap of God the way you had to with a storm that size and expect to go back to normal, whatever normal was. He'd been scared the way nothing had scared him since those days of the war when you loosed

your own terror only by scaring others to death. He'd been there, under the table, bargaining with God. It was the noise that did it, that was first outside him, and then came inside. That roar. I'll do anything, give up anything, I am at your mercy. And things had begun happening, people came to him—Pearl, Sarah—and others, Susan, Charlie; then Sarah had gone away. He'd been washed up like a piece of driftwood, he'd been flotsam, at sea in his life, bobbing in the darkness in the ocean of his aloneness. And then the god-damn choppers. Places you could only get to by boat or chopper. No wonder he couldn't preach to others, give comfort, pass on anything solid for them to hold. No wonder he'd failed. He'd based it all on what he needed himself, pretending to give to others, feeding his own need for safety.

Standing there in McCall's office, he had felt how much he wanted this chance, to be part of this journey. It was what he had wanted as a kid, even before he was drafted and sent to California to train. He simply wanted to be useful, to belong to something worthwhile. You had to find out the hard way, what was worthwhile, what was not. You couldn't regret it, having been there, knowing what it was, that war. If he had his life over again, would he still have gone? It was the one thing he couldn't explain to anybody. But Captain McCall, without even asking, had understood. Now the *Black Cat* was sailing in the morning, and he would be on board. As men had for centuries he was going to sea again to discover what could not be discovered on dry land.

HE hadn't heard from her. She would be back in her apartment—he tried and failed to imagine it—and back at work, maybe writing her article about the Florida he lived in, its flimsy arrangements, its constant damage. It was to be part of a whole series on global warming and extremes of weather, he remembered; then there was another she had planned to do, on the Florida Aquifer and the teams of divers who went down through the earth's crust to check on its levels and measure its pollution.

It was all very well to retreat to safe New York, he thought, and

leave him as if he too were a piece of flotsam. Something angry and dangerous in him stirred at the thought. But he was going where his thoughts and feelings would not be needed, where he would simply have to put them on one side and act. It was what men did, what they had to do. It was everything that he had moved away from since he came back from Vietnam: action, in place of feeling; movement, in place of introspection. Sometimes you just wanted to shut down and do what was needed, what was asked of you. It was, these days, a nearly forgotten part of being a man.

THERE was room for nothing else. No sooner was he set to haul lines on one side of the boat, than McCall shouted out that they were going about and he had to skid to the other. His hands were skinned after a day at sea. His back hurt and his legs cramped. The sailing was as McCall had said, the old-fashioned way, with lines to haul and belay and sweat on to the pins as the heavy sails were raised. The boat, a two-masted topsail schooner, seventy-six foot, metal-built, rose easily to the seas on the way out. Nothing got in their way. It was easy and smooth as a day cruise, all the way down. But for Jim it was rope burn and muscle ache, nights jolting in a narrow space, a sudden wave of nausea as the bow rolled. The crew all slept on boards set on top of the provisions, the sacks of beans and rice, the rolls of tarpaper. As the ship rolled, they slithered about, rolling into each other like babies. Jim, offered a turn in the fo'c'sle berth, curled into it like a fetus and slept, hands between his knees, until someone came to shake him awake for his watch. Then, feeling sick, he stumbled up the companionway and out into the stinging air.

He breathed in space and distance with the salt air. His eyes raw from lack of sleep, hands tingling. These nights, on watch with stars and clouds and the glittering water, when he took the wheel to steer, he was elated as a boy.

Guanaja, he'd been told. A name he'd never heard before. It was a small island off Honduras and it had been hit hard. Some young guy down there had contacted Reef Relief in Key West and asked for help for the shattered community. The hurricane had hit in the last week

of October. It had hit the barrier island twice, once on its westward track, again when it turned east. The eye had hung over them, while they had waited to see where it would turn, and what their fate would be.

It took them eight days of sailing southwest, around the end of Cuba, down the coast of Mexico, then east along the coast of Honduras itself. On the ninth, McCall said, they would make landfall in Guanaja. The island looked like the mangrove islands of the Keys, from a distance; but as they came closer, Jim saw that it was rainforest growth, only every tree had been whipped by the hurricane till it was leafless. The far end of the island was mountainous, lumpy mountains coming out of cloud; at first he had thought they were clouds. The vegetation had looked low-lying like mangroves simply because every tree had been torn up or picked clean. All that was left standing, as they sailed into Mangrove Bight, as the little port was called, were broken sticks, snapped off like pencils.

A patrol boat had spotted them, came out to bring them in. Suddenly, as they came within sight of the shore, small dive boats had appeared as if from nowhere, with men in them shouting in English and Spanish. The cargo that had taken two days to load was unloaded in two hours, and the little boats sped away, gunning their undersized outboards, back to the shore.

"We'll go through customs later," said McCall, grinning into his beard. "I heard they take everything themselves. The mayor just helps himself. This way, at least the people will get what they need."

Duct tape, claw hammers, curved hammers, steel sixteen-ounce hammers, hand saws, screwdrivers, plywood, 150 sheets, flashlights, utility knives, batteries, aerosol WD-40, rakes, garden picks, shovels, screws, tin tabs, roofing nails, felt paper, tarps, diapers, canned meats, canned vegetables and soups, baby food, juice, rice, penicillin, bandages, painkillers, vitamins, bed-sheets, towels, soap, tetanus vaccine, water purifying tablets, toilet paper: the ingredients for restarting a life.

They anchored offshore in the bay and took a small boat in. When they went in through customs, there was nothing left. Honduran

troops stood on the quay with AK 47's ready in their hands. "We already unloaded," McCall said waving a hand with a cigarette. There was nothing more to say.

Then Jim understood what he had not understood with his eyes and body before. Damage could be like this. The hurricane had stalled for thirty-six hours over the island, its eye only miles away. It had blown them to bits. All the flimsy buildings were down, the docks blown away. Out of several hundred houses, only eight were left standing. Twenty-five-foot waves had pounded the exposed north shore. People had lashed fishing boats together to make rafts and had run them full throttle in the only protected inlet, just to stay in place. On the narrow white beaches, people wandered up and down looking for pieces of driftwood to rebuild their fallen shacks. They looked shocked; had been unwarned and unprepared. No one here had been told by endless television weather reports or computer graphics that a storm of this size was on its way. A few only—nine people, at the present count—had been killed outright by the storm; the rest were simply made homeless, or tenants of roofless huts, the walls blown in.

A storm like this made nonsense of men's efforts. It left them wandering and vacant-eyed, childish with surprise. Even the island had changed shape, having been a peninsula, slimly connected by a sandbar; the sandbar had been blown away and the ocean had rushed in to make a new channel and a new island. Even the topography was new. He thought of sea charts of Florida on which was written: "Everything on this chart is subject to constant change." What he saw was the fate of the unprotected world.

Constant change, Jim saw, was all there ever was. It was life. It was what life was when the protection, costly, addictive, finally illusory, was taken away. It was the burned space where his own house had stood. It was Susan, gone, wanting a divorce. It was the shifting uncertain ground of his relationship with Sarah. It was everything that he had lost, and gained, since that original wind had struck. But this was on a different scale: these people had lost more than anyone in Key West could imagine, and it would not be returned to them. There was no insurance here, no FEMA, no Red Cross meals, no instant

reroofing, no giant machines roaring in from out of state to repair the damage, cart away the debris. Mainland Honduras, he heard, would take a century to recuperate, as the aid money simply did not ever get there. Poverty was having what you had never even received taken away. It was being stolen from while you had nothing. It was a double zero, a black hole.

SEAN, who had been a medical student, set up a makeshift clinic, with Andrea, the young deck hand, to help him. A red-haired man dressed in ragged cutoff pants and a soaked T-shirt showed them the way to a house which could hold patients and they began to set up a tent beside it. Jim and the tall redheaded man dragged the boxes of medical supplies across the sand, past smoldering fires where the remains of trees burned.

The wild-looking man said to him, "I'm the minister. My name's Tom Sykes. This is great. Wonderful. This stuff is going to make all the difference." His accent was thick to Jim's ears—was it Scottish? Irish? Tom Sykes shook his hand and he felt the calluses in the palm, the hard fingers.

"Hi, I'm Jim. I used to be a minister too." It was the first time of saying it in the past tense.

"Reckon you never had a parish quite like this one?"

"Well, no." He wanted to ask the man, how do you stand it? How can you face this hopelessness, day after day?

"We do what we can," Tom Sykes said. "Sometimes all we can do is be here." It was as if Jim had spoken aloud, or he had picked up his thought. "People have a lot to deal with in this world, wouldn't you say?" He lugged a box across a splintered floor and stood up, wiping his face with his arm. A black smear marked his cheekbone, and he had not shaved for days. "We pray to God," he said simply, "and look what happens? God sends you. But," he added, grinning, "we send messages through the government too. And faxes, when we can."

This man, younger than he was, had hung in here as minister, praying for help, collecting driftwood, heaving boxes, knowing that the island would be in need of aid for years but not whether it would

come. Usually, he said, aid stopped on the mainland, and never reached here. "We had to have a pirate ship to get it here." They both looked back to where the *Black Cat* was moored, the skull and bones replaced by the yellow quarantine flag at the yardarm.

"You said you were a minister?" he asked Jim as they passed a bottle of water back and forth, slaking their thirst with as little as they could. The water was warm and tasted of plastic.

"Yeah. It's a long story. But, well, stuff happened, and I found I couldn't preach anymore, or even hold the congregation together, and then my house burned down. I left because I wasn't doing any good. At least coming here I thought I could do something."

Tom Sykes listened to him, watched him with intent blue eyes that looked bleached by sunlight. His rough hair was reddish, his skin tanned the deep freckled brown of fair-skinned people after they have burned off a whole layer. His face was encrusted with salt, and it lay in the hollows of his cheeks, his eye sockets. "How did you know you weren't doing any good?" His hands were raw-knuckled, his feet bare and bony in sandals made of old tires.

"I felt it. I felt I was out of touch with God, and people. I got to feeling that I was only there to make myself feel better, and even that wasn't working." It sounded to him simply self-indulgent now. Yet the man was listening to him, watching him with a rare attention, his blue eyes alert.

"What were you doing? Just preaching?"

"That and cleaning up the church, from time to time. Gardening, weeding, stuff like that. Maintenance."

"So, how did you get here?"

"I did the first thing I could think of. I walked down to the dock and signed on as crew."

"Hmm," said the wild minister, picking a thorn out of his toe. "God organizes things in strange ways, would you not say? Sometimes we just get moved on, whether we like it or not. Now, let's see if we can give the young doctor a helping hand. It's lucky, not too many people have been hurt. It's mostly injuries that have happened since the storm, cuts from broken wood, someone hit his head on a roof

timber he thought had blown away, but it was still there. The tetanus jabs are important, with all this rusty metal around. Some kids managed to find some poison ivy, and a woman ate a dead fish she found and got sick. Everyone's suffering from hunger and dehydration of course. We should be able to manage." He spoke as if there was little that could not be managed. He looked at the thorn, rubbed his own blood away with his thumb.

"Where are you from? If you don't mind my asking?"

"Here. I live here."

"I mean, originally."

"We're mostly descendants of Scottish and English pirates. Few of us are Hondurans, really. I mean, we are not racially the same." Again, the burr of his speech, the slight archaisms to an American ear. Jim wondered if the man would spend his whole life on this strip of land, until it was completely washed away.

"Now, have you met the mayor? He is a true Honduran, his name is Julio Esperanza. That means hope. A good name to have here, would you not say?"

JIM napped for half an hour on the dock, muscles aching from the day-long work, and only woke when he heard a series of bumps, as if something, maybe a moored boat, was knocking against it. Above him was a roof of sky, and for a change what he lay on was not moving. He sat up and saw a gang of little girls, three of them banging patiently on the dock with sticks like people announcing an event; three little girls, quickly joined by four others, aged about two to seven as far as he could guess. They looked at him, scared but bold. Their hands outstretched, palms upward, where they stood in line and jostled each other. Someone must have told them to come. What could he give them? Then he knew. He heaved himself down, went to the supplies that were stacked at the base of the dock and felt for the plastic bags full of stuff donated by the hotels, things that had looked too small to be useful, miniature wrapped bars of soap, plastic bottles of shampoo and hair conditioner and tiny toilet kits made for hotel guests. The toys of rich America. He watched them. Their dark bent

heads as they went through the booty. The older little girls, serious and organized, divvied up the spoils. They wore ragged dresses and had their hair either in rattail braids or in clouds of tangled black and brown. He stood above them, looked down, saw a white path in parted hair run down a narrow head; small hands passing out little soap bars like dealing cards, like the beginning of a poker game. Then, he thought sharply of Sarah, of telling her this. The little boy, whose hand had found his yesterday, "Will you come see the wall we are building?" Now these small girls. The children were like the birds he had found in his church back in September, small, bright, agitated, fearless. He wanted to tell Sarah about them, because she understood about connections, she was at home in metaphor, in parallels, these twists of life. It seemed intolerable not to be able to tell her. But where she was now was so far away that he couldn't even imagine her. She had removed herself from him; he was on his own.

The children went away, carrying their spoils between them, serious as a group of adult women. Not a word had been spoken. He watched them go, tiny, stick-legged, upright figures, down the beach, the bags swinging between them. From the shattered village came the sound of hammering, the scrape of a saw. Turkey vultures overhead circled, no doubt looking for carrion. The morning was still, the air washed.

Everywhere, he saw, looked like a war zone. This was what a category five hurricane did. There were a few tents, discolored khaki, and wrecked houseboats slung up against the shore. Birds and small animals flung up into the branches of the stripped trees, flattened there to two dimensions, like stiff clothes hung out to dry on a hedge. Not a single fucking living creature left, that was not human. I want to remember this day, he thought, how it looks, how it is.

Last year, Tom Sykes told him, there had been floods. People here waited for the sea to come in and take everything away. They put things up which were almost immediately knocked down. They prayed, and asked for help, and sometimes help came. There were no guarantees. He thought, I have become used to life not being like this; in my country things are put up again, everything is set wildly into

action, so that it will all work. Things not working are unthinkable. That was the shock of the hurricane: casual wreckage, unmotivated destruction, erupting into the lives of those favored few who had thought themselves so safe. It was why his life had blown so wildly off course, why he felt himself so hollowed, so lost. But compared to these people, he had lost nothing that he could not afford to lose. Sarah, he said, as if into a dead phone line, wait for me. Be there. I am coming back to you. We have lost nothing, nothing.

ON the day before they left, the mayor, Julio Esperanza, made a speech. It was partly in English, partly in Spanish; Tom Sykes translated for him when he hesitated or the visitors looked confused. Only McCall and Sean, the mate, were fluent in Spanish.

"We thank you for coming from the bottom of our hearts. You have helped us when we did not expect help. You have brought us what we needed so badly, and you have also worked with us, until you are tired. You have become part of our family. It may take us many years to rebuild our lives here. We have lost much, but we have not lost our spirit. And you have brought with you the mercy of God. You have been our salvation."

The crew stood listening with tears in their eyes. Spider, the chief engineer, ducked his head under his battered straw hat and fidgeted his feet in a little dance as he often did when he took the wheel. Sean, exhausted and sunburned, let tears run down his face like rain. Andrea was rubbing her eyes, pushing back her sweaty, dirty hair. It was the moment they had not expected, the moment to feel things and be left with their feelings: no activity, no cigarettes, no rum to stave off the sharpness of what each one had been feeling for days. McCall cleared his throat and made his own speech, his hands behind his back, his head bowed as he thought what to say, and then lifted to face them all. He wore his filthy white shirt and stained jeans, and his hands and face were crusted with grime. But his captain's hat was in his hand and he spoke clearly, so that all could hear.

"We pledge ourselves to return," he said, and repeated it in Spanish. "We will come back every year, to bring what you need. This is

only the first of many visits. You have welcomed us into your family; and who leaves his family in need, when he can help?"

There were cheers, and the ragged people waved their arms in the air, and the little girls danced barefoot on the sand. Their hair had been washed and combed and made shiny with conditioner, and the ends of their braids were tied with colored string. They wore Christmas tree baubles strung from their necks. Jim thought, I know now what it feels like not to want to leave. He looked for Tom Sykes, who stood a little apart from the other villagers of Mangrove Bight, his arms crossed on his chest, listening to McCall.

"Hey, minister!"

"Hey, sailor."

They gripped hands, as they had when they first met.

"Go well. And God bless you." The man was taller and younger than he was, and had come from somewhere quite else; but Jim felt as if he were saying goodbye to a brother. Or as if some better part of himself was being left behind.

ON the return journey, the *Black Cat* was at sea for ten days. Storms came up from the Yucatan channel and pursued them, blowing them back towards the Caymans, as far north as the western end of Cuba. There, suddenly, they were out of fuel. There was no point in blame or recrimination, it was simply what had happened when nobody was looking. An early winter storm, and for two days they'd made fifty miles of sternway: going backwards, with three sails blown out.

McCall fell asleep briefly one dawn in the pilot's berth and woke, he told Jim later, to find the knowledge in him instantly, a physical certainty, that the boat was going the wrong way—180 degrees out. There was a gray ship chasing them down on the port side. The gray ship gave him nightmares; his boat had been searched for drugs before, crew members lined up on deck for hours at gunpoint. But no, it was not to search them this time, but to offer help. A U.S. Coast Guard boat, it came alongside, the men boarded and gave them fuel and band-aids for the first mate Sean's cut hand, sliced open with a galley knife, since all medical supplies had been left behind on

Guanaja. There was all this to deal with, injured men, no fuel, not enough supplies on board to feed themselves on much except soft potato chips, warm soda and rum.

On sea watch from eight to midnight with Sean, whose hand was in a bandage, they battled with the wind. The wind that had chased them nearly to Cuba and had swung round in the night, so that now they were facing into it. The struggle to move against the forces of the universe, wind out of the north, currents that hauled them backwards, stars that swung across the sky, the moon that dragged the oceans setting before midnight, a pale stain leaving the sky, deep darkness afterwards. Jim stood for hours at the wheel, spinning it between his hands, his eyes on the red needle of the compass, then on the star that shone through the rigging. Polaris, the north star. Directly to the south, Sirius. The cold planets, the stars of winter: dead stars, their light only reaching this far eons after their death. The wilderness of water. After several hours, you couldn't see what was before you; the eye conjured up shapes in darkness, trees, giants, moving lights where there were none. Was that a coastline? Or cloud, or simply something inside the eyeball strained by staring into the dark? For centuries, men had done this. They came home with stories of mermaids and sea monsters, men with heads below their shoulders. In the fatigue and wildness of the night, eyes straining to see, to interpret, the fantasies of what might be out there, that would fuel the stories they would tell. Nobody, Jim thought, would be able to do this day after day, week after week, month after month, and come home still sane. Sean called back to him sharply from the bow to change course by ten degrees. The captain was sleeping in the pilot berth just behind him, in the stern. He swung the wheel lightly, then steadied it back. The ship, like a huge animal, obeying him. The red needle darting back and forth. The red numbers. Slap, slap, the movement of black water. Waves going on forever. And the rocking masts against the sky, dipping, rising with the movement of the ship. White water flowed across the bow, ran down the deck. Over the closed hatches, where people slept in heaps below and clutched at each other in dream. Those earliest sailors had known this, the first ones to cross

the world, the press-ganged, the enslaved, the masses needed to work the New World. In the belly of a metal ship, men turned and flung out their arms to grip on as they had for centuries. While on deck, he steered and steered, loving it, appalled, his feet splayed and knees bent to take the wheel, which juddered and snatched like a horse at a bit, and Sean hung in the bow as lookout, his shirt a gleam of white, his dark vest, his head like cotton. McCall came quietly up from the pilot berth to check on their progress. He was silent and sleepy, stood to piss over the lifelines into the darkness, rolled a cigarette between his lips.

"You okay there, padre?" His hand briefly on Jim's shoulder.

"Yeah. Great." Words seemed to have dried up in him, these last days. They were few and sparse, all that was necessary, as the food was sparse, the crumbs they fed between their lips, the sips of water.

"Keep that course. The wind's right on our nose again, it's all we can do. Good thing we can use the engine, at least for now. Chief seems to think we're about to run out of oil." He sniffed the air, rubbed a hand around the back of his neck under his gray tail of hair, went below again, to lie lightly sleeping on his back on the narrow bunk right next to the navigation desk where the charts were laid out, his hat still on.

Jim Russo thought, there is no God but this universe. How can I have believed in a personal god, a hand-holding god, a kind and attentive individual, paying attention, of all things, to me? I see it now, there is only wildness. Wind, ocean, stars, planets, the immensity of it all. How can anything less than this be true? And he peered into darkness, past the phantom trees and hills, the whole cities and islands, the giant cauliflowers, the scene-shifters running about in the dark with their lanterns on long sticks to confuse sailors by moving the stars. It is beyond me, thought Jim Russo, the wheel between his hands and his feet slipping on the wet deck, and his heart lifted and swelled like a wave that would go on and on.

AT last, at ten A.M. on the last day, they reached Sand Key, where the rusted-out old light stuck up still over a patch of sand that had once

been an island. They passed its red skeleton, avoiding the sand bar, coming in down the channel that would lead to the Lakes, and at last, the ship channel into the port of Key West. Everyone began talking, he would tell Sarah later, about where they would go for lunch. The Thai Restaurant, on Front Street, was the vote in the end. Cold Thai beer, yes, and chicken satay. The smell of lemon grass already in their nostrils, their stomachs growling, the line on the horizon that was Key West, in sight. But the tide and wind were against them still, and the last lap, that last tantalizing stretch of water, took seven hours to cross. Seven hours! But morale on board was good, all the way. They were all lighthearted with relief at homecoming, at having survived; lightheaded too with lack of food. They were a ship's company, an entity where they had been single beings, and would be single beings again.

"What else? Tell me more!" He's imagined her insatiable for his stories, his mariner's tales. He's had to do this, to keep going. It's unimaginable, yet entirely possible, that she won't be there ever again.

"What else? Well, we had a whole bunch of dolphin around us around Cuba, saw scores of them in the Yucatan channel. A man spent the hurricane hanging from a tree, his legs flapping. All the small animals, even the pigs, had been blown away."

Yes, and it had reminded him, he would not tell her, uncomfortably of Vietnam. Small people, flattened by disaster; the faces of those who had nothing left. The calm face of Tom Sykes, who knew all this and yet believed in God's mercy, and did not want to be anywhere else. The little girls. The little girls so happy with their minuscule soaps and tiny bottles of shampoo, walking with such dignity away. He would, he must one day tell her about the little girls. Was this what love was, the urgent desire to go on telling someone, to communicate how you saw the world? To stand beside them, saying only—look!

"SO, what're you planning on doing when you get back to dry land, padre?" McCall stands beside him as they come down past the islands, Sean at the wheel with his eyes squinting into the light, an unconscious imitator of the captain. He flicks the wheel between his bandaged fingers, looks along the long lines of the ship to the bow,

calls out to the bow watch. McCall watches him, takes a drag of his cigarette. He's training up these kids to take over, Jim thinks. They are swift and barefoot on the deck, their ragged pants hanging from leather belts, one with long hair tied back and a scarf knotted pirate fashion; Andrea, slim and fast as a boy; Sean, spinning the wheel between his hurt hands, calling ready about, tacking up the difficult channel to save fuel, till he'll turn on the engine just outside the harbor mouth.

"You could use the engine now," McCall says to him. "No need to save fuel now; everyone wants their lunch. But you did good, Mr. Mate."

Jim is thankful for the time between the question and the answer. "I hope there's a woman waiting for me. There's not much else in my life, that I'm aware of, but I hope she's still there."

"Sure, every sailor there's ever been hopes that, when he's coming back into port. But you never know, that's the thing. What they get up to when we're away. You never know."

"I guess that's what makes life interesting." He feels McCall's eye upon him, still curious.

"No more preaching, then?"

"Nope. That's over. I quit. I couldn't see going on with it, not after my house burned down and my wife left."

"Well, that is quite a situation. Know what you'll do next?"

"Get a hot shower and a big meal and go looking for my woman. No, I'm not sure. Guess it might be time to move on, though I've been here more than twenty years."

"You got religion after the war, right?"

"Yeah, I guess that was it. But you know, preaching's a funny life. You always have to be so damn right. That's what I can't do anymore." He wants to say more, but the big engine kicks in then, its throb drowns their voices, and McCall has the crew run to the lines, hold them on the belaying pins and lower the big sails down. "Hold on the peak! Steady!" The lines are played out and the sails collapse into themselves one after the other with their rips and patches and are folded like laundry.

"Take us in, man," McCall takes the wheel from Sean and hands it to Jim. "Go ahead. You've got a watch on the bow, they can see what's coming. Just drive."

He drives. Miraculous, the turning ship under his hands, the whole length of her sliding into port. He slows the engine. The space between the bow and the dock narrows, deep stirred-up water, a margin of error.

"Okay, slow. That's good. Now back her in. Reverse. Just a couple yards. Okay. Kill the engine. We're in." The deck hands run to cast lines ashore, from the bow, amidships, stern.

The black ship lies along the dock, fenders in place, lines on cleats, and there is sudden quiet after the engine roar. Jim wipes his palms down his pants. "Why d'you let me do that?"

"Because you can. Because I knew you could."

"You trusted me not to hit anything? I could've smashed your boat."

"Let's just say, I knew you wouldn't. Hell, man, why d'you ever leave the sea? You don't belong in a church, far as I can tell."

Everyone stands there on deck for a moment, in the sudden silence. McCall and Spider light up their cigarettes and Jim has a brief longing for that first burning intake of smoke. Andrea slips an arm through his, "You did good." Sean cuffs him as he passes and says, "Good sailing with you, Jim." He wants, longs for their approval, and they give it lightly, no problem. They've been together all the way, and that's what counts.

When they stand on the dock, the earth rises up in a way he remembers. It rocks gently beneath him. It's the movement of years ago, of being young, and going ashore in foreign towns. He laughs, and McCall shakes his hand and says, "Good to have you with us. Come again." As they go for the first long slaking cold drink, with ice, in a frosted glass mug, the way he remembers; only this time it's not beer but Coke, and he's not a lost boy frightened to open his mouth and wanting drink to fill him and make him a man.

It's after Christmas. Maybe it's even after New Year's. He's lost touch with time, or time has abandoned him. He's in some unguessed-

at present, which goes on and on. No home to go to, no job to do. Empty-handed on the street, nothing to offer to anyone but himself. Land, he remembers, is different when you come back to it from the sea. His body remembers this fact. He has rejoined the ranks of men who leave, who go to sea in order to simplify their lives and come back to find waiting complexities like packed trunks, their contents undisturbed and unsorted yet somehow made irrelevant by absence. Some things you do not need in life. Coming back from a sea voyage, you know instantly and precisely what they are; in this moment, in which needs and habits have dropped away and not yet crept back to reassert themselves. He walks towards the town he has lived in for more than twenty years, experiencing it as a stranger. It's like coming quietly in through the back door of your own house, only to leave again. That he has no house hardly seems to matter. Houses are not where life happens, he thinks, they are where the wind, sun, and water have been shut out. Perhaps he will not need a house. A home port, only. A free man, an empty man, a man able to offer perhaps to another what he most needs, without craving its return. Who knows what winds come that make animals fly through the air and buildings blow out to sea, that catch men up and flatten them to hang in the branches of ripped-apart trees like a crucifixion.

Will she be here or will she be gone? He walks with his slightly rolling walk after the days at sea, in the direction of the house she has given away to others. Now he understands her need to give. Now, he isn't shocked or alarmed. It's in the nature of things, after all. It's what has to happen. It's what he has only just understood. He mutters, a phrase like the ragged edge of prayer. But even that isn't it. He can no longer clutch and hold on, beg and plead, bargain with God. That begging voice in him is gone, is maybe caught forever and held in a bare tree in Guanaja, drying in the wind from the sea, a shadow against the sun.

19

SARAH CAME OUT OF THE LITTLE Key West airport, hailed a
pink taxi with a young driver cruising, his brown arm on the rolled-
down window, and gave the address on Olivia where Martha lived
and where her own house was. It was just after Christmas and she car-
ried gifts, perfume for Martha, a single malt whiskey for Tom, a big
soft teddy bear for Molly, a shawl for the new baby on the way. The
bear's face stuck up out of a plastic carrier and made the cab driver
smile.

"Looks like you're visiting family, am I right?"

"You're close."

"This the one?"

"This is it."

She was still dressed for a northern winter, for work in the city,
her pants and sweater wool, her soft leather coat over her arm; she
had gone straight from work to La Guardia and from there to Miami.
It was just for signing over the house, making it legal. A few days, a
long weekend, and she would be gone again, that's what she was say-
ing to anyone who asked. The streets of the city she had found in
ruins were now swept clean, mended, the houses all being worked on
by carpenters and roofers. Only the trees showed what had been:
stumps left where there had been giants. New little palm trees rolled
tight like Christmas crackers were being stuck in new holes in the
sidewalk on some streets. Everywhere, Christmas lights hung on the
houses, were twined in the branches of trees. The whole town had
been rapidly mended, made fit for tourists, for the Christmas season.

Fatuous tunes tinkled, bulbs flashed red and green, one house had a giant inflatable Santa bulging out of its side. Martha's house was its usual self, but she had lit candles, set them in the windows, and as Sarah stood on the high deck, calling out to them, she saw a small lit tree.

He must be here, she knew, because Martha had told her on the phone that the *Black Cat* was back in dock. She would see him, then. She would resume her position as old friend, now ex-lover. Have a quick lunch somewhere, a cup of coffee. It would be easier, coming straight from New York, coming in from the outside, from work, from her colleagues at the paper. That was what she had told Martha, on the phone. "We'll just do the paperwork, go down to City Hall, have a drink maybe, and that will be all."

Martha didn't ask. She hugged Sarah, then Molly yelled and she went to see to her, carried her with her to the door. "You've brought all these things!" The little girl had a ribbon in her hair, was no longer quite a baby. She looked shyly at Sarah and held out a hand, palm up and then snatched it away again. The gifts Sarah had brought lay about in bags on the floor. She had felt the hard small mound of Martha's belly when she hugged her.

Love, she thought, has never found me where I am. It has tried. It has come close. Now, I know that it never will.

ON the wall, in the bedroom of the house that was about to be Martha's, a handprint, hers. He had come into her when she had not had time to wash, and the dust and sweat of her outstretched hand was on that wall. Anybody could see it. It would have to be scrubbed, painted over. Then there were the tiny signs, the hairs they had loosed from each others' heads, the liquids that had seeped into the sheets, the mattress, the marks of their bodies, secretions, spores, sloughed skin, the invisible dusts and grains of existence. Once again in the same lifetime they had come this close. She had told him, he could have been anybody. Her first lover and then her latest. A role, a part to play: an empty space into which any body could fit. What more did you have to feel, to make it essential to be with somebody,

to remove all doubt? Or was there always doubt, was it a territory over which you shifted continuously, back and forth? She thought, I will never know. It's not possible to join somebody else's life. As soon as she came close, the other person's life seemed to splinter and founder and become essentially unstable. It had happened to her over and over again. One man got ill and died, another was compulsively unfaithful, a third was married to somebody else in another country, and now Jim, who had had a job, a house and a life, albeit a married one, had become flotsam on the wind of a hurricane.

"AREN'T you going to see him?" Martha asked her. "Are you sure, Sarah? Sure you're not throwing something important away?"

"I'm sure."

"How do you know?"

"I had time to think about it."

"Well, what did you think?"

"I think I'll be better off on my own."

She saw Martha's frustration with her, her young woman's optimism that everything was always better if there were two of you, her annoyance that things were not the way she'd thought.

"Martha, let go, okay? I do know what I'm doing."

"Oh, God, you're so unromantic! It hurts!"

"I tried being romantic several times in my life, and it never worked. No, sex is one thing, but living with someone is definitely another. I know, Americans are supposed to believe they're one and the same thing, but, Mart, I grew up."

Martha looked at her for a moment so that she felt the easy cynicism of what she had just said. "What?"

"I don't think you realize. I mean—I know I'm a lot younger than you, but I have to say this—nobody's going to be good enough for you, if you think the way you do."

"Oh, God, Martha, that means what, exactly? That I should shack up with the next person I see?"

"No. Just think, do you want to be alone forever or take a risk, let

somebody in? You think everyone's just stuck into romance and happy ever after? I do know, Sarah. It's work, like anything else. But it's worth it."

THE two women outside on the high back porch, a bottle of wine between them. A frog hiccups. Tom, back from the Med, lies on the couch indoors, watching TV with Molly sprawled across him, asleep. The winter night: stars and a thin moon, graves glowing white in the cemetery below.

"So, did you hear how the rescue mission went?" She tips back her wicker chair, her feet on the rail.

"Seems like they did a good job, delivered the stuff, helped people out. McCall was happy with it. Said your guy was a good sailor, he was glad to have him on board."

Your guy. "He's not my guy, Mart."

"Well, you know what I mean." She fills Sarah's glass. The moon tips down the sky, Venus very close and brilliant, hanging off the bottom corner, a jewel from an ear. "I'd just love to see you happy."

"Okay, okay. Isn't you being happy enough?" She sees Martha's belly beginning to swell under her big shirt. Sees Tom's hand caress in passing, in the house, between the furniture; the nape of her neck, her cheek.

"I just want everyone else to be, too."

"Well, we can't all be huge and pregnant. I think it's your hormones speaking."

"Maybe, maybe not. You sure about the house? No last-minute regrets? There's still time to change your mind."

"No, I'm sure. It's great. It's exactly right."

"Have you ever thought, how with only one life, we only get to live out part of who we are? We're always making choices that leave something out. We have to. I mean, having two kids I'm leaving out the part of me that wants to go sailing around the world."

"Not forever."

"Probably not forever. But you never know. It could be forever. The strange thing is, I don't regret it."

"You're very complete. What the French call 'entière,' An entire person, all or nothing, very clear."

"I am?" Martha stretches her arms, clasps her hands behind her head. Her armpits soft with shadow, inside flesh white. "Yes, I guess I've always been this way. Lack of imagination, is what some people call it."

Each thinks at the same moment, this is friendship. This is what it means. They exchange a glance. Below them in the jungle of leaves a cat fight yowls into action, there's the long purring roar of territorial defense. A chill wind starting up from the north makes them go in, at last. One by one, the lights in the house beside the cemetery go dark.

THAT night, in the house which was still hers and would be Martha's tomorrow, she dreamed, woke from the dream, and lay there wide-eyed, shaking, at four in the morning, all senses warned. A body fell from a high window and she was there in the courtyard below, watching the body come down. It would land at her feet, explode into pieces before her eyes, flesh smashed, bone splintered, she would have to see it, what she had not seen. She stood, and the courtyard was dark, and the body fell and fell and never hit the ground. She cried out, *No!* But the sound was carried away harmlessly, was a bird's squeak, unheard. Then someone had hold of her hand and was hurrying her away from there, and she would never have to return.

She sat up, switched the light on and looked around her. The clock said 4:10. It was dark outside, and twigs scraped at the shutters, she heard the night close and intimate in a way it never was up north, the tropical night even in winter with its hands and eyes, its living invisible creatures, lizards and frogs and bugs. She had come back to Key West to sleep alone in this room, to dream. She swallowed water from a plastic bottle, threw back the sheet and blanket that she'd pulled over her against the sudden chill. Georges. The name of a hurricane and the name of a young man who had killed himself, who seemed to want to kill himself over and over in her dreams. The human body. That young, pliant, unbreakable thing. But why now? The body in her dream fell and fell and never hit earth. Who was it, who was falling,

who fell without arriving, without any outcome? Who, after all this time?

Sarah got up from the wreck of the bed, the mattress she had shared with Jim only months ago, wrapped a shawl around her shoulders, and went into the next room, where the phone was. She thought, I must speak to him, not avoid him. That much is clear. He isn't the only one who has dreams. But, I have no idea where he is. Asleep on a moored boat? In some harbor, close against some dock? Homeless and sleeping on the beach? Curled in a doorway, his head upon a backpack, his hands tucked in for warmth? Back with Susan, even, and up in Georgia already, going back to his old life? There's no way to know, and at this time of night, no way to find out.

She boiled water, made tea as usual with a tea-bag in a mug. Being here seemed to mean being sleepless, making tea in the small hours. The house was silent around her, hers for this one last night.

IN the morning, the baby-sitter takes Molly to the park and Tom, Martha, and Sarah walk down to City Hall. A morning of sharp light and blowing leaves: the sky is dark blue, the wind from the north; in the harbor all the moored boats rattle their halyards, move in their chains like tied animals. Few people on the street, it's early, people sleep in late in season. A huge cruise ship, dwarfing everything, has just docked, is there at the end of the street like King Kong with a town in its grip. In a few minutes, people will pour out of it; there will be chaos on the street. The city will tune up to its most raucous; in two days it will be a new year.

They sign the papers that transfer the house deeds, then cross the street to go into the lawyer's office, sign more, drink coffee from Styrofoam cups. The attorney at her desk swings her pale blond bob and is curious. She wears a pale blue sweater, a gold cross at her neck. "No money involved? Really?"

"No, a straight gift."

"And you aren't relatives?"

"No, just friends."

Sarah and Martha grin across the table at each other.

Tom's standing up, swaying slightly; one hand on the table steadies him. Can he believe in this? Is this how life goes, after all? His family has sold all its property in this town and now there comes to him, on a stranger's whim, the gift of a house. He sees Martha's firmness, her hand as she signs. No trembling about her. This is who she is, this firmness, this strength. It is why good things come to her. It is why he loves her. And the other one, Sarah, so willful, so strange at times, why is she doing this? It's a deal between women, it has no solid underpinnings, no reason, just feelings. It's whimsical, flimsy. Can he trust it? Then he sees the ink on the page, the hands wielding pens, the attorney's firm thump of a stamp. He shakes himself awake. If this is what happens, it's a new order, a new way of going on, and he is in a world he doesn't yet recognize. All the rules seem to have changed. He shakes his head as if to clear his ears of water. Martha, her hair pulled back into a knot, flashes him her blazing look of happiness. Sarah, pushing the chair back, reaches out a hand.

"It's yours now. Your turn to sign, Tom. Then we're done."

His hand, crawling across the paper, signs his name.

OUTSIDE in the street, the passing traffic, the well-dressed lawyers going across to the courthouse, people on bikes going to work, wobbling, café con leche in one hand, car horns, engines: the familiar throb of downtown on a Monday morning. He's been here all his life, walked every inch of this coral rock, played in every street, spoken to every person sitting out on every front porch, shouted the odds to the guys he's known forever. The city is subtly changed for him today, because he is a house owner, not a rent payer; because something that belonged to his ancestors has been given back. He's been paid back in full. He takes Martha's elbow, steers her across the street, Sarah coming just behind them, Sarah whom he has not known either to kiss or hug or simply thank. What do you say to someone who has given you back your life?

He sees across the street, standing on the opposite sidewalk, a tall thin man probably in his fifties, well-dressed in narrow pants and a jacket, with a white shirt and a tie, holding a bunch of flowers.

Something about the man is familiar. He feels Martha's elbow in his ribs, looks down to see her teeth caught on her lower lip as she prevents a smile. It's the preacher, the one who went AWOL, he remembers, who ended up on the *Black Cat* going down to Honduras with supplies. They're headed straight for him. The man looks uncomfortable, holding this big bunch of bright daisies, all colors.

"Hey," says Martha, "you and I are getting out of here right now. Turn left! We're going home."

Sarah is standing in the street with bicycles and cars passing; she is staring straight ahead.

Martha says to her quickly, "I couldn't accept what you have given us without giving you this." Then she drags Tom down a side street, out of sight.

"WHERE did you get the clothes?" She stands laughing in the sharp December light, her jacket open, hands on her hips.

"Thrift store. They have some good stuff these days, all these big shots who come here and want to get rid of their winter clothes."

"Brooks Brothers? It looks like it." She fingers the cloth of his shirt. He feels her close, breathing hard like an impatient horse.

"Martha told me I had to dress up."

"Martha?"

"She told me to be here, when you came out of the lawyer's. She said, wear something she's never seen you in before. She said, buy flowers."

"Gerbera daisies! I love them. But they weren't your idea."

"Well, I might have had the idea, but she's pretty bossy. Anyway, it's the thought that counts."

"Cliché, Jim. So what are you saying? Why are you here?"

"Isn't it obvious?"

"No?"

"I've come to—what do you call it—press my suit."

"I've never seen you look so spiffy. And the tan. It suits you."

"I'm a sailor now. Nor more indoor life. Sarah. You weren't really going to come without seeing me, were you?"

"I didn't know where I could find you. Are you officially homeless now?"

"No more than yourself, I think."

She giggles. "That's true. Neither of us has a place to lay our heads."

"That sounds Biblical enough. But tell me, do you mean, our heads, plural, or each one his, her, head—separate?"

"There are hotels, I suppose," she says, looking at him. Her eyes very green this morning, as she is wearing a green shirt. Her hair, brushed back as if she has been in a strong wind. She looks head-strong, reckless. She takes the daisies from him as if something has been decided.

"Yeah, there are a lot of hotels in this town." He holds her gaze, daring himself not to flinch. She will always be leading the way.

"Are you destitute?"

"Not completely. Susan cleaned out the joint account and collect-ed the house contents insurance. She's back in Georgia, by the way, she changed her mind about wanting me. I think that was for your benefit. But I'm working for McCall, and he says there might be work on some big ship out of Jacksonville."

"So, you're a real sailor now."

He smiles down at her.

"And that was all she wanted, in the end? Susan, I mean."

"Yeah. She thought I was a bad deal."

"Which you are. So you and Martha cooked up this scene? Crafty little witch."

"She said she owed you one. She said giving her the house you'd allowed her to want her new baby. She said you'd be glad, too, in the end."

"She did? Well, for God's sake. What can I say? How does she know?"

"Sarah. I don't want to rush you, but—"

"Oh," she says, and kisses him fast on the mouth. "Somebody said to me once, you have to learn to receive. When Johnny gave me his

house. So if you are my gift from Martha, I guess I have to accept you with grace."

MARTHA, turning from her husband's side, craning back to look, sees at least this: a man, a woman, neither of them young, both walking in the same direction, walking close even, like people who may have a future together as well as a past, for whom one season, or even two, may not have been enough. She grins and pokes Tom in the ribs. "Looks like it may have worked out," she says.

SARAH has her theories, of course, about the effects of weather on the human frame. Hurricanes, she concedes now, may have a more than basic meteorological effect. They blow right through lives and change everything in their wake. It may be the barometric pressure. It falls fast and is at its lowest just before a hurricane. Tornadoes are different, they suck matter towards them. Then they rip through space narrowly, taking only what is in their immediate path. If you want to know if water-spouts are likely, look for flat banked clouds. In Hawaii, she has read, silence is an earthquake warning. Imagine, not hearing anything, until silently the earth begins to move. Lightning, when it strikes, reassembles cells. It can stop electric clocks and start them again. People say that it never strikes twice, but it is not true; there is an American writer, she has forgotten her name, who was struck twice. It burns the shapes of people into furniture, it photographs you as you fizz in its power. In the Middle East, people are driven crazy by the khamsin, the wind that blows for fifty days, hence its name, Arabic for fifty. In the Mediterranean, she remembers, the mistral blows for seven days or four. Never more, nor less. Remember that, Jim? When it blows, you go indoors, shut shutters. It scours the sky and dries your mouth if you open it to speak.

There is a wind that comes in from Africa that brings red dust from the Sahara and covers everything with it. There are sandstorms, ice storms with hail as big as tennis balls. What effect do all these have upon lives? What chance do we have?

Surely, she says straddling a chair, her shirt hanging open, her hair in little points, darkened with sweat, surely the effects of weather have never been sufficiently investigated. We should start an investigation on extreme weather conditions and the speed and regularity of heart-beats, the amount of saliva produced, all the secretions of the body. We are atoms, caught up in movement—if I'm right, we are no more responsible for our actions than a butterfly in a high wind.

He lies back on the hotel bed, on the white sheets in the clean room in which no trace of weather has been allowed to enter.

"Are you saying that the hurricane changed me so that my heart beat faster and I produced more tears, more sperm, I secreted more and so you came and found me, and you, who were not even here, were changed by the pull of a low pressure system several hundred miles from where you were and driven to come here?"

"The whales were close to shore. Remember, I told you. When I went to Provincetown on the boat. The whales were feeding where they never feed. Perhaps they felt it coming. Who knows? Whales are bigger than we are, probably more intelligent."

"So, your thesis is that we are after all, after all these centuries, creatures of wind and weather, our emotions manipulated by low and high pressure, our mating determined by forces outside ourselves, our lives at their mercy?"

"Well, what did you see in Guanaja?"

"Nobody had time or energy to fall in love, that's for sure." But there was an opportunity to become a Tom Sykes, if you could only take it. Few people could, he had discovered, and he was not among them. He would tell her later about Tom Sykes.

"But maybe after a few months, they will. Maybe the energy of a new spring will shift them, like all the trees here getting their new leaves in September last year, and they'll all be fucking like bunnies. But seriously," she says, "how can we imagine what it's like for Alaskans, when the ice melts? Their food supply simply disappears. Tuvaluan fishermen are watching their islands disappear beneath the waves. In Peru, cities are facing the collapse of their water supplies, because of the retreat of glaciers. There are landslides, villages are

buried. In Mongolia, the herders are faced with blinding sandstorms. It's predicted that in the Caribbean there will be more frequent and more violent hurricanes. What we've seen is just a beginning. It's bound to happen again and again. It's going to happen here, where we are. Someday we won't be able to resist it, everything is going to go. Here we are, living at sea level as if nothing was happening. Some day, the ocean will just come in. Maybe even soon."

He thinks of the shock of Guanaja, the place the wind took; of men on the beach, exhaustedly picking up driftwood. How can these things be borne? She crosses to the bed, sits beside him, one bare leg tucked under her. The bones of her knee, little hollows at their sides. Her strong knuckled fingers, the cavities at her collar bones, like scoops in sand, beneath the open collar of the shirt. In her gravity, he finds her more than ever beautiful. The human body in its seriousness, wearing the marks of age, here for so short a time.

"The point is," she says, "we apparently can't pay attention, until it is too late."

He reaches for her, takes her hand and holds it to his chest. He doesn't want it to be too late, ever. Then, she comes down to him, her shirt open. Words won't do, but the body has its ancient consolations.

"WE should get up, go out, maybe."

"Are you hungry? We could call for room service."

"No, not yet, but it's good to know we can. Ice. That's what it's nice to know we can order, ice. It's a remarkable luxury. I don't think I'm ever going to forget that. Ice, and time, all I want."

"I don't think Martha is expecting me back any time soon, seeing as she set this up."

"They're most likely enjoying being house owners. You were right, to do that."

"I thought you thought I was nuts. To give it away." She lies along him, their limbs long and relaxed, like people who have been doing yoga. Their feet speak to each other.

"I don't anymore," he says. "I've learned the value of being homeless myself. And another thing. What is given to you, you have to give

away. You knew that, before I did. Mine had to be forcibly removed. Then, seeing those people who had nothing, who never would have anything—"

"You've changed."

"Yeah, I guess. I had to."

"I'm hungry now. Let's see what we can get."

"You don't want to go out, do you?"

"I want to stay here, Jim, because it's as near as I can get to living in the present, right now. I have a flight booked out of here tomorrow, don't forget."

"Are you going to be on it? Perhaps there'll be another storm. Perhaps they'll close the airport. Then you won't be able to go."

She leans towards him, runs her hands across his shoulders, looks him straight in the eye. He shivers a little, wants to look away. She has left him, she will do it again, she will always be doing it, as long as he knows her, as long as he lives. But he can stand still, now, he can stand there and be left, and have that movement around him, coming, going, in and out like the tide, and not be threatened. He has that stability. He takes a deep breath. He is not the man he used to be, down on his knees and shaking when the storm hit, when Susan yelled, when the dreams came, when everything cracked and opened around him and men fell through burning air and there were screams and someone died in front of him and life, maddening, meaningless, appalling, went on. He thinks of the little girls on the barrier island, gravely unpacking their tiny bars of soap. Of a man singing in sunlight as he gathered pieces of driftwood together to mend his shattered shack. Of the human effort, everywhere, to rebuild, remake, start again, no matter what has happened, no matter what force has struck. The patient, hopeful mending of a shattered world. He himself is matter, sucked at and blown by the elements, frail as a bird flattened into a tree; but he is also this solidity, this ability to mend. Her hand lies lightly upon his chest as if she is feeling for the reliability of his heart, its strength to go on. He waits, breathing easily now, to hear what she will say.

"We go about in pity for ourselves and all the while a great wind is bearing us across the sky."

—from an Ojibwa poem,
with thanks to Peter Matthiessen